CONTENTS

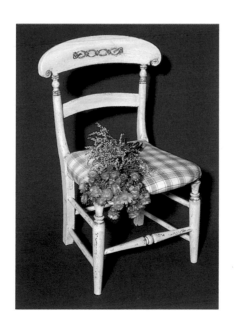

INTRODUCTION

There is nothing new about paint effects – they have been around for years. However, what is new is that there is no longer any need to use smelly oil glazes to create the effects . . . for we are now in the age of acrylic scumble glazes. Scumble glaze is a product which, when added to paint, allows you to create a design in it. It is easy to use, non-toxic and above all quick drying. I started to play and experiment with it some eight years ago, when it was hard to find anybody who knew what it was, let alone sold it. It is now readily available on most high streets, along with all the other products mentioned in this book.

There are many different paint effects, but I have concentrated on what I consider to be the main ones, including colourwashing, sponging, ragrolling, dragging and flogging. I have shared with you the basic rules for these but I hope that you will soon be experimenting to create your own variations. There are no rules that say you cannot use any household object to make a pattern in the glaze on your walls or furniture, so raid those cupboards and explore other possibilities. Remember, one of the joys of working with paint mixed with scumble is that you can always start again if you are not happy with the result.

I have also included a section on antiquing effects such as crackling, distressing, liming and gilding. All of these can be used on their own, or in conjunction with other antiquing or paint effects. There is nothing to stop you going completely over the top and using four effects on the same piece.

Treasure found at a boot fair, objects in your child's bedroom, or the kitchen door that you have hated for years can all be transformed for very little outlay in time and money, to give you years of pleasure. For the purposes of this book, I have worked on small items, but you should not be frightened of applying these techniques to larger areas – doors, walls, floors or ceilings for example.

My whole home is filled with bits and pieces that have been transformed – my walls have been ragged, dragged and flogged in an array of splendid colours. I am now moving into the garden and have begun to transform furniture and pots out there. If you start small, perhaps on a flower pot, before you know it you will be sponging, gilding and crackling everything that moves – my husband is certainly frightened to stand still!

There is nothing mysterious or difficult about paint or antiquing effects, so have a go. Providing you follow a few simple rules, there is no limit to what you can create.

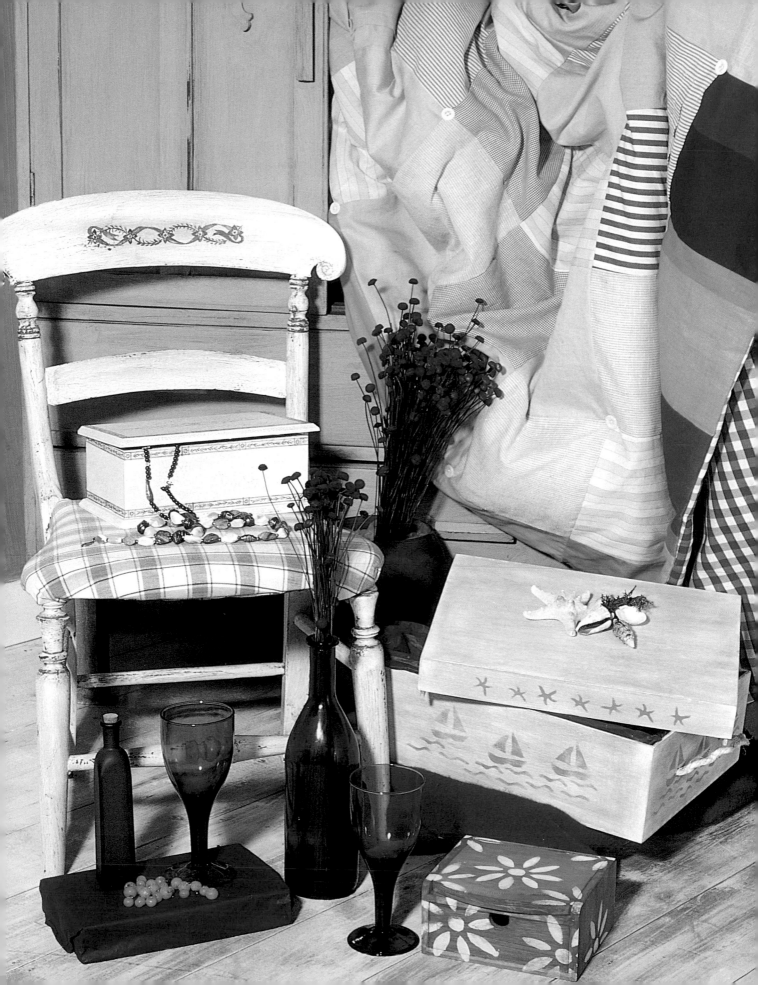

MATERIALS

You should not have a problem in obtaining any of the materials or equipment mentioned in this book. Everything is widely available from independent retailers and large DIY stores. You will also be surprised what you can utilize from your own home.

Paints

A neutral coloured vinyl silk emulsion or an acrylic eggshell paint is used as a basecoat for the paint effects. The paint effects themselves can be worked over the top using any water-based paint – from pure pigment powders to household emulsion or acrylics. All these types of paint are available in a fantastic array of colours, from subtle historic shades that will always be with us, to a range of bright contemporary colours that may come and go with fashion. There are also literally hundreds of shades of white to choose from. So, whatever your taste or mood there will be a colour that is right for you.

Brushes

You do not need all the brushes featured opposite to begin creating paint effects. It is best to buy the relevant ones as and when you need them.

1. Small paint brush *For painting small items and for detailing.*

2. Medium paint brush *For basecoating or crackle glazing small to medium sized items. A brush up to 1cm (½in) will fit neatly into most small paint pots.*

3. Large paint brush *For covering large areas, such as walls, table tops or doors.*

4. Fitch brush *For creating a stippled effect. It can also be used for getting into awkward areas, and its chiselled edge is useful for straight, neat lines.*

5. Stencil brush *A flat-ended brush for applying paint when stencilling.*

6. Dragger brush *A long-haired brush that is pulled through the paint to create a pattern and leave an unbroken brushstroke.*

7. Flogger brush *This is the longest of the brushes and is used to break up the surface of the paint. It is usually used in conjunction with a dragger.*

8. Softener brush *A soft natural-haired brush used to soften harsh lines sometimes left behind in paint effects.*

9. Bristle stipple brush *A square brush used for tapping the paint to give an all-over broken effect.*

10. Plastic stipple brush *A cheaper variation of the bristle stipple brush. This brush will give a looser effect.*

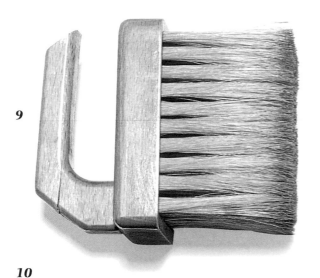

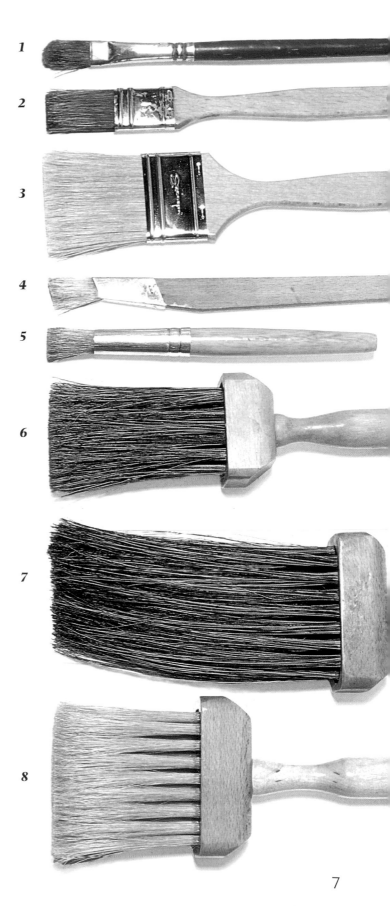

7

Other materials

The painting and antiquing techniques shown in this book all require different tools and materials. The essential ones are shown here. In addition, you will need a palette to mix the paint on – I use an old plate – or a paint kettle if you are mixing large quantities. A comprehensive list of all the materials you need accompanies each demonstration – you should check this carefully before you begin.

An ordinary paintbrush can be used for most of the techniques shown here. Where a specific brush is required, it is pictured.

You will need to use scumble glaze for all paint effects shown in this book, with the exception of woodwashing. Scumble glaze is a product which, when added to paint, holds the paint open (or wet) long enough to create a design in it. It also makes the paint translucent, allowing the basecoat to show through.

COLOURWASHING

Scumble is mixed with water-based paint for this and all the other techniques on this page. A softener brush can be used to soften the effect.

SPONGING

Natural sponges give the best effect, but you can use synthetic ones – try pulling out little pieces to create more texture.

FROTTAGE

Clingfilm is used to create a frottage effect. You can also use newspaper – this will produce a more pronounced veined effect.

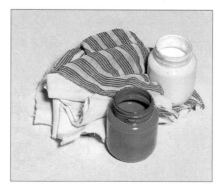

RAGROLLING

Lint-free cloths are used for ragrolling and ragging. Visit charity shops for old sheets to tear up.

WOODGRAINING

Rubber woodgraining tools are readily available. You can choose from a range of different sizes, which will produce varying widths of grain.

LIMING

A bronze wire brush is used to raise the grain of wood. The wood can be coloured or stained if necessary, using a wood stain. Fine grade wire wool is used to apply liming wax or paste and a lint-free cloth is used to remove the excess.

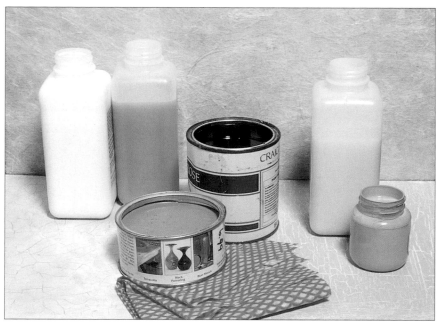

CRACKLING

Two-part water-based crackle varnish creates the effect of aged, cracked varnish. The varnishes react with one another to form cracks. Oil-based paint or coloured wax is rubbed into the cracks with a cloth to reveal them.

Crackle glaze produces the effect of peeling, aged paint. It is sandwiched between two paints and it then cracks the surface of the topcoat to reveal the background colour.

Both of these effects should be sealed with an oil-based varnish.

STENCILLING

Acetate stencils are best to use, but you can use waxed paper ones. A stencilling brush or sponge can be used to apply the paint over the stencil.

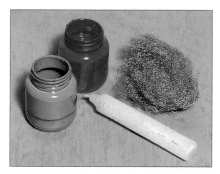

DISTRESSING

White candle wax is used as a resist over a background. Coarse grade wire wool is used to rub back a topcoat to reveal the background.

GILDING

Dutch metal leaf is available in gold, silver and bronze. It comes in loose leaf or transfer form. Gilding size is a clear liquid that leaf adheres to. A soft brush is used to remove excess leaf.

PAINT EFFECTS

All the techniques in this section create a pattern in the paint, with the exception of woodwashing. The effects are worked while the scumble glaze and paint mixture is still wet. This mixture stays wet for quite a long time, so if you make a mistake you can simply brush through it and start again.

If you are working a large area, concentrate on only one square metre at a time, leaving a wet edge so that you can move on to the next section. If you are working on a large room, avoid ugly joining lines by trying to ensure that you finish a designated area in one painting session. For example, do not break off half way through painting a wall! To speed up the process, why not enlist the help of a partner. One of you can apply the scumble glaze/paint mixture and the other can follow behind creating the effect.

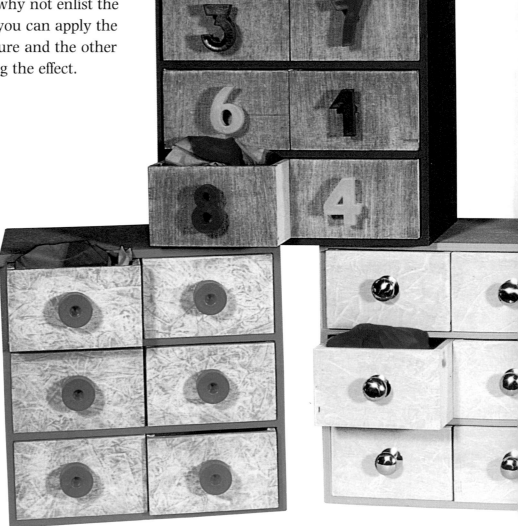

All these miniature chests of drawers are decorated using paint effects featured in this section.

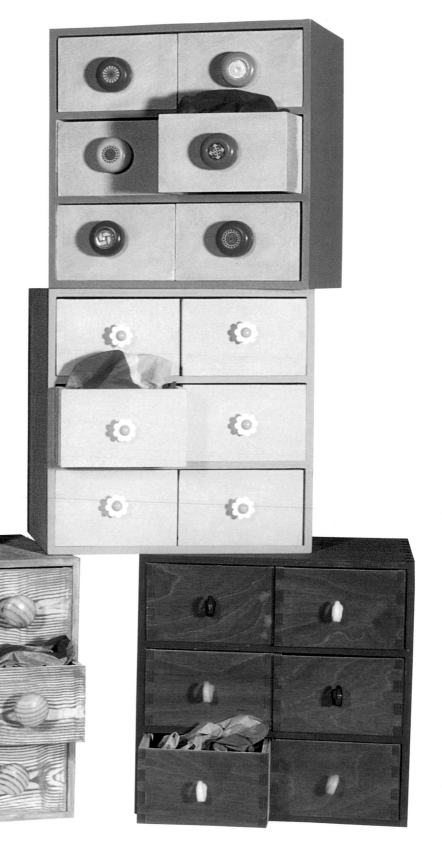

Clockwise from top right:

COLOURWASHING
STIPPLING
WOODWASHING
WOODGRAINING
FROTTAGE
RAGROLLING
DRAGGING & FLOGGING
SPONGING

11

PREPARING SURFACES

You need to follow a few simple guidelines before you begin working a paint effect. Preparation is essential and it is important that you ascertain what your surface is before you begin painting. Rough surfaces need to be sanded – there are various grades of sandpaper and wet-and-dry paper available. Primers are available for specific surfaces such as metal, tiles and formica. All surfaces will require a basecoat. I use vinyl silk emulsion or acrylic eggshell as matt paint restricts the movement of the scumble/paint mixture. I tend to use white or ivory for the basecoat colour as this shows up the translucency of the scumble/paint mixture best. However, you can use any colour, depending on your colour scheme and the effect you want to achieve.

Wood

1. Sand the wood using a coarse grade sandpaper to begin with, working to medium, then fine.

2. Wipe over with a piece of damp cloth or absorbent paper to remove all traces of dust and debris.

3. Apply a neutral basecoat. It is best to use vinyl silk emulsion or acrylic eggshell. When dry, apply a second coat. Leave to dry thoroughly.

Plaster

Wash with warm soapy water to remove dirt and grease. Apply two coats of vinyl silk emulsion or acrylic eggshell.

Metal or ceramics

Sand with fine wet-and-dry paper to provide a key. Wipe over with a damp cloth to remove dust. Apply an oil-based or acrylic-based primer. Apply two coats of vinyl silk emulsion or acrylic eggshell.

NOTE
The information given here on surface preparation applies to paint effects only. Some of the antiquing effects require little or no preparation – instructions are given in each demonstration.

STARTING TO PAINT

Scumble glaze is mixed with paint to ensure that the paint will stay wet long enough for you to create your effect, and to hold the shape of the pattern. Mixing the paint with scumble will not change the colour itself, but it will change the intensity of the colour, making it translucent.

Pre-coloured glazes (colourwashes) are now available, but it is much more fun to mix your own. For small projects, mix the paint and scumble together on a plate. For larger projects, such as walls, mix in a paint kettle, an old plastic tub or a bucket.

> *NOTE*
> *The more scumble you add, the more translucent the paint mixture will be, and it will stay workable for longer. You can mix up to six parts scumble with one part paint – this will stay open for up to an hour. A 50/50 mixture will stay open for about thirty minutes.*

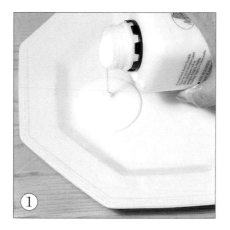

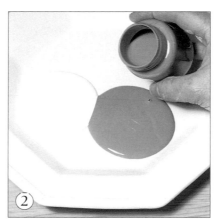

1. Pour one part scumble on to a plate.

2. Add one part water-based paint.

3. Mix the paint and scumble together using a brush. Continue mixing until you have a smooth, even colour.

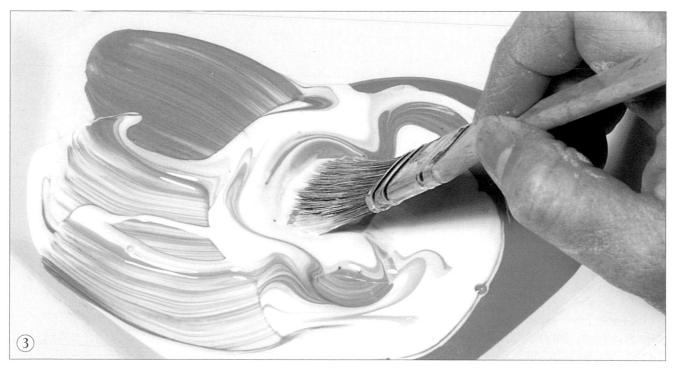

COLOURWASHING

YOU WILL NEED

Vinyl silk emulsion or acrylic eggshell
Water-based paint
Scumble glaze
Palette or paint kettle
Paintbrush
Softener brush

Colourwashing leaves an all-over, uneven, random effect that is reminiscent of old painted plaster. You can either leave it with the brushmarks visible, or you can soften the brushmarks to create a smoother finish. This effect is particularly suitable for walls.

The size of the paintbrush needed will be dictated by the size of the surface you are working on (see page 7).

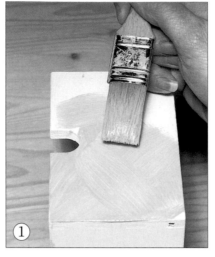

1. Prepare and basecoat your surface (see page 12). Apply the scumble/paint mixture loosely, using a random cross-hatch motion (see page 18).

2. Soften the effect by gently wafting over the painted area with a dry softener brush. Work the brush in various random directions until you get rid of the brushmarks.

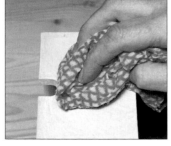

NOTE

You can soften the background using a cloth instead of a brush if you prefer. This will create a more delicate, clouded effect.

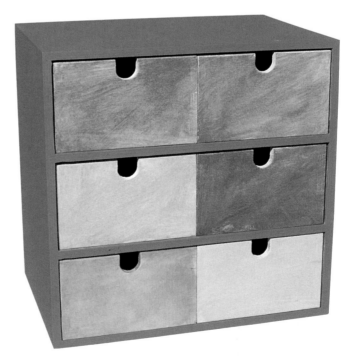

Colourwashing lends itself to the earthy colours of the Mediterranean. Sand yellows, terracottas and rich oranges all work well with this technique.

WOODWASHING

YOU WILL NEED
Water-based paint
Water
Palette or paint kettle
Paintbrush
Medium grade sandpaper
Old cloth (or absorbent paper)

Woodwashing is a technique used to colour untreated wood. There are many ready-mixed woodwashes now available but you can easily mix your own. I use a mixture of water and good quality water-based paint to stain the wood. The wood should be coloured and not covered – excess paint is wiped away, to allow the grain to show through. For best results, choose a wood with a prominent grain.

NOTE

This technique does not use scumble glaze, and so the paint will dry quickly. Work small areas at a time.

1. Sand your surface. Mix the water-based paint with water until it is the consistency of pouring cream. Apply the paint loosely.

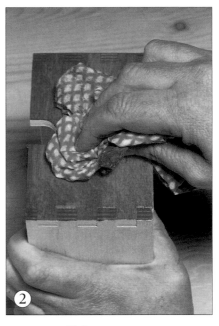

2. Wipe off the paint using a cloth or absorbent paper.

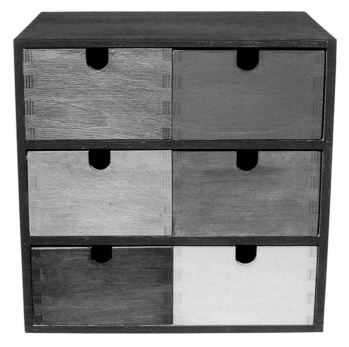

Woodwashing looks most effective on new, white wood with plenty of grain. However, there are many smooth-grained wooden items available which can also be transformed. Bright colours can look stunning, but for a more subtle effect, try using shades of off-white or cream.

SPONGING

YOU WILL NEED

**Vinyl silk emulsion or
acrylic eggshell**

Water-based paint

Scumble glaze

Palette or paint kettle

Paintbrush

Natural sponge

The sponging technique has been around for quite some time, and it is an old favourite. In the past, the paint was mixed with water rather than scumble glaze and the result was a harsher, more rigid effect. Mixing the paint with scumble glaze gives a much softer, more translucent look.

This is a technique that looks particularly good when more than one colour is used on the same surface. Interest is added and depth is built up by randomly applying different colours as you sponge.

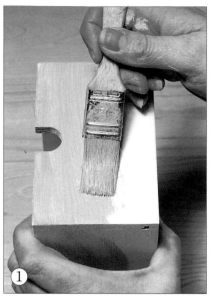

1. Prepare and basecoat your surface (see page 12). Apply the scumble/paint mixture loosely.

2. Pat a damp natural sponge on to the scumbled surface. Continue patting to remove a little of the scumble glaze and create a random patterned surface.

NOTE

The technique demonstrated here is sponging off. You can sponge on, by applying the scumble glaze/paint mixture to the sponge with a brush and then patting this on to your surface.

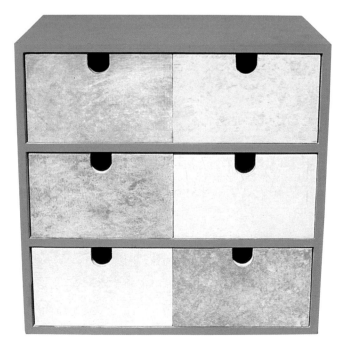

Sponging looks most effective in watery blues and sea greens. It is a great effect to use in the bathroom, or to brighten up a cloakroom.

RAGROLLING

Ragrolling is a great technique that creates an instant effect. Most of us have got an old sheet lurking in the airing cupboard somewhere – there are no other special tools needed.

You need to change the rag frequently when working this effect, so it is a good idea to tear the sheet up into lots of pieces before you begin.

1. Prepare and basecoat your surface (see page 12). Apply the scumble/paint mixture loosely.

2. Form a rag roughly into a cylinder, then roll this over the paint. Continue, rearranging the rag as you roll, to produce a rippled effect.

NOTE

You can use a rag to make lots of different patterns. Form the rag into any shape that you like and dab it into the scumble/paint mixture to create different effects. This technique is known as ragging.

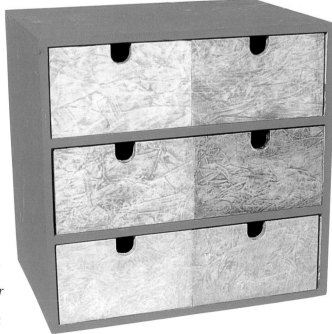

This effect looks great in any colour, and is suitable for any project, large or small. Try using it above a dado with a solid colour below.

STIPPLING

YOU WILL NEED
**Vinyl silk or acrylic
eggshell paint
Water-based paint
Scumble glaze
Palette or paint kettle
Paintbrush
Stipple brush**

The tip of a stipple brush is used to create texture in this technique and produce a very subtle effect.

Stipple brushes come in lots of different sizes, and with different handles. It is often a matter of personal taste as to which you prefer. Plastic stipple brushes are also available – these are relatively inexpensive but still produce good results.

NOTE
You can stipple small areas with a stencil brush or add small areas of colour to a larger area, i.e. gold highlights.

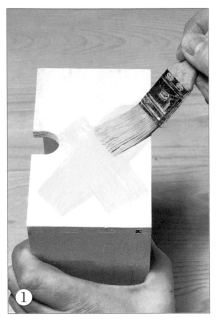

1. Prepare and basecoat your surface (see page 12). Apply the scumble/paint mixture using random cross-hatching strokes.

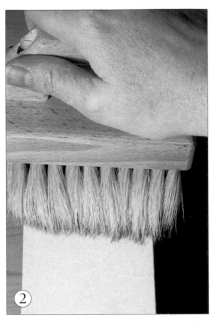

2. Dab all over the painted surface with a stipple brush. Try to keep the brush vertical and stab it quite firmly into the scumble/paint mixture to create a soft texture.

Stippling can be used on pale colours to produce a subtle effect. A more pronounced patterning can be achieved if you work on darker colours. Stippling will create a textured, almost fabric-effect on walls.

DRAGGING AND FLOGGING

YOU WILL NEED

Vinyl silk emulsion or acrylic eggshell

Water-based paint

Scumble glaze

Palette or paint kettle

Paintbrush

Dragging brush

Flogging brush

Dragging and flogging are, technically, two different techniques. Dragging looks great on doors and flogging is very effective on walls. However, in this demonstration, the techniques are worked together rather than separately.

1. Prepare and basecoat your surface (see page 12). Apply the scumble/paint mixture in a downward motion.

2. Pull the dragging brush down through the paint. Try to keep the brush hairs as parallel to the surface as possible.

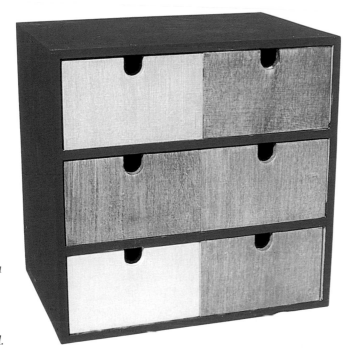

Dragging and flogging looks effective in any colour, but if you want to create a textured wallpaper effect, deep tones look particularly good.

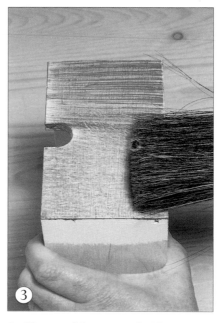

3. Slap and bounce the flogging brush up the dragged line to break up the effect.

WOODGRAINING

YOU WILL NEED

**Vinyl silk emulsion or
acrylic eggshell**
Water-based paint
Scumble glaze
Palette or paint kettle
Paintbrush
Woodgrainer

There are lots of different grainers available, from fine- to coarse-heart ones. Depending on which you use, you can create the impression of different woods, with wider or narrower grains.

This technique takes a little practice. The most important thing to remember when using this tool is to pull and, at intervals, rock it to create an authentic grained effect. Remember, if you make a mistake or if you are not happy with the effect you have created, simply brush over the paint and start again.

NOTE
Rocking the wood grainer as you pull it towards you, is what produces the knot pattern. In order to achieve a realistic, random effect, you should try to avoid rocking the grainer in the same place on an adjacent row.

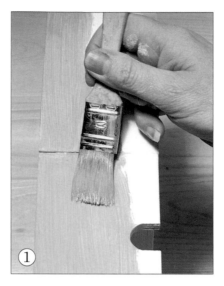

1. Prepare and basecoat your surface (see page 12). Apply the scumble/paint mixture loosely.

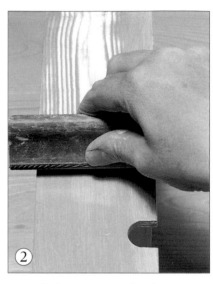

2. Pull the grainer slowly through the paint. Work towards you.

3. After approximately 15cm (6in), rock the grainer towards you and then away from you as you pull it through the paint. Continue pulling and rocking until you have covered your surface. Work one row at a time.

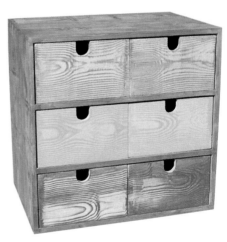

This effect looks most authentic when worked in natural, wood colours, rather than in very vibrant shades – try giving plain kitchen cupboards a new lease of life. You can use this technique on any surface, but it can be difficult to achieve a realistic effect on very small areas.

FROTTAGE

YOU WILL NEED
Vinyl silk emulsion or acrylic eggshell
Water-based paint
Scumble glaze
Palette or paint kettle
Paintbrush
Clingfilm

Frottage was traditionally done with newspaper, but clingfilm can be used nowadays – this gives a more intricate effect and it is much cleaner than newspaper as it does not leave ink on your hands!

You can frottage using two shades of the same colour to create a marbled effect. When the first colour is dry, simply repeat the technique with a second colour.

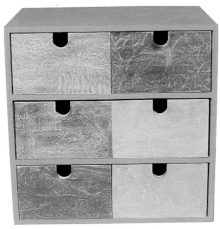

Frottage looks great on smaller projects such as tabletops or door panels. One-colour frottage can be worked in any colour.

1. Prepare and basecoat your surface (see page 12). Apply the scumble/paint mixture loosely.

2. Lay a piece of clingfilm over the wet scumble glaze/paint mixture.

3. Smooth over the clingfilm with your hand to push paint into the creases. Try not to move the clingfilm or the pattern will change.

4. Peel off the clingfilm carefully to reveal the pattern.

ANTIQUING EFFECTS

You can make anything look old and well-loved using the quick and simple techniques covered in this section.

There are some wonderful products available that enable you to artificially age a surface. Paints and varnishes take years to deteriorate, but nowadays it is possible to create the same look easily and inexpensively, in just a few hours.

Generally, antiquing effects look most authentic on objects rather than on, say, walls. It is possible to combine different techniques – for example, découpage and crackle varnishing – to create an inspirational piece.

Try distressing your new furniture further by deliberately damaging it – you could use a hammer to create dents, or you could hit it with a bicycle chain to create random pockmarks.

You can use a small amount of varnish or scumble tinted with a little dark acrylic paint to create the impression of fly marks – simply load an old toothbrush with the tinted varnish or scumble, and run a knife over the bristles to create a fine spray over the surface.

Changing handles helps to alter the appearance of a piece. Use cotton reels, buttons, or perhaps some unusual finds from a bootfair.

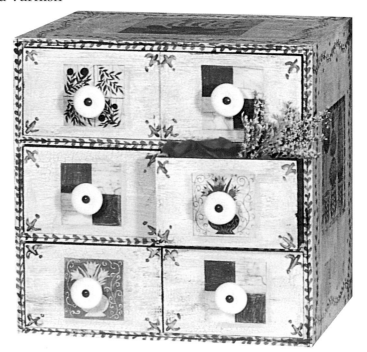

All these miniature chests of drawers are decorated using antiquing techniques featured in this section.

22

Clockwise from top right:

CRACKLE VARNISHING
LIMING
GILDING
VERDIGRIS
CRACKLE GLAZING
DISTRESSING

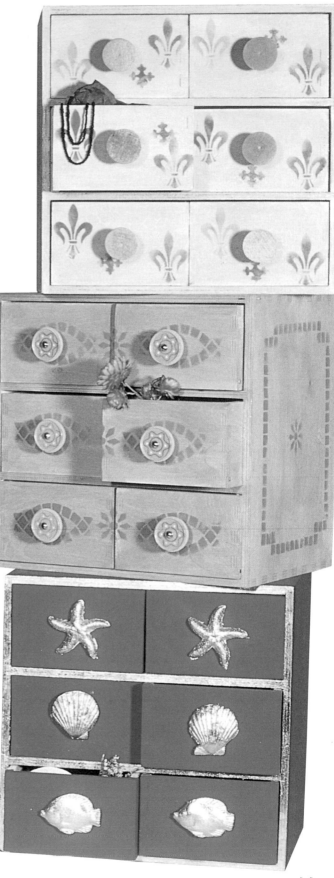

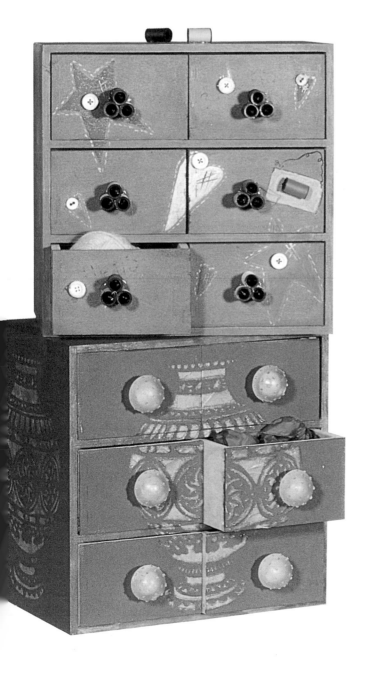

23

DISTRESSING

Cupboard

Distressing is a technique that involves rubbing back paint to give a worn look. To achieve a natural effect, it is best to rub back areas that would wear naturally – for example, around handles and along edges.

In theory, it is possible to distress any surface. This project is worked on natural wood which has been sanded first. The grain in the wood means that the surface is slightly raised in places; this will give a natural look to a distressed piece. I have aged the cupboard further by finishing with a tinted varnish.

Although this cupboard is distressed back to the bare wood, there is nothing to stop you from using a background colour, and distressing back to that.

I have used chilli and leaf stencils for this project, making it an ideal piece for a kitchen. However, you can decorate the cupboard using any image of your choice.

YOU WILL NEED
Small wooden cupboard
Emulsion paint: pale blue
Acrylic paint: red and green
Palette
White candle
Coarse grade wire wool
Chilli and leaf stencils
Masking tape
Stencil brush
Medium paintbrush
Absorbent paper
Tinted varnish

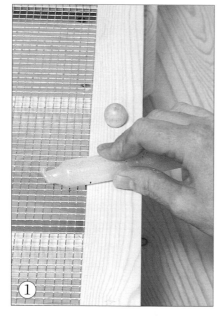

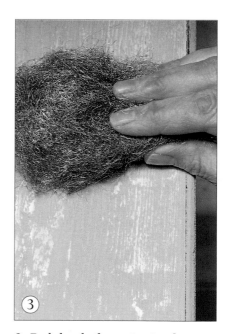

1. Lay a white candle on its side and rub it on to the areas you want to distress. Usually, the areas that would distress naturally are those that get the most wear.

2. Use a paintbrush to apply undiluted emulsion to cover the whole piece. Leave to dry.

3. Rub back the paint in the areas where the candle wax has been applied, using coarse grade wire wool. Work with the grain.

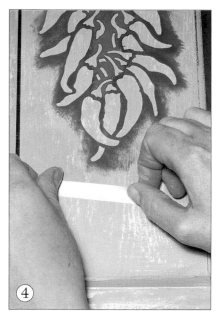

4. Position the chilli stencil on one of the sides of the cupboard, then secure it in place with masking tape.

5. Decant acrylic paint into a palette. Place a little paint on a stencil brush, then dab on to absorbent paper to remove excess paint. Work the brush over the stencil in a circular motion. Repeat, changing colours, to build up the image. Use the same technique to add a chilli image to the other side of the cupboard, and leaf decoration around the front edges. Leave to dry.

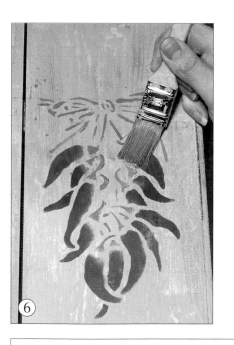

6. Brush tinted varnish all over the cupboard. Leave to dry.

NOTE

You can buy tinted varnish, or you can make your own by adding a little coloured acrylic paint to clear acrylic varnish. You can use whatever colour you like – choose something to complement your piece.

Opposite
Distressed variations

Distressing is the recipe for a perfect country kitchen. Use New England shades alongside natural wood tones to recreate an authentic farmhouse look.

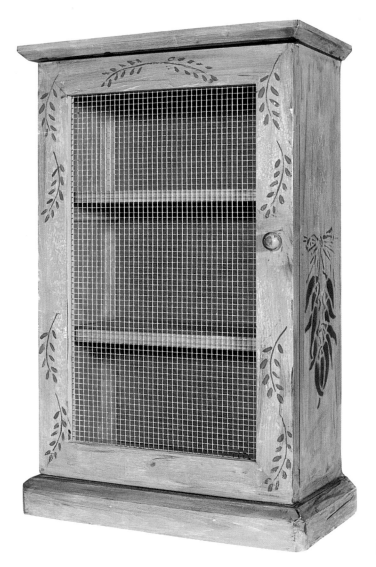

Distressed cupboard (see pages 24–25)

Distressing is an excellent way of making a new cupboard look old. Here, stencilling is also used on the cupboard to add interest, but découpage would be just as effective.

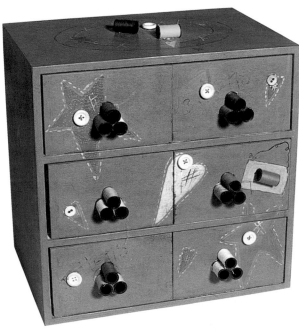

Sewing box

There are lots of ways to embellish a distressed piece. Patchwork designs can be painted on and cotton reels can be used as handles to create an unusual sewing box to treasure for life.

LIMING

Spoon rack

Liming is a technique that can only be worked on wood. The lime is rubbed into the wood and it fills the grain to leave a subtle white sheen. You can use white emulsion instead of liming wax to achieve a similar effect. If you do this, you should stipple the paint into the grain using a very dry brush. The easiest way to achieve a dry brush is to remove excess paint on absorbent paper before you begin. Although this is a good alternative to liming with genuine wax, the effect will not be as authentic.

In normal conditions, you should have about forty minutes working time between applying the wax and having to remove it before it dries. If you are working on a large area such as a floor, for example, you may have to work sections at a time.

You can work on natural wood, or you can colour it first with a natural wood stain or a wood colour – the choice is yours.

To finish, I have worked furniture wax into this spoon rack to protect the surface further and to enhance the sheen.

YOU WILL NEED
Wooden spoon rack
Bronze wire brush
Medium paintbrush
Wood stain: antique pine effect
Liming wax
Natural furniture wax
Pieces of old cloth
Fine grade wire wool

NOTE
Woodstain gives a good contrast with liming. However, you can work liming wax directly on to natural bare wood. Alternatively, try woodwashing the surface (see page 15) to get a different effect.

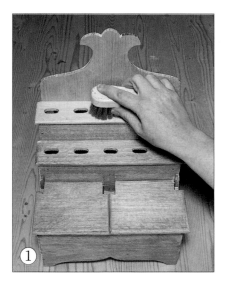

1. Scrub over the surface of the wood with a bronze wire brush. This will raise the grain.

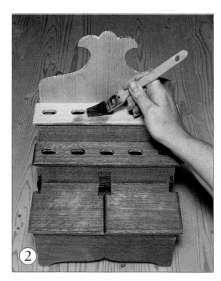

2. Apply wood stain all over the spoon rack. Leave to dry.

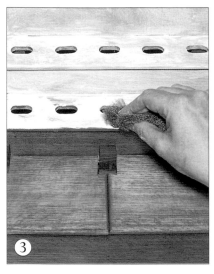

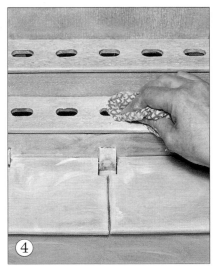

3. Work liming wax into the grain using fine grade wire wool. Work small areas at a time. When the spoon rack is completely covered, leave for approximately five minutes.

4. Use a cloth to wipe off all the excess liming wax, so that you are left with wax filling the grain.

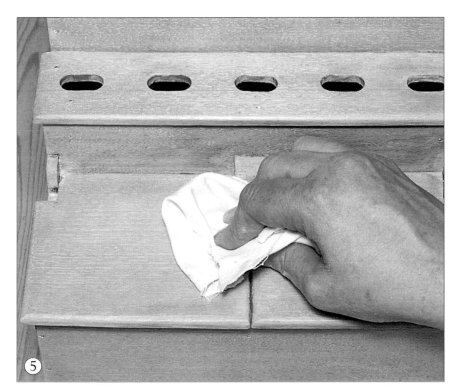

5. Rub natural furniture wax over the surface, then buff up with a clean cloth.

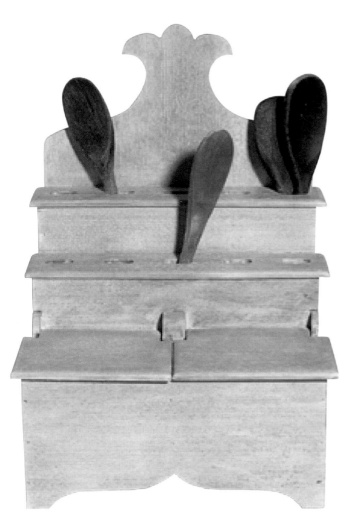

Spoon rack (see pages 28–29)

This piece is stained with an antique pine wood stain, before liming. The wood is fine-grained, which gives a very subtle effect.

Salt box

This wonderful salt box is made from a piece of old oak, which has a very open grain, and the hinge is made from an old piece of leather. It would be inappropriate to stain this piece, as the natural wood is so beautiful. The lime is therefore worked directly into the wood.

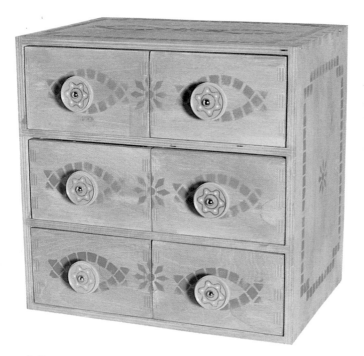

Miniature chest of drawers

Liming can be worked over a surface that has been coloured with woodwash. The addition of a stencilled design will quickly transform a simple piece of furniture into a mosaic treasure chest.

Opposite
Liming variations

You can lime any wooden item. Chairs, cupboards, wardrobes and floors can all be transformed. You can achieve a very different effect by colouring the piece before liming (see page 28), or you can stencil over the limed piece to add colour.

VERDIGRIS

Garden urn

Verdigris is the green and/or blueish effect produced by the oxidising of copper, brass or bronze. It has become very popular to emulate this effect and use it to decorate items such as candlesticks and garden ornaments.

This technique involves building up colour. A dark colour is laid down as the base, then two colours very close in tone are used to variegate the colour. If you are working on metal, you can use verdigris wax to colour the surface.

Gilt cream puts the finishing touches to the verdigris effect. It is worth keeping a brush specifically for gilt cream as it is difficult to wash out. If you prefer, you can use black patinating wax in place of the gilt cream to give a different effect.

I have used a cement urn for this project, but terracotta can also be used. Before you begin, wash the pot with warm soapy water and allow to dry.

YOU WILL NEED
Cement urn
Acrylic paint: dark green, light green, pale turquoise
Gilt cream
Palette
Absorbent paper
Fitch brush
Medium paintbrush
Damp cloth

1. Apply a coat of dark green acrylic paint all over the urn. Leave to dry.

2. Apply a little light green to a fitch brush, then dab on absorbent paper to remove excess paint. Randomly stipple on patches of light green.

3. Wipe off a little of the light green paint using a damp cloth. Try to wipe off from the raised areas, so that the darker green stays in the indentations.

4. Stipple on pale turquoise, using the technique described in step 2. Wipe off a little of the pale turquoise (see step 3).

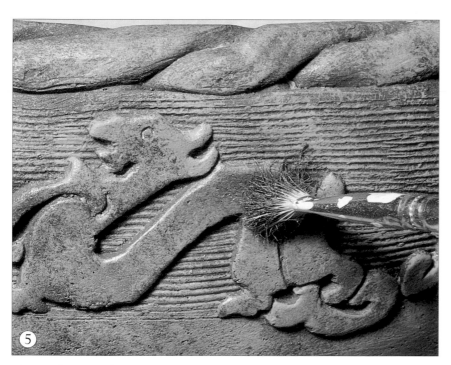

5. Stipple on gilt cream to highlight the raised areas.

Opposite
**Selection of verdigris
variations**

*You can verdigris a variety of items,
from elegant busts to plain terracotta
pots. Even plastic urns, if primed
properly, can be transformed into
metal lookalikes.*

Garden urn *(see pages 32–33)*

*I liked this urn because of the Japanese design, which the verdigris highlights
beautifully. The result is an impressive urn that will add a touch of class to
any garden.*

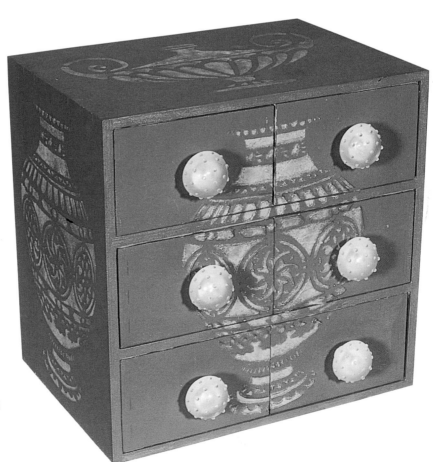

Miniature chest of drawers

*A background colour can be used to
complement a verdigris effect. I have used
powdered filler over a stencil to create
raised urn designs on this miniature chest
of drawers. The stencil is removed and
the filler is allowed to dry. The stencil is
then placed back over the image and a
verdigris effect is worked over the urns.*

CRACKLE GLAZING

Key cupboard

Crackle glazing is a technique that creates the effect of old, peeling paint. A basecoat is applied and a specialist crackle glaze is painted over that. Finally, a top coat in a contrasting colour is applied. This top coat reacts with the crackle glaze making it contract and crack.

It is better to use a dark colour as a basecoat, and a lighter one as a topcoat. Some crackle glazes work better if the topcoat is watered down slightly – refer to the manufacturer's instructions.

Crackle glaze should be left until touch dry before applying the top coat – this will take approximately half an hour, depending on temperature and atmospheric conditions.

This project is worked on natural wood which has been sanded first. The cupboard is distressed as well as crackle glazed, to add to the aged feel. A coat of oil-based varnish or shellac seals the finish.

YOU WILL NEED
Wooden key cupboard
Emulsion paint: red and dark green
Palette
Crackle glaze
Medium paintbrush
White candle
Coarse grade wire wool
Shellac or clear oil-based varnish

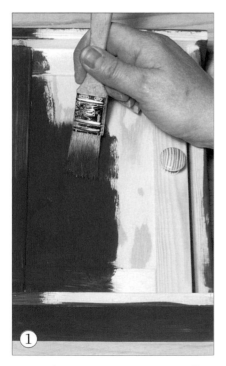

1. Apply a coat of red paint all over the cupboard. Leave to dry.

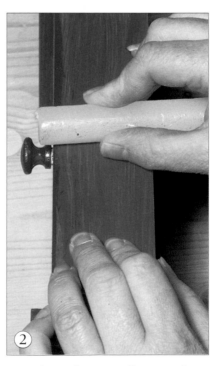

2. Rub a white candle over the sides and top of the cupboard.

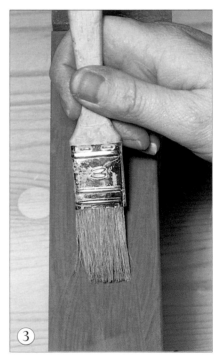

3. Apply a coat of dark green over the areas rubbed with the candle.

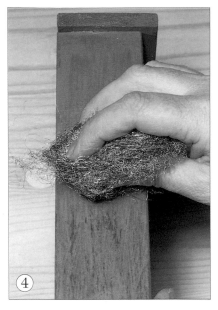

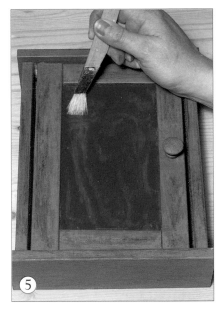

4. Rub back the green top coat with coarse grade wire wool.

5. Apply crackle glaze medium over the front of the painted cupboard. Leave until touch-dry.

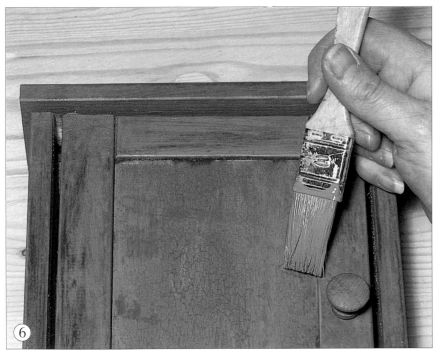

6. Apply a topcoat of dark green over the area covered in crackle varnish. Leave to dry for the cracks to appear. Apply a coat of shellac or oil-based varnish.

NOTE

Paint the topcoat on quickly and do not go back and repaint areas as this will pull the paint off.

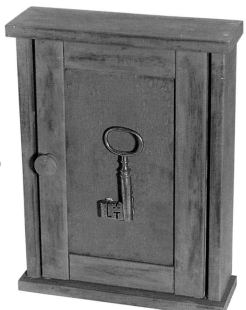

Key cupboard (*see pages 36–37*)
This key cupboard is crackle glazed and distressed to age it. An old key glued to the front of the door adds the finishing touch.

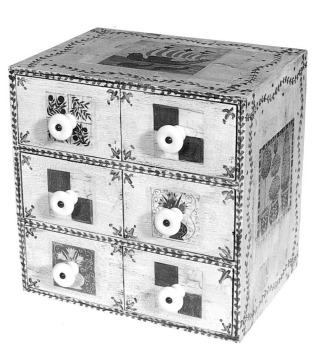

Miniature chest of drawers

You can be as over-the-top as you like with crackle glaze. It can be worked under simple découpage and handpainted images to create a very dramatic effect.

Opposite
Crackle glazed variations
Look out for old watering cans and buckets to transform using the crackle glazing technique. Stencilling can also be used to add a touch more colour.

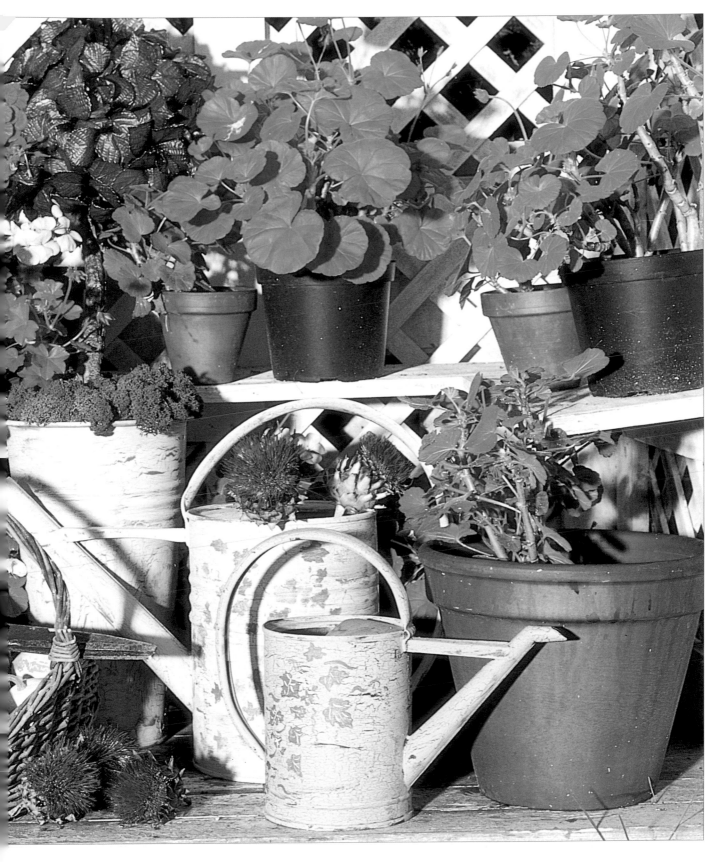

CRACKLE VARNISHING

Jewellery box

Crackle varnishing allows you to produce fine, random, hairline cracks like those found on old masters, antique porcelain or aged varnished furniture. A colour is rubbed in to the cracks to reveal them. I have used a green, verdigris wax for this project, but you can use any coloured wax. Alternatively, use artist's oil paint, gilt cream or any other medium that is coloured, waxy and oil-based.

Water-based crackle varnish can be worked directly over card or paper, or it can used over a painted basecoat. Any water-based paint can be used as a basecoat – from poster paint or emulsion to acrylic paint.

Crackle varnish can be a little unpredictable, particularly in damp atmospheres, so be patient and persevere.

The border on this box is created using the découpage technique. Try to find a gift wrap that has a natural border pattern on it. Alternatively you can paint your own border.

YOU WILL NEED
MDF jewellery box
Two-part water-based crackle varnish
Water-based paint: cream
Palette
Verdigris wax
Medium paintbrush
Absorbent paper
PVA glue
Gift wrap
Scissors
Shellac or oil-based varnish

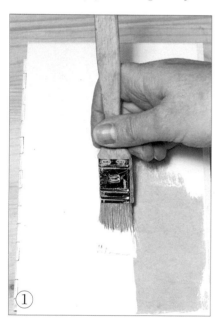

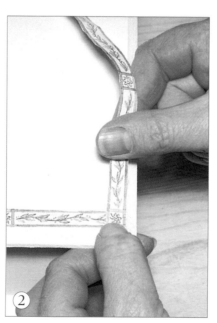

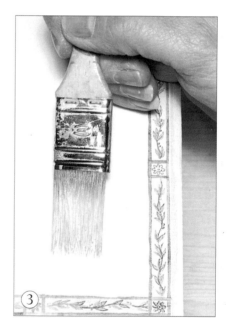

1. Apply a coat of water-based cream paint. Leave to dry. Apply a second coat.

2. Cut out strips of giftwrap. Mix up a 50/50 solution of PVA glue and water and brush on to the back of the strips. Stick in place to create borders around the top and the bottom of the front and sides of the box and the lid.

3. Apply a base coat of crackle varnish over the painted surface and the paper borders. Leave to dry. Apply a top coat of crackle varnish. Leave to dry until cracks appear.

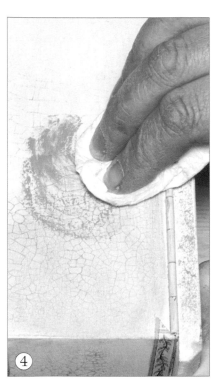

4. Rub verdigris wax into the cracks using absorbent paper.

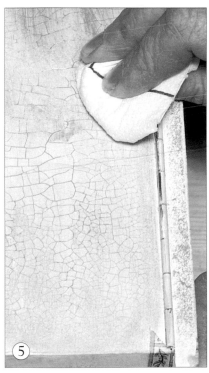

5. Use absorbent paper to wipe away excess wax and leave colour in the cracks. Leave to dry. Apply a coat of shellac or oil-based varnish.

NOTE

If you find it difficult to remove the wax, you can use a small amount of white spirit on the absorbent paper.

Jewellery box *(see pages 40–41)*

This box has been painted, découpaged and crackled. It started off life as a plain MDF box, which provided the perfect surface for a smooth finish.

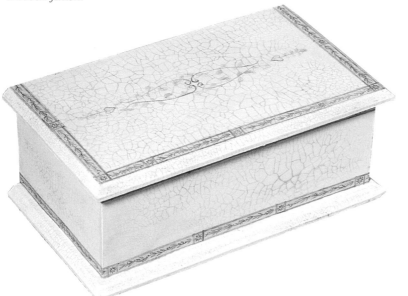

Opposite
Crackle variations

The jewellery box featured in this photograph uses the same techniques as the project, but the cracks are highlighted with antique pine wax. Handpainted decoration on the lid complements the découpaged borders. You can combine techniques with crackling to produce fabulous effects. The orange table has dragged legs with a two-colour frottage and crackled top. You can crackle most surfaces, providing you prepare them correctly. The paper lampshade and ceramic lamp base both look very effective – particularly considering they were bought for next to nothing from a car boot sale.

Miniature chest of drawers

Crackle varnish is available in both small and large crack versions. I have used small cracks over stencilling on this miniature chest of drawers. Try using the larger cracks on a table top or wardrobe doors.

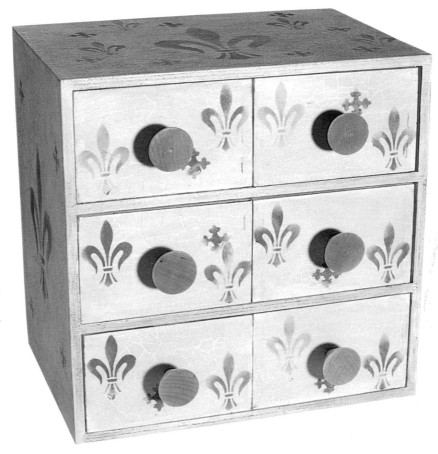

42

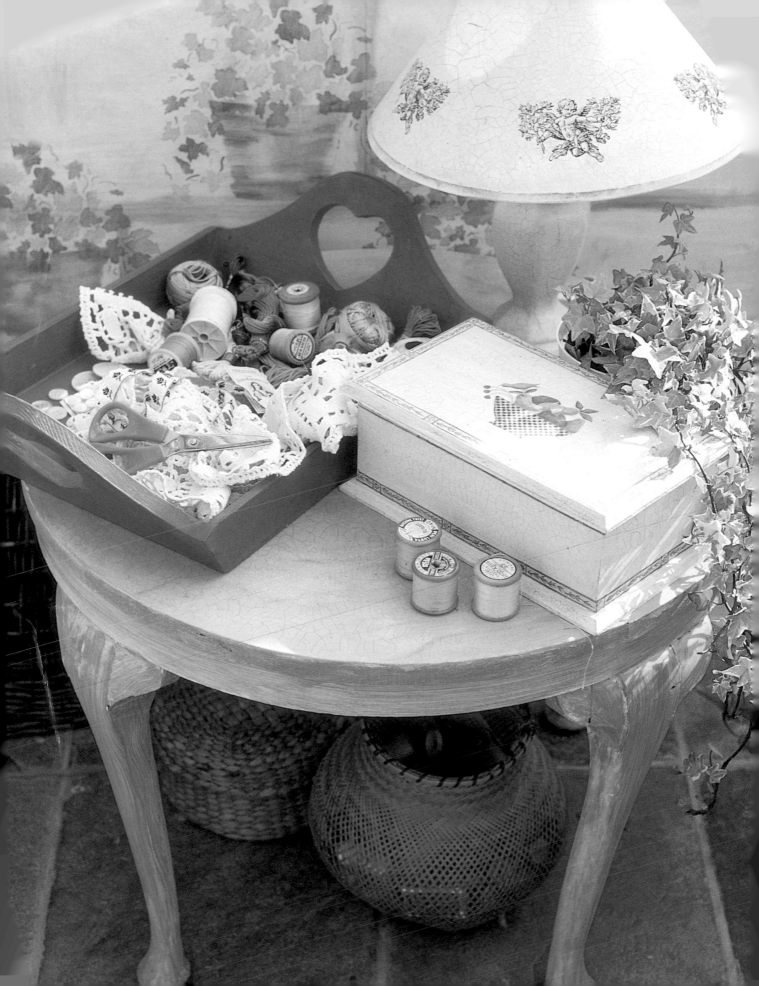

GILDING

Picture frame

Gilding is a quick and easy way to spectacularly transform a huge variety of items. It will add glitz and lustre to even the drabbest article.

Gilding is worked over a coloured basecoat. If you are working with gold or bronze leaf, try using terracotta or black underneath; if using silver, work over a deep blue.

Gilding looks best on three-dimensional objects such as plaster mouldings, wardrobe edgings, handles and door knobs. This project transforms a very basic wooden picture frame. I have used moulding to embellish the front. The amount of moulding you use will depend upon the size of the frame you are working on. You could use wooden or plaster moulding, but I have used a plastic one which comes with an adhesive strip on the back, so you do not need to use glue. This type of moulding is available from most DIY stores.

YOU WILL NEED
Wooden picture frame
Moulding
Emulsion paint: dark red
Dutch metal gold leaf
Gilding size
Small paintbrush
Soft stencil brush or soft make-up brush
Palette
Hacksaw
Fine grade wire wool

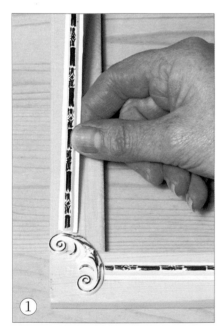

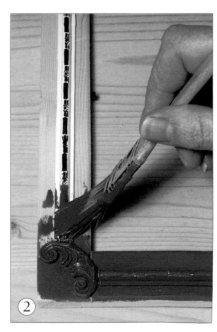

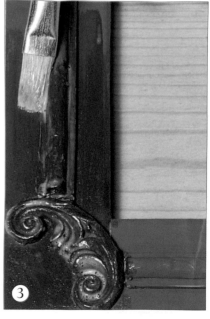

1. Use a hacksaw to cut strips of moulding to fit around your frame. Arrange them on the frame with ornate motifs for the corners. Remove the backing and stick in place.

2. Apply a coat of dark red emulsion paint all over the frame and the moulding. Scrub the brush into all the small areas to ensure that the entire frame is covered. Leave to dry.

3. Brush gilding size all over the painted frame. Leave to dry for approximately five minutes, or until the size goes clear.

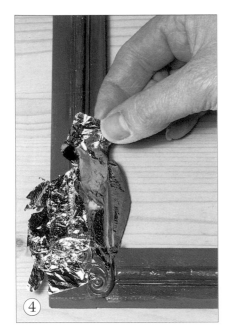

4. Overlap small pieces of gold leaf on top of the gilding size. Work small areas at a time.

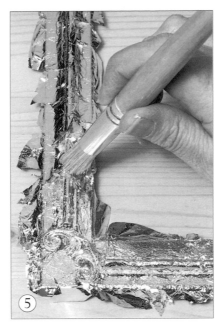

5. Tap the surface gently with a soft stencil brush to adhere the leaf to the size.

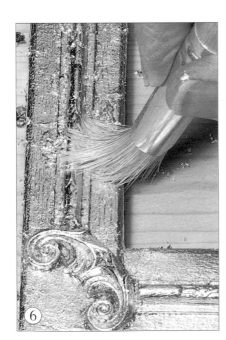

6. Use the stencil brush in a circular motion to brush away the excess leaf.

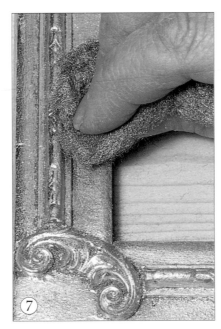

7. Gently rub the gilded frame with very fine wire wool to tarnish the surface slightly.

Picture frame (see pages 44–45)

This impressive gilded frame is very simple and inexpensive to create and it makes an ideal Christmas present or wedding gift. You can complete the project by adding a photograph or picture of your choice.

Miniature chest of drawers

I have used plaster shapes as the handles for this chest of drawers – these are available in craft shops. I wanted the gilding on this piece to remain really bright to complement the base colour. In order to achieve this, I decided not to tarnish the gold with wire wool.

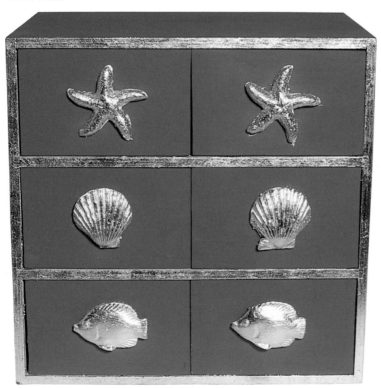

Opposite
Gilded variations

You can use gilding to totally or partially decorate an item. Here, the firescreen and the cupboard are decorated with a gilded stencil image. To do this, the size is applied to the area inside the stencil, instead of paint, and the leaf adheres to that. The handles are also gilded on the cupboard to complete the transformation. You can gild anything – the vase is metal and the lamp base is pre-coloured ceramic.

INDEX

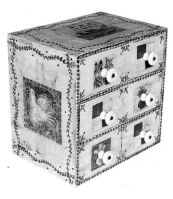

Andrea Kettenmann

DIEGO RIVERA
1886–1957

A Revolutionary Spirit
in Modern Art

TASCHEN

KÖLN LISBOA LONDON NEW YORK PARIS TOKYO

FRONT COVER:
The Calla Lily Sellers, 1943
Vendedoras de alcatraces
Oil on wood, 150 x 120 cm
Jacques and Natasha Gelman Collection, Mexico City
Photo: Jorge Contreras Chacel

ILLUSTRATION PAGE 2 AND BACK COVER:
Diego Rivera in front of the charcoal and watercolour drawing
The Calla Lily Seller (1938), 1945
Photo: Manuel Alvarez Bravo,
courtesy Cenidiap Archive, Mexico City

© 1997 Benedikt Taschen Verlag GmbH
Hohenzollernring 53, D-50672 Cologne
Reproductions with the kind permission of the
Instituto Nacional de Bellas Artes y Literatura, Mexico City
Cover design: Angelika Taschen, Cologne
English translation: Antony Wood in association with
First Edition Translations Ltd, Cambridge, UK

Printed in Germany
ISBN 3-8228-8560-6

Contents

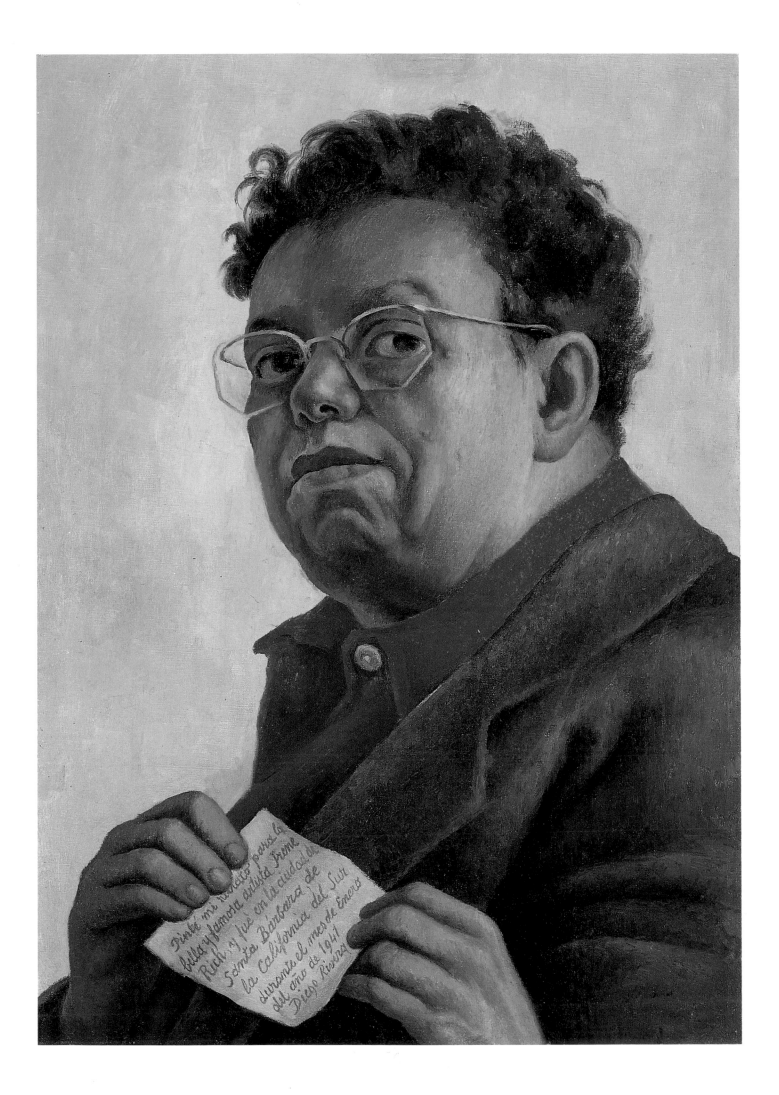

An Artist is Born

An extraordinary artist, a political militant and an eccentric spirit of his age, Diego Rivera played a prime role in an outstanding period in Mexican history, which made him a controversial figure outside his own country and the best-known artist of Latin America. A painter, draughtsman, graphic artist, sculptor, book-illustrator, costume- and stage-designer and architect, Rivera was also one of the first private collectors of pre-Columbian Mexican art.

Linked to names like those of Pablo Picasso, André Breton, Leon Trotsky, Edward Weston, Tina Modotti and Frida Kahlo, he was the object of love and hatred, admiration and disgust, legend and abuse. The myths that surrounded him, even in his own lifetime, arose not only from his work but also from his active participation in the life of his time, his friendships and conflicts with leading figures, his imposing physical appearance and his rebellious nature.

Rivera himself contributed not a little to this myth-making process in his memoirs, which have been drawn upon in numerous biographies. He liked to present himself as being of exotic origin, precocious in youth, a young rebel who fought in the Mexican Revolution, a visionary who declined to join the European avant-garde and whose role as leader of the artistic revolution in Mexico was predestined. That the facts were much more mundane, and that Rivera had great difficulty in separating fiction from reality, is attested by Gladys March in her preface to the artist's autobiography as told to her: "Rivera, who later, in his work, was to make Mexican history into one of the great myths of our century, was incapable of restraining his colossal imagination when telling me of his own life. He had transformed certain events, especially those belonging to his earliest years, into legends."[1] To present the life and the work of this extraordinary artist will therefore be to bring the two into closer relationship.

José Diego María and his twin brother José Carlos María were born on 8 or 13 December 1886 (the sources give different dates), the eldest sons of Diego Rivera and María del Pilar Barrientos, two years after their marriage, in Guanajuato, capital of the State of Guanajuato in Mexico. Both parents were teachers. Diego Rivera was of Creole origin; his father, owner of numerous silver mines in Guanajuato, is said to have been Russian born and, after emigrating to Mexico, to have fought alongside Benito

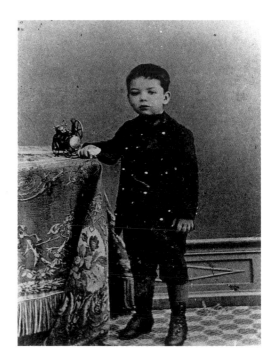

Diego Rivera at the age of four, 1890
Courtesy Cenidiap Archive, Mexico City

ILLUSTRATION PAGE 6:
Self-portrait dedicated to Irene Rich, 1941
Autorretrato dedicado a Irene Rich
Oil on canvas, 61 x 43 cm
Smith College Museum of Art,
Northampton, Massachusetts,
Gift of Irene Rich Clifford, 1977

7

The twins Carlos María and Diego María
Rivera Barrientos aged one (Diego on
right), 1887
Photo: Vicente Contreras, Guadalupe Rivera
Marín Collection, Mexico City
Courtesy Cenidiap Archive, Mexico City

Diego Rivera, with an unidentified woman,
in front of the house of his birth in
Guanajuato (now Museo-Casa Diego
Rivera), c. 1954–1955
Courtesy Cenidiap Archive, Mexico City

Juárez, who was the first president of Mexico after independence, against
Maximilian, emperor of Mexico (1863–1867), and the invading French.
The maternal grandmother is said to have been of half-Indian blood. Both
these claims, though as yet unproven, nevertheless reflect those ancestral
elements to which Rivera was later to attach special value. He was proud
both of his right to call himself, through his grandmother's Indian blood, a
real mestizo, and of the revolutionary inheritance from his grandfather that
was to prove so important to him.

The birth of María del Pilar, Diego's younger sister, in 1891, consoled
the family for the loss of his twin brother, who had died at the age of eight-
een months in 1888. As a result of this experience María Barrientos took up
medical studies and became a midwife. Her and her husband's espousal of
the radical ideas published in the twice-weekly liberal newspaper *El Demócrata*,
of which Diego's father was coeditor, provoked hostility towards the family
on its arrival in Mexico City in 1892. General Porfirio Díaz, military leader
of the Republic during the French intervention, who made himself absolute
dictator after seizing power, and was president of Mexico almost uninter-
ruptedly from 1876 to the outbreak of the Revolution in 1910, endeavoured
to stamp out all opposition. Because of the Riveras' fallen standing in middle-
class circles of the provincial town where they lived, and also because the
wealth of the silver mines of Guanajuato had been exhausted, the parents
sought a better situation in the capital.

María del Pilar Barrientos was a strict Catholic, and Diego, who had
been taught to read by his father at four, was sent to school, in 1894 at the
age of eight, to the Carpantier Catholic College. Receiving a distinction in
the third class in 1896, Diego, who was showing artistic gifts, began even-
ing classes at the San Carlos Academy. The boy had been passionately
fond of drawing from an early age, and his talent was now developed by
painting lessons. His father insisted that he enter a military school, which he
soon left to enrol as a student at the respected San Carlos Academy. Art was
paramount in his life: as he later wrote, he saw it as an organic human
function, not only useful but life-supporting, like the consumption of bread
and water or the breathing of air.[2]

Rivera's course of study at the Academy from 1898 to 1905 was a
rigorous one, following traditional European models, based on technical
proficiency, absolute ideals and rational enquiry. He was taught by the
Spanish painter Santiago Rebull, who was a pupil of Ingres and an ardent
admirer of the Nazarenes, and by the Naturalist artist Félix Parra, who
influenced Rivera above all as an expert in pre-Columbian Mexican culture
and also taught him how to copy classical sculpture (see *Classical Head*,
1898; ill. p.9). On the death of Santiago Rebull in 1903 the Catalan painter
Antonio Fabrés Costa became vice-rector of the Academy; he provided his
students with photographs instead of prints of old masters to be used as
models and introduced a new drawing method based on that of Jules-Jean
Désiré Pillet.[3]

Alongside his studio work Rivera began *plein air* drawing and painting.
As a student of the landscape painter José María Velasco, and profiting
from his lessons in perspective, he was soon painting his first landscapes;
Velasco's teaching and influence are clearly reflected in *The Threshing*

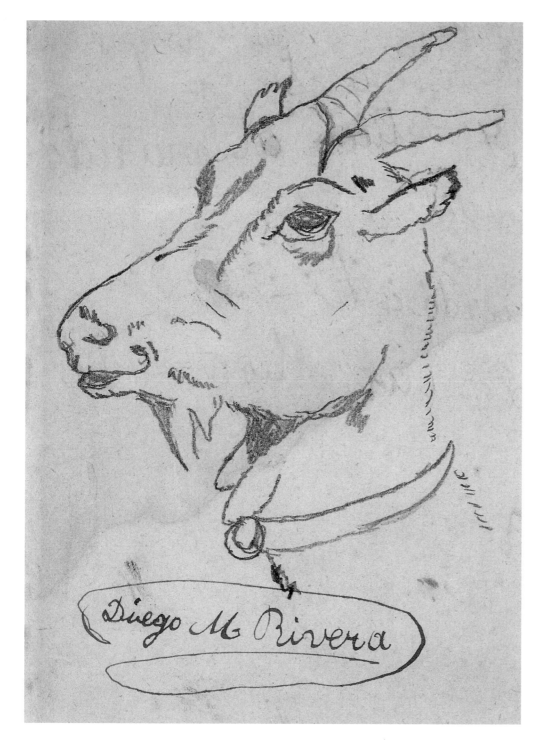

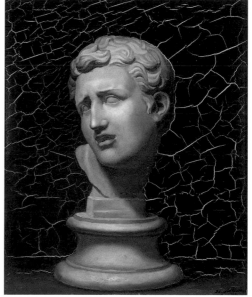

Head of a Goat, c.1895
Cabeza de cabra
Pencil on paper, 12.5 x 9.5 cm
Rafael Coronel Collection, Cuernavaca
Photo: Rafael Doniz

Classical Head, 1898
Cabeza clásica
Oil on canvas, 48.5 x 39.2 cm
Museo-Casa Diego Rivera, Guanajuato
Photo: Rafael Doniz

Floor (1904; ills. pp.10, 11). In this depiction of a team of horses on the edge of the broad plain below Popocatepetl, the volcano south-east of Mexico City, the handling of light as well as the whole conception of landscape reveal the teacher. Like Velasco, Rivera sets out to convey the distinctive colourfulness of a typical Mexican landscape.

While at the Academy Rivera also made the acquaintance of the landscape painter Gerardo Murillo, who, more on account of his theory than of his painting, is often described as the ideological forefather of the Mexican artistic revolution because he proclaimed the values of Indian crafts and Mexican culture. Dr Atl, as Murillo called himself later, after a monosyllabic word in the Nahuatl language meaning "water", had just returned from a visit to Europe, and his account of contemporary European art made a

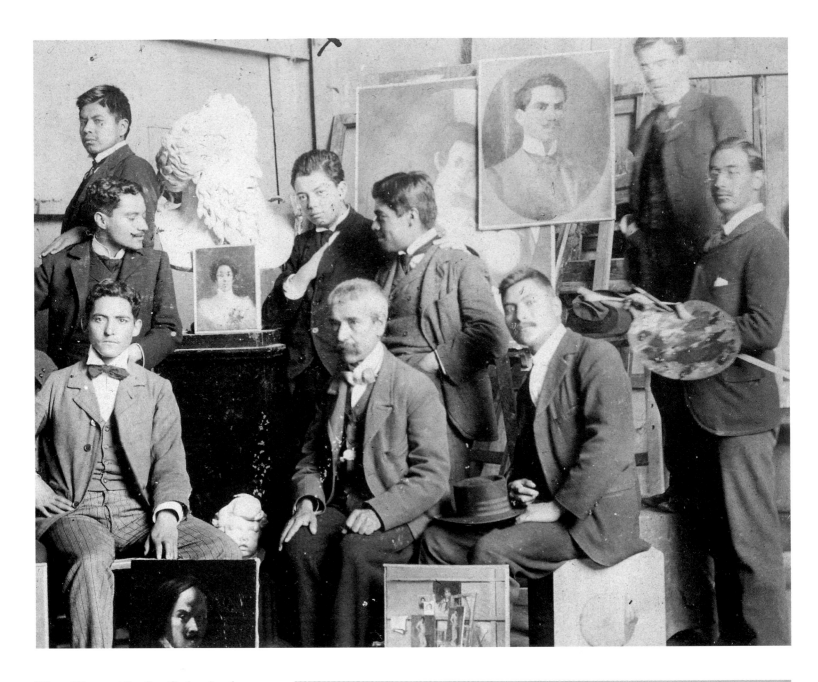

Diego Rivera at the San Carlos Academy,
with his teacher Antonio Fabrés Costa and
fellow students in the painting class (Rivera
is above, in the middle), 1902
Museo-Casa Diego Rivera, Guanajuato
Photo: Rafael Doniz

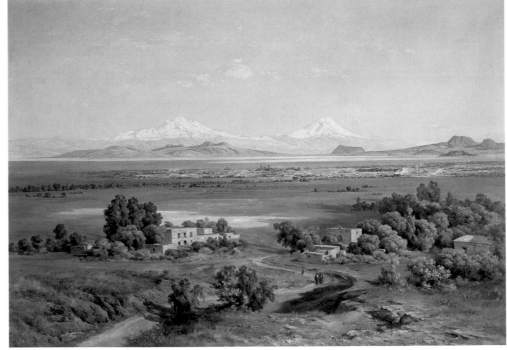

José María Velasco
Mexico Valley seen from the Tepeyac, 1905
El Valle de México tomado desde el Tepeyac
Oil on canvas, 75 x 105 cm
Museo Nacional de Arte, MUNAL – INBA,
Mexico City
Photo: Rafael Doniz

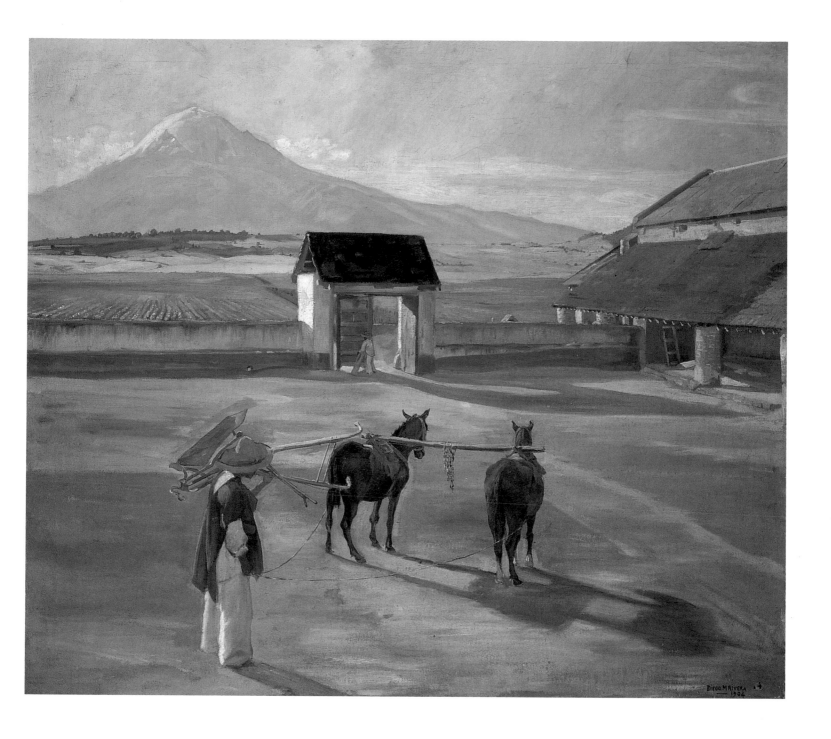

profound impact on his young students. Murillo spurred Rivera to widen his artistic range, and thanks to a grant from the governor of Veracruz, Teodoro A. Dehesa, and the sale of some works at a group exhibition organized at the San Carlos Academy by Murillo in 1906, he was enabled to visit Europe.

The Threshing Floor, 1904
La era
Oil on canvas, 100 x 114.6 cm
Museo-Casa Diego Rivera, Guanajuato
Photo: Rafael Doniz

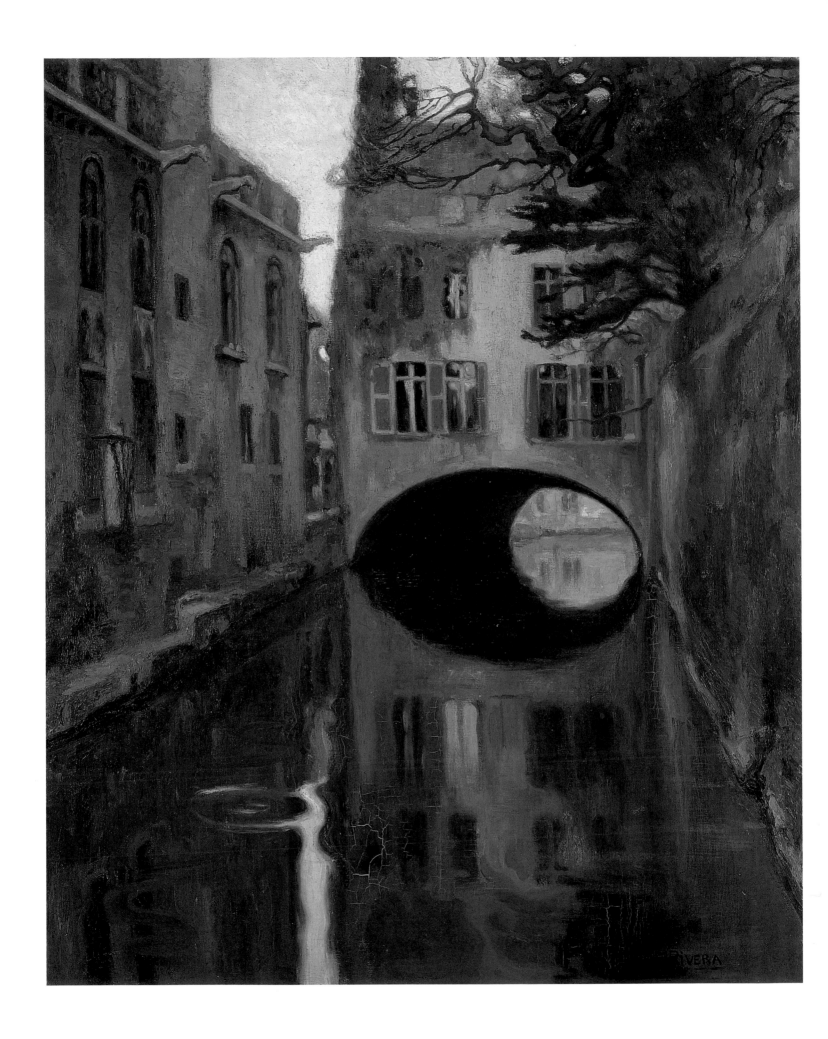

Apprentice Years in Europe

In January 1907 Diego Rivera took ship for Spain. Later the artist described his euphoria: "I remember, as if I saw it from another point in space, outside myself, a dimwit of twenty, so vain, so full of the blackheads of youth and dreams of being master of the universe, just like all the other fools of his age. The age of twenty is simply ridiculous, even when you're talking of Genghis Khan or Napoleon . . . Diego Rivera, standing erect on the foreship of the *Alfonso XIII*, looking at the ship and how she cleaves the water, her wash foaming behind her, bawling out passages from *Zarathustra* in the face of the profound and melancholy silence of the ocean, is the most pathetic and kitschy thing I know. That was me . . ."[4]

For two years after his arrival in Spain Rivera absorbed the most diverse influences, incorporated into his work what he found useful, and espoused many of the most important aesthetic movements and trends of the day.[5] In Madrid he started working in the studio of the leading Spanish Realist Eduardo Chicharro y Agüera, to whom Murillo had given him a letter of introduction. This symbolist painter of Spanish *costumbrista* (regional genre) subjects took Rivera as a pupil, and encouraged him to travel in Spain in the years 1907 and 1908.

The intellectual curiosity of the young painter, and his capacity for learning equally from old masters and from contemporary trends, is reflected in the variety of styles with which he experimented in the next few years. In the Prado he studied and copied works by Goya, especially the late "Black Paintings", El Greco, Velázquez and the Flemish masters. When Rivera met the Dada writer and critic Ramón Gómez de la Serna, one of the outstanding figures of Madrid's literary and artistic bohemia, he began to move in Spanish avant-garde circles, whose leading artistic representatives, Pablo Picasso, Julio González and Juan Gris, had actually lived in Paris for the last few years.

In spring 1909 Rivera followed his new friends to France, after which he returned to the peninsula for only short and sporadic periods, although continuing to be in close touch with Spanish artists and intellectuals. In Paris too he studied the museum collections, visited exhibitions, attended lectures, and worked in the free schools of Montparnasse and on the bank of the Seine.

In the summer of 1909 he visited Belgium; in Brussels, home of the Symbolist artists, he painted *House over the Bridge* (ill. p.12), and met a

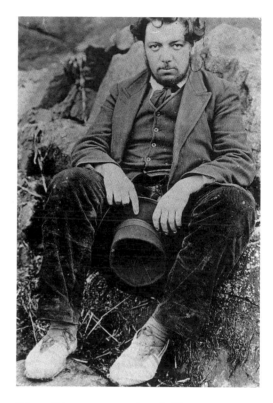

Diego Rivera as a student in Europe,
c. 1908–1915
Museo-Casa Diego Rivera, Guanajuato
Photo: Rafael Doniz

ILLUSTRATION PAGE 12:
House over the Bridge, c. 1909
Casa sobre el puente
Oil on canvas, 147 x 120 cm
Museo Nacional de Arte, MUNAL – INBA,
Mexico City
Photo: Rafael Doniz

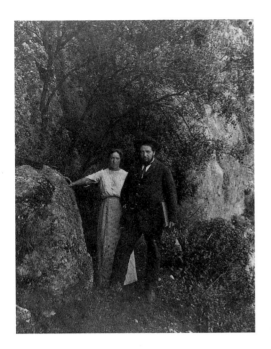

Diego Rivera with Angelina Beloff, 1909
Courtesy Cenidiap Archive, Mexico City

Portrait of Angelina Beloff, 1917
Retrato de Angelina Beloff
Pencil on paper, 33.7 x 25.4 cm
The Museum of Modern Art, New York,
Gift of Mrs Wolfgang Schönborn,
in honour of René d'Harnoncourt

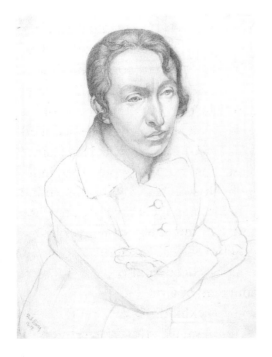

young Russian painter six years older than himself, Angelina Beloff (ill. p.14 above). Born in St Petersburg of liberal middle-class family, she had been trained as a teacher of art at the St Petersburg Academy, and was now on her way to Paris, where for twelve years she was to live as Rivera's first partner.

After a short visit to London, during which he became acquainted with the work of Turner, Blake and Hogarth, Rivera returned to France with Beloff at the end of the year. On a trip to Brittany he painted among other works *Head of a Breton Woman* (ill. p.15) and *Breton Girl* (ill. p.15 below), showing his interest in scenes typical of Spanish *costumbrista* painting. The technique of chiaroscuro, learnt from Dutch seventeenth-century paintings in the Louvre, is in evidence here.

After the young artist had exhibited with the Society of Independent Artists for the first time in 1910, he returned in the summer of that year to Madrid. His grant expired in August, at a time when he was preparing for his return to Mexico and arranging transport of the works painted during his spell in Europe, which were to be exhibited at the San Carlos Academy as part of the celebrations of the centenary of Mexican independence being organized by Porfirio Díaz. At the same moment Francisco I. Madero, the opposition's rival presidential candidate, with his "San Luís Potosí Plan" exhorting the people to seize arms, proclaimed the Mexican Revolution, which continued for the next ten years. Despite the political turmoil now unleashed, which forced Díaz's resignation in May 1911, the exhibition was a great artistic as well as financial success for Rivera. The proceeds from the sale of his pictures enabled him to decide on a journey to Paris in June 1911; he was to spend ten further years in Europe, not to return to Mexico again until the age of 34. The story that turns up in later biographies of his fighting alongside the peasant guerrillero Emiliano Zapata, during the brief period that he spent in Mexico at the beginning of the Revolution, remains unproven.

In Paris Rivera set up house with Angelina Beloff, and in the spring of 1912 went with her on a visit to Toledo, where he met a number of Latin American artists living in Europe and struck up a close friendship with his fellow-countryman Angel Zárraga. The two made a study of the work of the Spanish painter Ignacio Zuloaga y Zabaleta, and Rivera also felt strongly drawn to El Greco's painting, which he took as his particular model. He accentuated the angles in his landscapes of Toledo and his genre works, elongated his figures and picked up El Greco's characteristic feeling for space. In *View of Toledo* (1912; ill. p.16) Rivera even used almost exactly the same viewpoint as the Spaniard in his work of 1610–1614 of the same title (ill. p.16 below). This painting displays the beginning of Rivera's interest in the juxtaposition of spatial shapes and surfaces, which was eventually to lead him to Cubism.

After returning to Paris, Rivera and Beloff moved in autumn 1912 to 26 rue du Départ, a building in which various Montparnasse artists had studios (ill. p.17 above). Through the work of his neighbours here, the Dutch painters Piet Mondrian, Conrad Kikkert and Lodewijk Schelfhout, whom contact with Paul Cézanne had brought to artistic maturity, Cubist influences reached Rivera. It was in the year 1913 that his transition to analytical

Head of a Breton Woman, 1910
Cabeza de mujer bretona
Oil on canvas, 129 x 141 cm
Museo-Casa Diego Rivera, Guanajuato
Photo: Rafael Doniz

This work is strikingly reminiscent of 17th-century Flemish portrait-painting, studied by Rivera during his recent stay in Belgium.

Breton Girl, 1910
Muchacha bretona
Oil on canvas, 100 x 80 cm
Museo-Casa Diego Rivera, Guanajuato
Photo: Rafael Doniz

Cubism took place, when he attained an understanding of Cubism that he then developed in some two hundred works over the next five years. His attempts, following his first Cubist works, to find a style containing both Cubist and Futuristic elements reached their apogee towards the end of 1913 in the oil painting *Woman at a Well* (ill. p.19). In this as well as in most of the works that followed it, he uses a brilliant palette, unusual in earlier Cubist works by his contemporaries.

Rivera achieved a convincing, more static presentation of simultaneity with a kind of compositional grid, which he used in 1914 in works like *Sailor at Breakfast* (ill. p.18). In this painting the grid is made up by the figure of a man with long black hair and a moustache seated behind a table, wearing the white-and-blue-striped shirt and cap with red pompom of the French sailor, on which the word "patrie" is inscribed; he holds a glass in one hand and on a plate before him lie two fish. This and other works of the time clearly reflect the artist's friendship with Juan Gris, whom he had met at the beginning of 1914. The synthetic Cubism of the Spanish artist from whose pictorial language Rivera learned much is especially to be seen in his use of the compositional method evolved by Gris. In his work of this period Rivera attempts the Spaniard's typical grid covering the whole picture, each individual area of the composition showing a different object and perspective being consistently preserved within each area. The mixture of paint with sand and other substances, the thick, opaque application of paint and the use of a collage-like technique are further reminders of Gris.

While his work was being shown at group exhibitions outside France, in 1913 in Munich and Vienna, and in 1914 in Prague, Amsterdam and

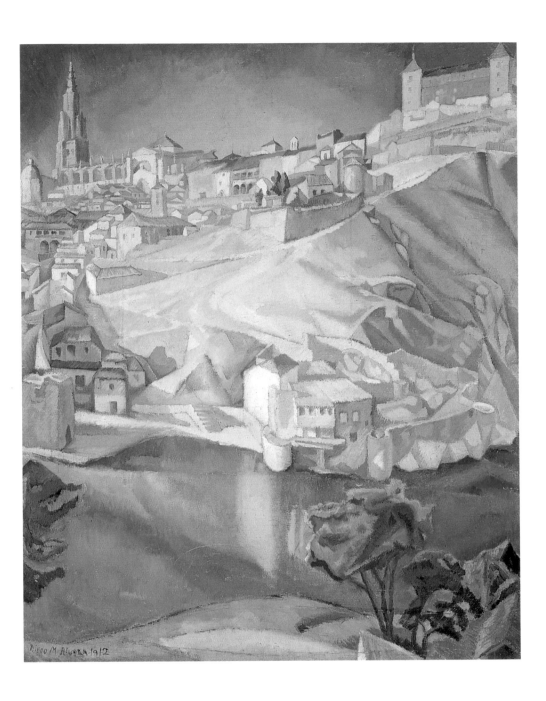

View of Toledo, 1912
Vista de Toledo
Oil on canvas, 112 x 91 cm
Fundación Amparo R. de Espinosa
Yglesias, Puebla
Photo: Rafael Doniz

El Greco
View of Toledo, 1610–1614
Vista de Toledo
Oil on canvas, 121 x 109 cm
The Metropolitan Museum of Art, New
York, H.O. Havemeyer Collection

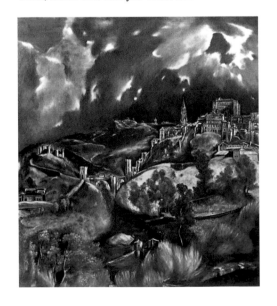

Brussels, Rivera took enthusiastic part in the Cubist painters' theoretical debates, and one of those with whom he held discussions was Picasso, whom he had met through the Chilean artist Ortíz de Zárate. At his first one-man exhibition in April 1914 at the Galerie Berthe Weill, Rivera showed twenty-five Cubist works, and a number of these were sold. His problematic financial situation consequently improved, enabling him in July of that year to take a trip to Spain with Angelina Beloff and also Jacques Lipchitz, Berthe Kristover and María Gutiérrez Blanchard. The party's stay on Mallorca was lengthened by the outbreak of war and extended by a trip to Madrid, where Rivera saw more of the writer Ramón Gómez de la Serna and other Spanish and Mexican intellectuals. In Madrid in 1915 he showed work at the exhibition *Los pintores íntegros* organized by Goméz de la Serna, at which Cubist work was shown in Madrid for the first time; the exhibition gave rise to heated critical debate.

Rivera received news of political and social events in his home country through Mexican friends living in exile in Madrid and Paris, and from his

Diego Rivera in his Paris studio in the rue
du Départ, 1915
Courtesy Cenidiap Archive, Mexico City

mother, who visited him in Paris in 1915 after his return from Spain. Even if
Mexico was on the brink of anarchy and chaos, Rivera was clearly inspired
by the idea of a Mexico waking from colonial sleep and, as the revolution-
ary folk hero Emiliano Zapata promised in his *Manifesto to the Mexicans*,
preparing to give the land back to the people. Reports from his homeland
and preoccupation with his origins find strong expression in *Zapatista Land-
scape – The Guerrilla* (ill. p.17), painted after reunion with his Mexican
compatriots in Madrid.

Now one of the leaders of the so-called "Classicist" group, which in-
cluded Gino Severini, André Lhote, Juan Gris, Jean Metzinger and Jacques
Lipchitz, Rivera was achieving increasing success. In 1916 he participated
in two group exhibitions of Post-Impressionist and Cubist art at Marius de
Zaya's Modern Gallery in New York, and in October of the same year the
latter also invited him to take part in an *Exhibition of Paintings by Diego M.
Rivera and Mexican Pre-Conquest Art*. Léonce Rosenberg, dealer and direc-
tor of the Effort Moderne gallery, secured him on a two-year contract. He
actively participated in the philosophical discussions of the group of artists

Zapatista Landscape – The Guerrilla, 1915
Paisaje zapatista – El guerrillero
Oil on canvas, 144 x 123 cm
Museo Nacional de Arte, MUNAL – INBA,
Mexico City
Photo: Rafael Doniz

Rivera paints an iconographic portrait of the
revolutionary Emiliano Zapata in Cubist
style; the rifle, the bandolier, the hat worn
by the Zapatistas and the *sarape* (blanket)
are clear references to the Mexican Revolution.

17

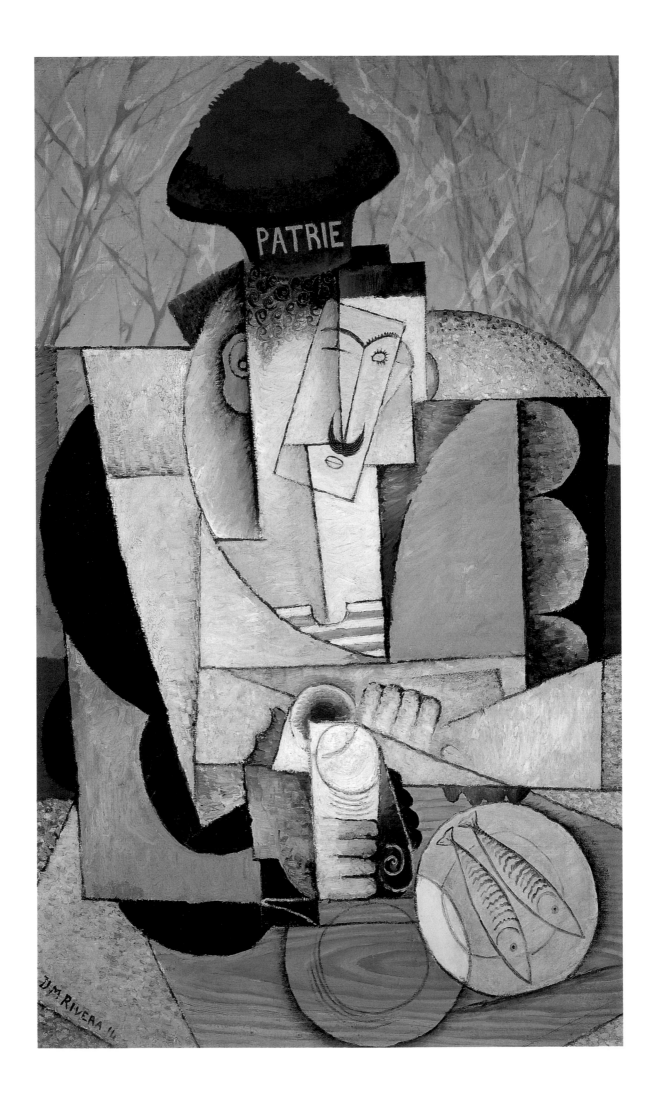

and Russian émigrés organized through the war years by Henri Matisse. In this circle, to which he was introduced by Angelina Beloff, he met the Russian writers Maximilian Voloshin and Ilya Ehrenburg. Preoccupation with scientific and philosophical ideas led to an increasingly unadorned "classical" style and compositional simplicity, which may be seen in the painting *Motherhood: Angelina and the Child Diego* (ill. p.21), straightforwardly depicting Angelina Beloff sitting on a chair feeding their son, born on 11 August 1916. Weakened by cold and hunger, "Dieguito" fell ill during an influenza epidemic in the winter of 1917/18 and died before the end of the year. Some drawings of the mother and child, and the use Rivera made of them in this Cubist painting, are mementos of his young son.

Not long afterwards the couple moved to an apartment in rue Desaix near the Champ-de-Mars, some distance away from the artistic-intellectual milieu of Montparnasse. The break-up with the Cubist painters occurred through a row between Rivera and the art critic Pierre Reverdy in the spring of 1917, later referred to by André Salmon as "the Rivera affair". During the absence of Guillaume Apollinaire through the war years Reverdy had become the theorist of Cubism. In his article "Sur le Cubisme" he had written of the work of Rivera and André Lhote so derogatorily that when the Mexican met the critic at a dinner arranged by Léonce Rosenberg, a dispute ensued that ended in fisticuffs. The result of this incident was Rivera's total abandonment of Cubism and break with Rosenberg and Picasso. Braque, Gris, Léger and even his close friends Lipchitz and Severini turned their backs on him, and his painting *Zapatista Landscape*, which Rosenberg had bought, was locked away until the 1930s.

In 1917 Rivera began intensive study of the work of Paul Cézanne, in the course of which he returned to figurative painting. He turned again to the Dutch masters of the seventeenth century and painted a series of still-lifes and portraits, strongly reminiscent of Ingres. While he was searching for a new realistic form of expression, Fauvist elements may be seen in his work before he took up the style and palette of Pierre-Auguste Renoir. In his return to figurative painting Rivera found support from Elie Faure, a doctor and recognized art critic, who had invited him earlier, in 1917, to take part in the group exhibition *Les Constructeurs* which he had organized, and later wrote of the Mexican: "In Paris about twelve years ago I met a man whose intelligence was almost uncanny. [. . .] He told me wonderful things of Mexico, where he had been born. A mythologist, I thought, or perhaps a mythomaniac."[6]

It was also Faure who kindled Rivera's interest in Italian Renaissance art. As he discussed with Faure the necessity of art having a social status and considered mural painting as a representational form, a vista of possibilities opened before him. The Mexican ambassador in Paris, Alberto J. Pani, who had commissioned portraits of himself and his wife and bought a number of post-Cubist paintings from Rivera, managed to convince the new rector of Mexico City University, José Vasconcelos, to award Rivera a travel grant to Italy. This enabled him to go to Italy in February 1920 and spend seventeen months there studying Italian art history through Etruscan, Byzantine and Renaissance works of art. He made more than three hundred sketches and drawings after works by Italian masters and of landscapes, architecture and

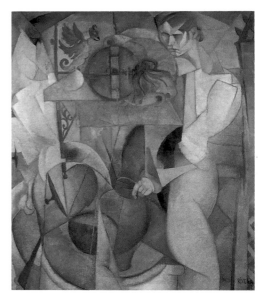

Woman at a Well (reverse of *Zapatista Landscape*, 1915), 1913
La mujer del pozo
Oil on canvas, 144 x 123 cm
Museo Nacional de Arte, MUNAL – INBA, Mexico City
Photo: Rafael Doniz

ILLUSTRATION PAGE 18:
Sailor at Breakfast, 1914
Marinero almorzando
Oil on canvas, 117 x 72 cm
Museo-Casa Diego Rivera, Guanajuato
Photo: Rafael Doniz

At the beginning of 1914 Rivera met the Spanish Cubist Juan Gris in Paris. The influence of synthetic Cubism is especially evident here in the "grid" method of composition which Gris evolved.

Diego Rivera with Angel Zárraga, his
mother María del Pilar Barrientos de Rivera
and Angelina Beloff (Diego Rivera is on the
extreme right), 1915
Photo: Vicente Contreras, Courtesy
Cenidiap Archive, Mexico City

people, in sketchbooks, according to his wont, distributed over various
jacket pockets. Most of these drawings are lost today. From Giotto's fres-
coes and murals of the Trecento and the Quattrocento he discovered a
monumental form of painting that later, on his return to Mexico, would
prove the spur to a new, revolutionary, public art.

In spring 1920, just after Rivera had arrived in Italy, the new president
of Mexico, Alvaro Obregón, appointed José Vasconcelos his minister of
education. One of his first actions on taking office was the introduction of
a comprehensive programme of popular education, which included the
provision of murals in public buildings as educative media. Shortly after his
return from Italy in March 1921 Rivera, drawn by socio-political develop-
ments in Mexico, decided finally to leave Europe, and he prepared to return
to Mexico. He left behind him in Paris with Angelina Beloff his daughter
Marika, born on 13 November 1919 of his liaison with Marevna Vorobyov-
Stebelska, another Russian artist whom he had met in 1915 in the Russian
circle to which he had been introduced by Angelina Beloff. For a time
Rivera maintained relationships with both women, and in 1917 he lived for
six months with the spirited, six years younger Marevna. On his return to
Mexico, however, he broke off all contact with both. From time to time,
through mutual friends, he sent Marevna maintenance payments for his
daughter, though without ever acknowledging paternity. Back in his home-
land, he turned his back on Europe completely.

ILLUSTRATION PAGE 21:
***Motherhood – Angelina and the Child
Diego***, 1916
Maternidad – Angelina y el niño Diego
Oil on canvas, 132 x 86 cm
Museo de Arte Alvar y Carmen T. de
Carrillo Gil, MCG – INBA, Mexico City
Photo: Rafael Doniz

This Cubist portrait depicts Rivera's partner
in Paris, the Russian Angelina Beloff, with
their son Diego who died when only a few
months old.

The Mural – a Post-Revolutionary Ideal

"My homecoming aroused an aesthetic rejoicing in me which is impossible to describe," wrote Diego Rivera later. "It was as if I had been reborn; [. . .] I found myself at the centre of a plastic world, in which colours and forms existed in total purity. Everywhere I saw a potential masterpiece – in the crowds, the markets, the festivals, the marching battalions, the workers in the workshops, the fields – in every shining face, every radiant child. [. . .] The first sketch I did filled me with astonishment. It was really good! From then on I worked confidently and at peace with myself. All inner doubt, the conflict that had so tortured me in Europe, had disappeared. I painted as naturally as I breathed, spoke or sweated. My style was born like a child, in a moment, with the difference that this birth took place at the end of a painful, 35-year gestation."[7] Thus Rivera describes his new-found identity and the emergence of his new style, in his old surroundings which were suddenly so new to him.

On his return to Mexico, Rivera was immediately enlisted by José Vasconcelos to help carry out the government's cultural policy; after ten years of civil war the minister of education was in search of a new form of artistic presentation for his programme. He had begun to put interested artists of the country to work to use his Mexican ideology and humanist ideals in a programme of wall-paintings, and was determined, through the comprehensive cultural reform movement that he proclaimed, to support the social and racial equality of the Indian population which had been the ideal of the Revolution and, after centuries of Spanish-Christian blocking of Indian cultural integration, to reclaim independent Mexican national culture. The educational use of wall-paintings was an important instrument of his policy; by this means he wished to demonstrate a break with the past, although not with tradition, and above all, to establish a rejection of the colonial epoch and nineteenth-century European culture.

In November 1921, together with other artists and intellectuals like himself just returned from Europe, Rivera was invited by Vasconcelos on a trip to Yucatán to visit the archaeological sites of Chichén Itzá and Uxmal. Vasconcelos accompanied the group, and called on its members to familiarize themselves with the artistic heritage of Mexico, since this would form the basis of their future work. In response to the promptings of Vasconcelos, whom he accompanied on further trips to the provinces, and in search of new possibilities of expression by means of which he could communicate

Edward Weston
Diego Rivera at the Ministry of Public Education (Secretaría de Educación Pública – SEP), 1924
Cenidiap Archive Collection, Mexico City

ILLUSTRATION PAGE 22:
From the cycle: Political Vision of the Mexican People:
The Painter, the Sculptor and the Architect, 1923–1928
El pintor, el escultor y el arquitecto
Stairway and second floor of the Ministry of Public Education, Mexico City
Photo: Rafael Doniz

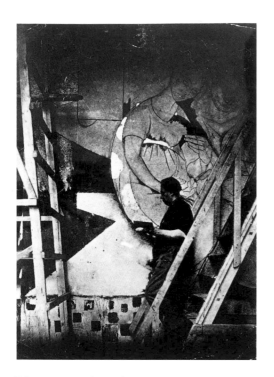

Rivera at work on the mural *Creation* in the Anfiteatro Simón Bolívar, 1922
Photo: Mayo Brothers, Courtesy Cenidiap Archive, Mexico City

Rivera with his two Mexican daughters Ruth and Guadalupe, *c*. 1929
Photo from: Bertram D. Wolfe, *Diego Rivera*, New York/London, 1939

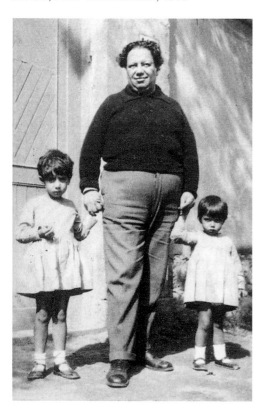

with the population of his country, Rivera began to conceive plans for an art that would serve the people, and show it its own history in wall-paintings.

In January 1922, six months after his return from Europe, Rivera began work on his first mural, *Creation* (ill. p.25), in the National Preparatory School (Escuela Nacional Preparatoria), the upper school of the former College of San Ildefonso in Mexico City.[8] His work here was the prelude and touchstone of the so-called Renaissance of Mexican mural painting. While a number of other artists worked on the walls of the inner courtyard, Rivera spent about a year in completing the experimental fresco in the Bolívar Amphitheatre at the school (ill. p.24 above). For this first as for almost all his later murals Rivera, a skilled draughtsman, developed his design in preparatory drawings in charcoal and red chalk, in the manner of the artists of the Italian Cinquecento. While in the easel works that Rivera painted in the first months after his return to Mexico themes from Mexican everyday life are predominant, in this mural he depicts Christian and European subjects, a vivid Mexican colourfulness and various Mexican figure-types in order to provide contrast. This is a work in which Nazarene stylistic elements are evident, and in the execution of which Rivera found his Italian studies of great use.

Themes in the Bolívar Amphitheatre embrace, in the artist's words, "the origins of the sciences and the arts, a kind of condensed version of human history."[9] The scene depicted seems to reflect Vasconcelos's ideology: racial fusion, represented by the mestizo couple; education through art; the striving for virtues, which teach Judaeo-Christian religion; and the wise use of science in order to control nature and to lead man to absolute truth.

In the murals Rivera painted next his pictorial language was modified, acquiring a political slant not present in the Amphitheatre mural. The forms of a classical aesthetic ideal on which he falls back in this transitional work are replaced in his next murals, at the Ministry of Education (ills. pp.22, 26–31, 33), by those of an Indian aesthetic ideal, which, together with Jean Charlot and other contemporary artists, he himself created and fixed.

For the depiction of *Woman* or *Eve* the artist had taken as his model Guadalupe Marín (ill. p.36 above), with whom he now began a liaison, following relationships with other models. In June 1922 Rivera and the Guadalajara-born Lupe Marín were married and took a house in Mixcalco Street, just outside the main square of Mexico City, Zócalo Square. From their five-year marriage two daughters, Guadalupe and Ruth, were born in the middle of 1924 and at the beginning of 1927 (ill. p.24 below).

In these first as in all his subsequent frescoes Rivera's detailed knowledge of Mexican traditional art combines with his skilful use of contemporary elements of plastic style. His work of the next few years critically depicts the past as well as the present, and conveys the utopian conviction that man can creatively change society to achieve a better and more just future. Rivera uses Marxist theory in shaping the themes of his murals, although his biographers Bertram D. Wolfe and Loló de la Torriente assert that he himself never read Marx and was reluctant to accept dogma of any kind. However, through the Revolutionary Union of Technical Workers, Painters and Sculptors (Sindicato revolucionario de trabajadores técnicos,

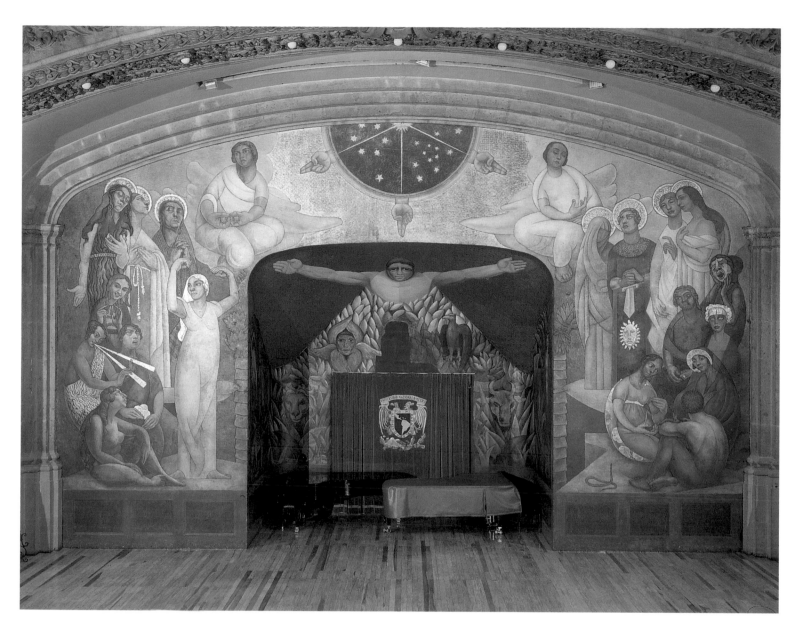

Creation, 1922–1923
La creación
Experimental fresco in encaustic with gold leaf
Total wall surface 109.64 sq. m
Anfiteatro Simón Bolívar, Escuela Nacional Preparatoria,
Colegio de San Ildefonso (now Museo de San Ildefonso), Mexico City
Photo: Rafael Doniz

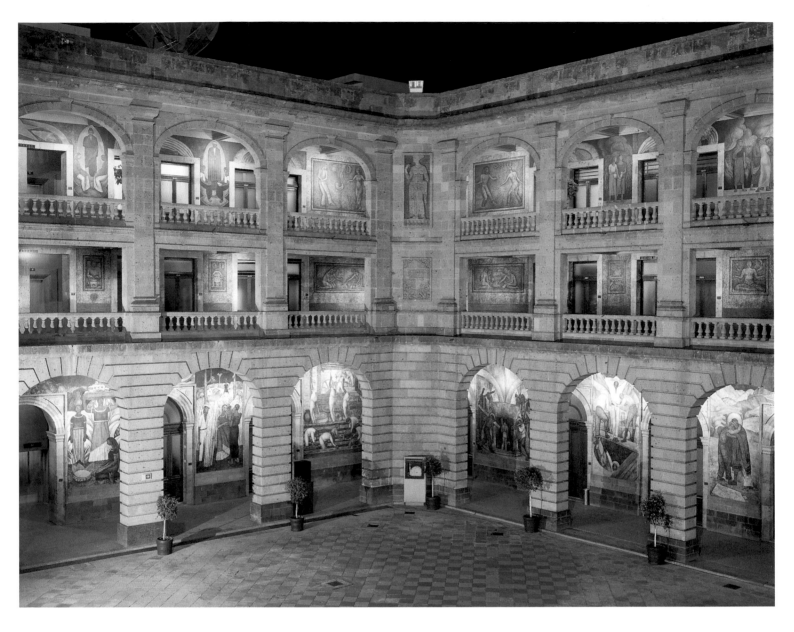

Political Vision of the Mexican People,
1923–1928
Visión política del pueblo mexicano
Traditional and experimental fresco with
nopal cactus liquid
235 wall panels, total painted surface
1585.14 sq. m
Arcaded walls of the two three-storey inner
courtyard buildings, block with connecting
staircase and elevator
Ministry of Education (Secretaría de
Educación Pública – SEP), Mexico City
General view of the "Court of Labour",
north and east walls
Photo: Rafael Doniz

pintores y escultores), which he helped to found in autumn 1922, he was
soon confronted with communist ideology.

The Mexican painter David Alfaro Siqueiros, whom Rivera had met in
Paris at the beginning of 1919 and whose view of the Mexican Revolution
and the task of a truly Mexican art and its social value he shared at the time,
had returned from Europe in September, to join the figures who formed the
intellectual élite of the new artists' movement – Carlos Mérida, Amado de la
Cueva, Xavier Guerrero, Ramón Alva Guadarrama, Fernando Leal, Fermín
Revueltas, Germán Cueto and José Clemente Orozco. Like many other Latin
American avant-garde groups, the newly founded trade union, emulating its
European counterparts, published a manifesto, the text of which, expressing
the common denominator of its artist-members' ideals, Siqueiros had com-
posed in Spain.[10] In 1924 the news-sheets that the union printed and distribu-
ted grew into the newspaper *El Machete*, which later became the official
organ of the Mexican Communist Party. In its first form it served to proclaim
the union's position as an organic entity between artistic and political revolu-
tions. At the end of the year 1922 Rivera joined the Mexican Communist Party
and together with Siqueiros and Xavier Guerrero he formed its executive
committee.

Political Vision of the Mexican People:
a) Court of Labour, 1923:
1. The Weavers
2. Tehuana Women
3. The Sugar Mill
4. Entry into the Mine
5. The Country Schoolmistress

b) Court of Fiestas, 1923–1924:
1. The Maize Festival
2. The Sacrificial Offering – Day of the Dead
3. The Burning of the Judases
4. Good Friday on the Santa Anita Canal
5. Ribbon Dance

ILLUSTRATION PAGE 28:
From the cycle: Political Vision of the Mexican People (Court of Labour):
Entry into the Mine, 1923
Entrada a la mina
4.74 x 3.50 m, ground floor, east wall
Photo: Rafael Doniz

ILLUSTRATION PAGE 29:
From the cycle: Political Vision of the Mexican People (Court of Labour):
The Sugar Mill, 1923
El trapiche
4.82 x 3.66 m, ground floor, north wall
Photo: Rafael Doniz

ILLUSTRATION RIGHT:
From the cycle: Political Vision of the Mexican People (Court of Labour):
Tehuana Women, 1923
Mujeres tehuanas
4.76 x 2.14 m, ground floor, north wall
Photo: Rafael Doniz

In March 1922 Vasconcelos announced the major project of the first decade of the mural movement in Mexico, the wall-decoration of the two inner courtyards of the Ministry of Education (Secretaría de Educación Pública or SEP); its new buildings had been opened the year before.[11] He placed Rivera in charge of the project. With a team of assistants Rivera was to paint 117 spaces, a total surface area of almost 1600 square metres (over 17,000 square feet), on the arcaded walls of the two inner courtyards, one lying behind the other, of the huge three-storey complex. Work on the project, in which Rivera set out to supply a hitherto non-existent national revolutionary iconography, took over four years to eventual completion in 1928.

The thematic programme for the ground floor of both courtyards, whose murals are works of simple design and concentrated expressive power in classical figurative style, consists of motifs of revolutionary ideals

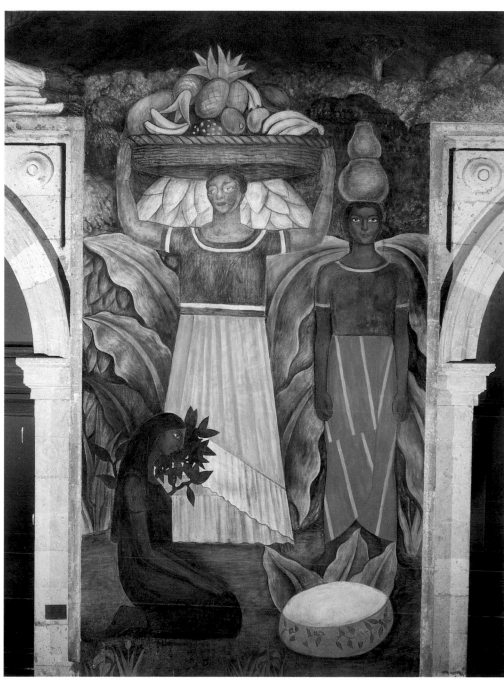

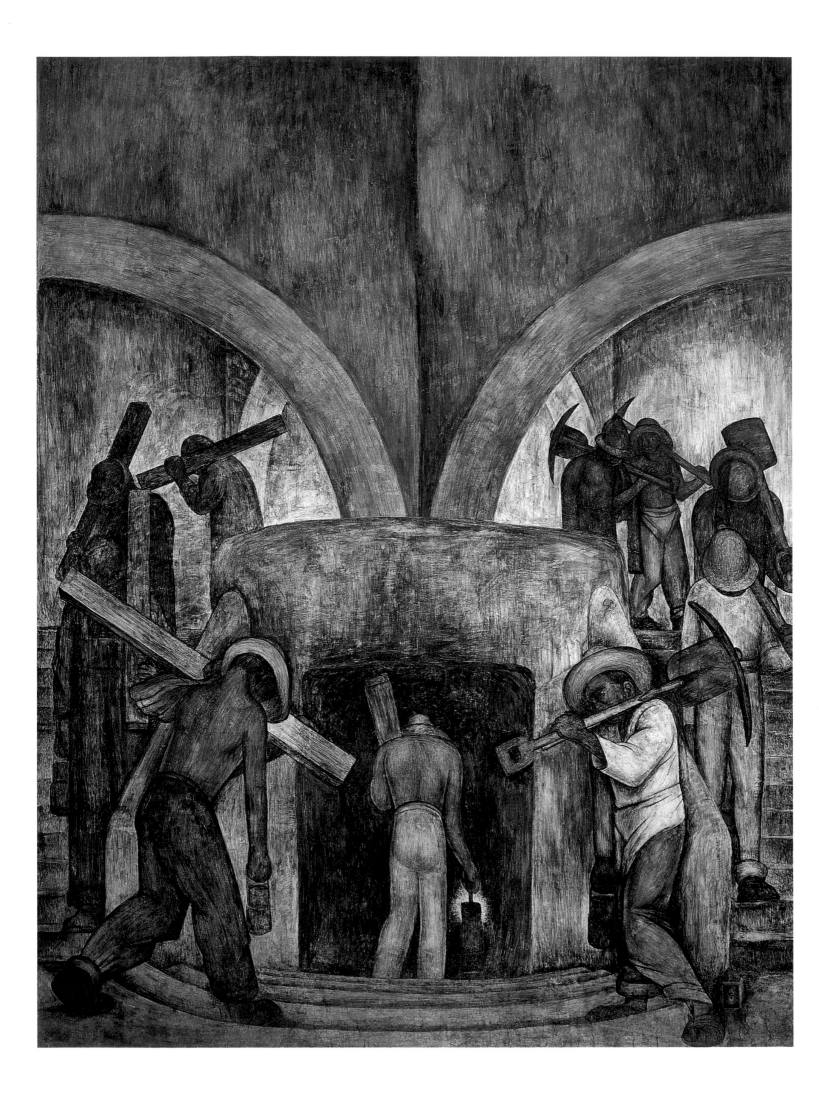

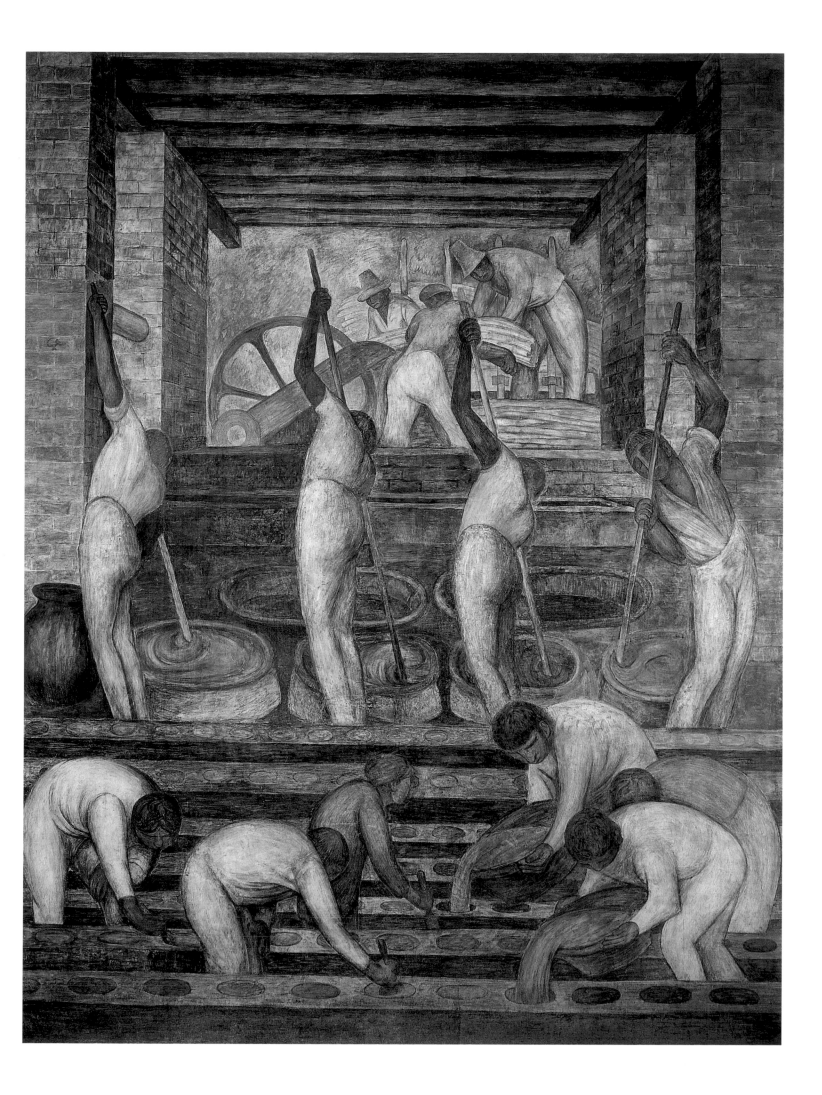

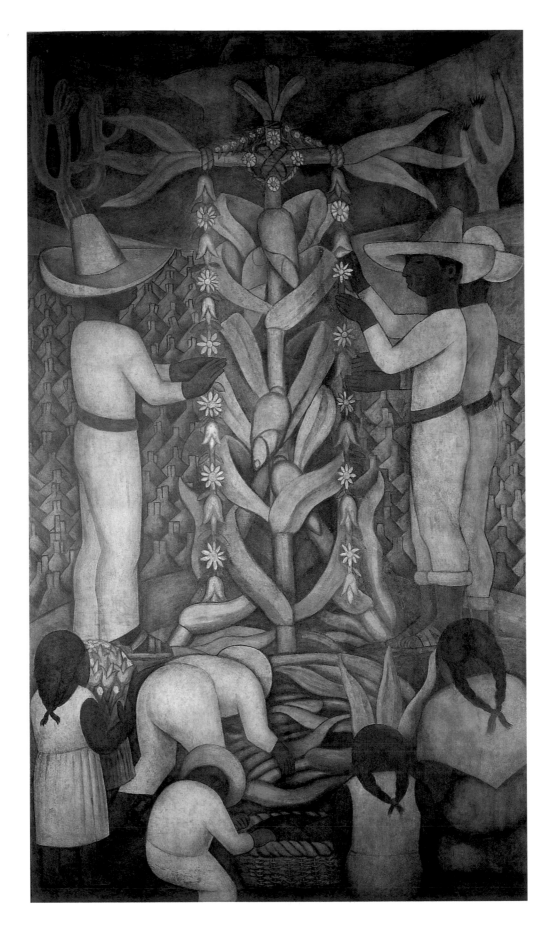

From the cycle: Political Vision of the Mexican People (Court of Fiestas):
The Maize Festival, 1923–1924
La fiesta del maíz
4.38 x 2.39 m, ground floor, south wall
Photo: Rafael Doniz

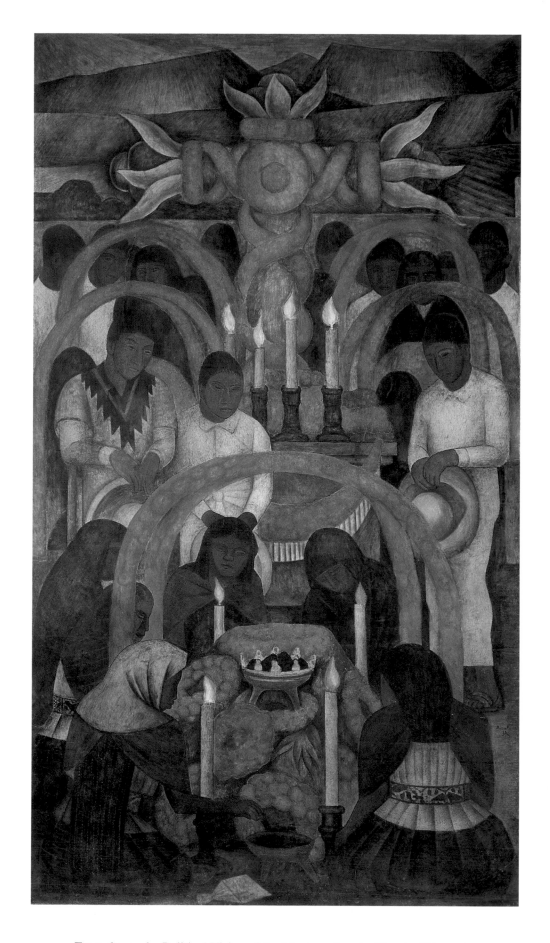

From the cycle: Political Vision of the Mexican People (Court of Fiestas):
The Sacrificial Offering – Day of the Dead, 1923–1924
La ofrenda – Día de muertos
4.15 x 2.37 m, ground floor, south wall
Photo: Rafael Doniz

Tehuantepec Woman Washing, 1923
Bañista de Tehuantepec
Oil on canvas, 63 x 52 cm
Museo-Casa Diego Rivera, Guanajuato,
Marte R. Gómez Collection
Photo: Rafael Doniz

ILLUSTRATION PAGE 33:
From the cycle: Political Vision of the
Mexican People (Court of Fiestas):
Good Friday on the Santa Anita Canal,
1923–1924
*Viernes de dolores en el canal de Santa
Anita*
4.56 x 3.56 m, ground floor, west wall
Photo: Rafael Doniz

Woman Grinding Maize, 1924
La molendera
Encaustic on canvas, 106.7 x 121.9 cm
Museo de Arte Moderno, MAM – INBA,
Mexico City
Photo: Rafael Doniz

and Mexico's Indian heritage. The smaller court, which Rivera called the "Court of Labour" (ill. p.26), contains depictions of the everyday life of the Mexican people – working scenes of rural, industrial and craft activities in the different provinces and the struggle to improve living conditions (ills. pp.27, 28, 29). The larger "Court of Fiestas" contains scenes of traditional Mexican folk festivals (ills. pp.30, 31, 33).

Since Rivera's daily remuneration amounted to only two dollars a day, he now began to sell drawings, watercolours and also paintings to collectors, predominantly North American tourists. These were often sketches or preliminary designs for murals. Mexican and indigenous motifs that occur in murals also appear in the same or similar form in easel works: *Tehuantepec Woman Washing* (1923; ill. p.32 above) is akin in subject-matter to the mural *Bathing at Tehuantepec* near the entrance to the elevator of the Ministry building. *Woman Grinding Maize* (1924; ill. p.32 below) is identical with a detail of *Potters* on the east wall of the same building in the "Court of Labour". In both scenes Indian women are depicted in one of their everyday activities in Rivera's typical so-called "classical" style. What begin as flattish figures become increasingly modelled and solid. Multiple use of individual motifs is seen in the "Court of Fiestas" and becomes frequent in the later cycles.

In 1924, spurred by the political unrest provoked by conservative groups, a party of upper school students carried out an attack on the murals by Orozco and Siqueiros in the inner courtyard of the Preparatoria and demanded the cessation of all mural projects. Interviewed by the press about the incident, Rivera, seen as the most prominent figure in the mural movement, who on completion of the work in the Preparatoria had been appointed director of the Education Ministry's Department of Plastic Arts, sharply criticized the attack. Vasconcelos, now less and less in agreement with Obregón's policies, resigned from the Ministry. For the moment, the conservatives had achieved their goal: the mural project was stopped and most of the painters were dismissed. Many of them, like Siqueiros, left Mexico City to seek work in the provinces. Only Rivera, who had managed to convince the new education minister, José María Puig Casauranc, of the project's importance, kept his post so that he could complete the decoration of the Ministry.

On the first floor of the SEP building are depictions of the coats of arms of the States of the Mexican Federation, together with some less spectacular representations of the theme of "Intellectual and Academic Work". On the second floor is another narrative cycle; in *Corrido of the Revolution*, divided into two sections, the *Agrarian Revolution* and the *Proletarian Revolution*, extracts from a popular ballad are written on painted strips, which wind like a garland through successive panels and link them together. This plastic depiction of the *corrido*, a four-line ballad-like musical genre familiar to all Mexicans, was a radical artistic innovation that addressed a largely illiterate population and accustomed it to receiving news by means of verses and of songs.

The *Proletarian Revolution*, which consists of scenes of revolutionary struggle, the setting up of cooperatives and victory over capitalism, opens with what is probably the best known mural of the whole cycle, *The Arsenal*

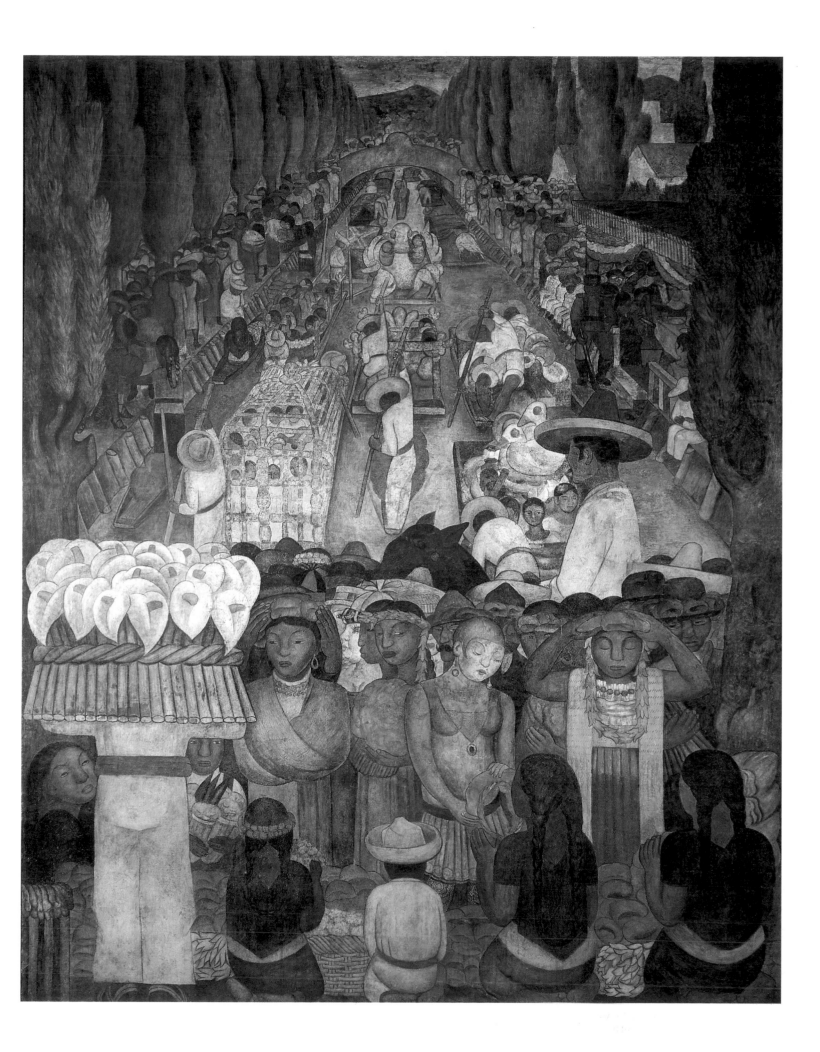

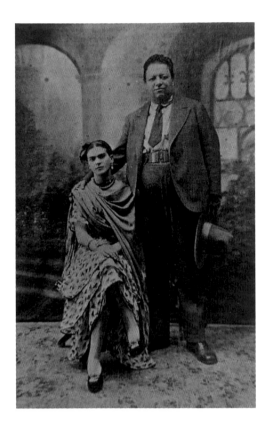

Wedding photograph of Diego Rivera und
Frida Kahlo, 21 August 1929
Courtesy Cenidiap Archive, Mexico City

(ill. p.35). In the only landscape-format mural of the series Rivera portrays
friends and comrades of the circle around Julio Antonio Mella, the exiled
Cuban Communist living in Mexico. At the centre of the mural stands Frida
Kahlo, distributing arms and bayonets to the workers who have decided to
fight. Rivera had met Kahlo, who became his wife a year later, in 1928
through the progressive circle of artists and intellectuals he depicted. She
joined the Mexican Communist Party in the same year, and Rivera shows
her, like the other Party members, with the red star of the Communist ac-
tivist on the breast. At the left edge of the painting David Alfaro Siqueiros,
Rivera's like-minded colleague, wears the uniform of an army captain,
which he had actually been in the revolutionary years around 1915; Mella,
who was murdered in the street in Mexico City on 10 January 1929 on the
orders of the Cuban dictator Gerardo Machado, stands at the right edge next
to his partner Tina Modotti, who hands bandoleers to comrades.

Tina Modotti, an American of Italian extraction, who was later well-
known as a photographer and a Communist activist in Mexico and the
Soviet Union and in the Spanish Civil War, had already visited Mexico in
1922 and met Rivera, Xavier Guerrero and other members of the progress-
ive artists' group. In June 1923 she came to Mexico again with the
American photographer Edward Weston and his son Chandler. She greatly
admired Rivera's monumental work, and took Weston to the Ministry of
Education to show him the murals. On 7 December 1923 he recorded his
impressions of the mural-painter in his diary: "I observed him closely. His
six-shooter, ready for use, and his bandoleer were in marked contrast to his
friendly smile. They call him the Lenin of Mexico. The artists here are very
close to the Communist movement; no salon politics for them. Rivera has
small, sensitive hands, like a craftsman's, his hair falls back from his fore-
head, leaving a large area over half his face free, a mighty dome, broad and
high. Chandler is pretty impressed with Diego – his huge proportions – his
infectious laugh – his mighty revolver. 'Does he use it to defend his pictures
with?' he asked."[12] In one mural on the second floor of the stairwell of the
SEP building Rivera uses a photograph that Weston took of him (ill. p.23) as
a model for the self-portrait that is to be seen in *The Painter, the Sculptor
and the Architect* (ill. p.22). In this painting Rivera put into his narrative
cycle his conception of the plastic artist on the Italian Renaissance model –
painter, sculptor and architect of a *Gesamtkunstwerk*.

Rivera's mural cycle at the Ministry of Education is often described
as one of his most successful works. "It is surpassed perhaps only by the
chapel in Chapingo," writes the Mexican poet and Nobel Prizewinner
Octavio Paz. "In the frescoes of the Ministry of Education numerous in-
fluences give Diego wings that carry him far away, and enable him to show
his great gifts. These paintings are like a vast extended fan which, little by
little, reveals the multi-faceted, unique artist: the portrait painter, at cer-
tain moments reminiscent of Ingres; the skilled student of the Quattrocento,
who, if he sometimes approaches the severity of Duccio di Buoninsegna,
at other times rediscovers – that is the right word – the colour-rich art of
Benozzo Gozzoli and his seductive combination of physical, animal and
human nature; the artist of volume and geometry, who was capable of
applying the lesson of Cézanne to the wall; the painter who extended

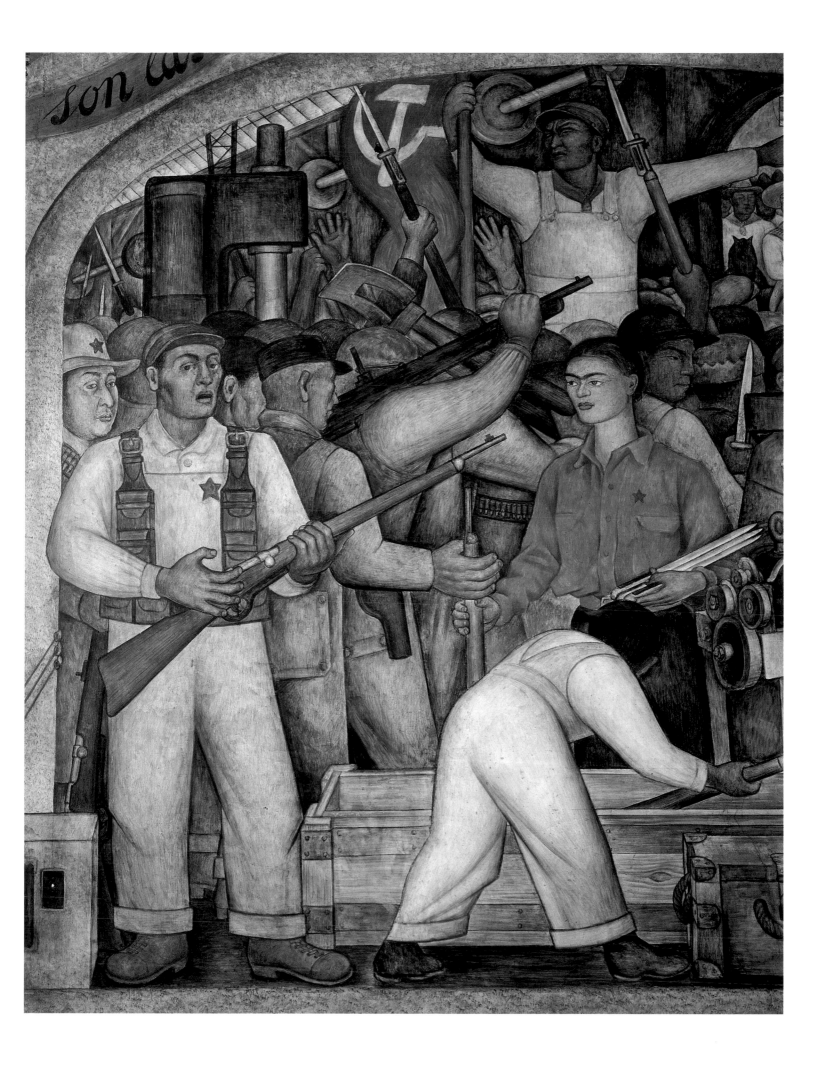

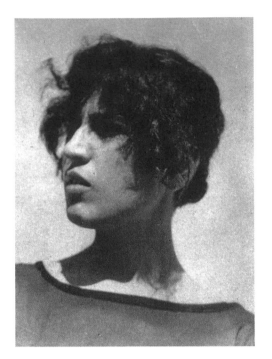

Edward Weston
Guadalupe Marín, first wife of Diego
Rivera, c. 1925
Photo from: Bertram D. Wolfe, *Diego
Rivera*, New York/London, 1939

ILLUSTRATION PAGE 37:
***Song to the Earth and to Those who Till it
and Liberate it***, 1926–1927
*Canto a la tierra y a los que la trabajan
y liberan*
Fresco
14 main and 27 subsidiary wall areas, total
painted surface 370.23 sq. m
Nave and cupola of the chapel in the
National School of Agriculture (Escuela
Nacional de Agricultura), Autonomous
University of Chapingo
General view of the interior of the chapel,
showing the east wall with the mural
***The Liberated Earth with the Powers of
Nature Controlled by Man***
(*La tierra liberada con las fuerzas naturales
controladas por el hombre*), 6.92 x 5.98 m
Photo: Rafael Doniz

Gauguin's vision – trees, leaves, water, flowers, bodies, fruit – and made
it bloom again; and lastly the draughtsman, the master of the melodious
line."[13]

Towards the end of 1924, when Rivera was still busy with the design
of the ground floor of the "Court of Fiestas" and General Plutarco Elías
Calles became the new president of Mexico after Alvaro Obregón's term of
office had run, the artist received a commission for a new mural project at
the National School of Agriculture (Escuela Nacional de Agricultura) at
Chapingo.[14] Rivera at once began to decorate the entrance hall, main stair-
way and first-floor reception hall of the administration building with
frescoes, demonstrating through the theme *The Liberated Earth*, with un-
ambiguous educational intent, the revolutionary task of the agricultural
college.

In 1926 he turned his attention to the chapel of the former convent and
later hacienda at Chapingo. Built, like many other Christian churches in
Mexico, above an Aztec temple-pyramid, it now served the School as an
assembly hall. Rivera's frescoes, covering all the walls and ceilings of the
chapel, and knitting the whole ensemble together, may be compared, for
their effect of total unity, to Michelangelo's decoration of the Sistine Chapel
or Giotto's Arena Chapel frescoes. The design was intended to give the new
generation of agricultural planners and engineers inspiration and guidelines.
The theme of the cycle, in the nave divided into four bays and a small area
above which the organ gallery used to be situated, is on the left-hand side
Social Revolution (ill. p.38 above) and the duty of agrarian reform which it
creates, and on the right-hand side *Natural Evolution* (ill. p.39 above), the
beauty and fertility of the earth, the natural growth of which runs parallel to
the equally natural changes brought about by the Revolution. The whole
scheme is crowned, on the chapel's round-arched end wall, by the large
female nude, which is surrounded by the four elements, of *The Liberated
Earth*. Nature and society develop out of chaos and exploitation into a state of
harmony between man and nature as well as between men. In an originally
Jesuit chapel, using early images of the world and nature, religious pic-
torial motifs and socialist symbolism, the artist is preaching a revolution-
ary credo.

While in *The Liberated Earth* Rivera portrayed his pregnant wife
Guadalupe Marín (ill. p.36 above), for other allegorical female figues Tina
Modotti was his model (ills. pp.38, 39 below). The relationship into which
he entered with the American photographer during his work with her led to
large-scale rows with Lupe Marín and a temporary parting from her; after
the birth of his daughter Ruth in 1927 he finally broke off the relationship.
However, contact with the mother of his daughters, whom he supported
financially, was soon regularized, and the two women became close
friends.

After completion of the Chapingo project, Rivera made a trip, in
autumn 1927, to the Soviet Union to take part in the tenth anniversary
celebrations of the October Revolution as a member of an official dele-
gation of Mexican Communist Party functionaries and various workers'
representatives. He had wanted to visit Russia since his years in Paris,
and now he was to see the land of the Soviets with his own eyes. He

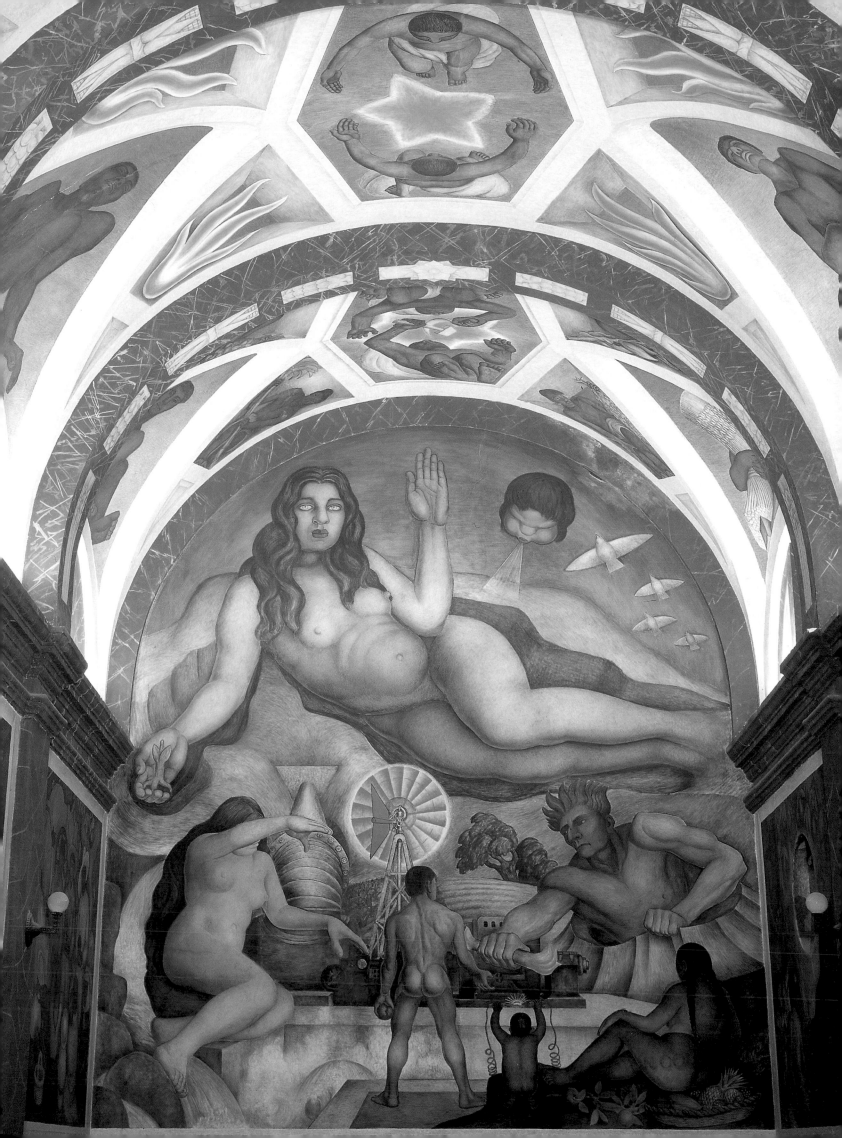

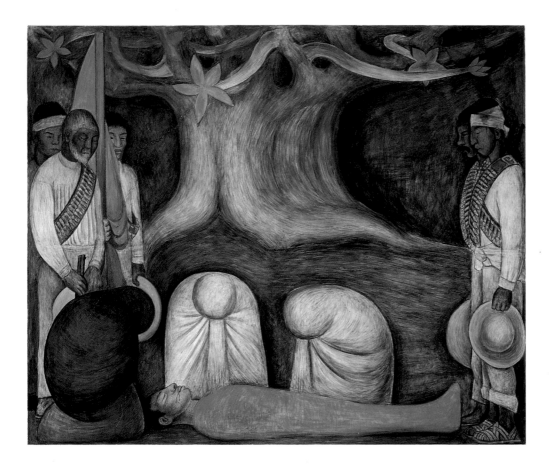

From the cycle: Song to the Earth
(Social Revolution):
***The Perpetual Renewal of the
Revolutionary Struggle***, 1926–1927
*La constante renovación de la lucha
revolucionaria*
3.54 x 3.57 m, third bay of the fourth wall
on the left side
Photo: Rafael Doniz

From the cycle: Song to the Earth (Natural Evolution):
Germination, 1926–1927
Germinación
3.54 x 3.48 m, second bay of the third wall on the right
Photo: Rafael Doniz

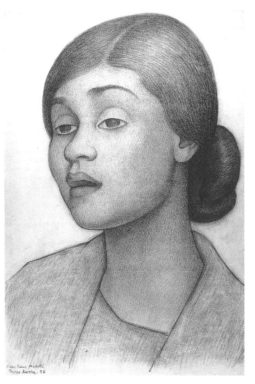

Portrait of Tina Modotti, 1926
Retrato de Tina Modotti
Charcoal on paper, 48.5 x 31.5 cm
Philadelphia Museum of Art, Philadelphia,
Lola Downin Peck Fund, from the Estate of
Carl Zigrosser

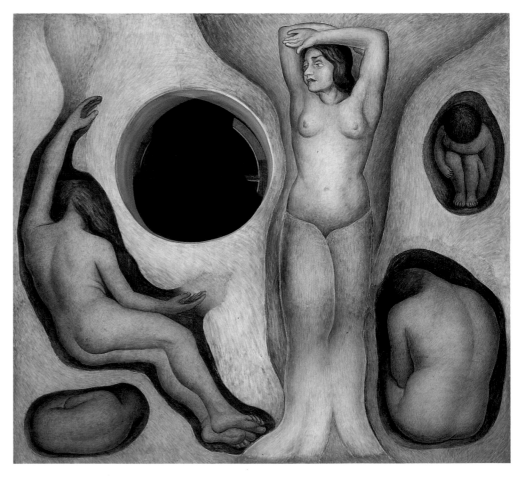

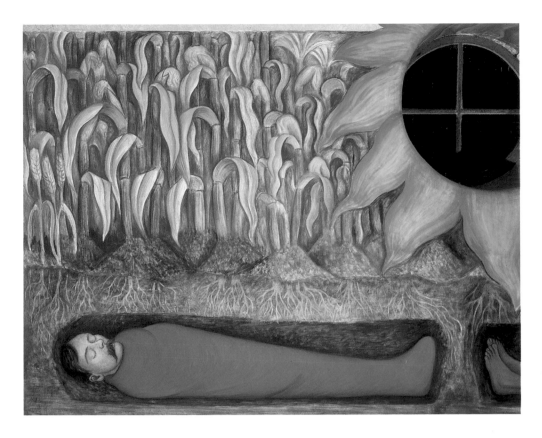

From the cycle: Song to the Earth (Natural Evolution):
The Blood of the Revolutionary Martyrs
Fertilizing the Earth *(detail)*, 1926–1927
La sangre de los mártires revolucionarios
fertilizando la tierra
2.44 x 4.91 m, first wall, right side
(vestibule)
Photo: Rafael Doniz

From the cycle: Song to the Earth (Natural Evolution):
Maturation, 1926–1927
Maduración
3.54 x 3.67 m, third bay of the fourth wall, right side
Photo: Rafael Doniz

Edward Weston
Tina Modotti, 1925
Photo from: Bertram D. Wolfe, *Diego Rivera*, New York/London, 1939

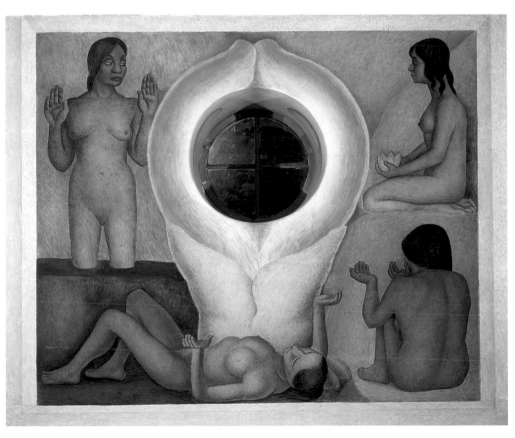

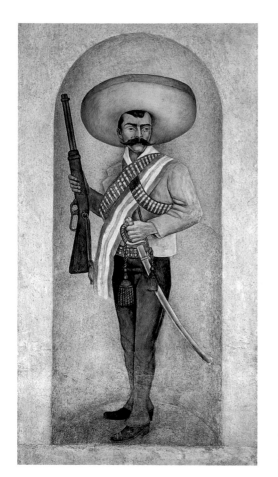

From the cycle: History of Cuernavaca and Morelos: *Zapata*, 1930–1931
2.14 x 0.89 m
The central arch from the east, with pillars dividing the gallery
Photo: Rafael Doniz

hoped to learn from the state of artistic development there, and to have the opportunity of contributing to the country's revolutionary progress by painting a mural. After a short stay in Berlin, in the course of which he met German artists and intellectuals,[15] he went on to spend nine months in Moscow. He gave lectures, was appointed a "Lecturer in Monumental Painting" at the School of Fine Arts, and maintained close contact with the newly founded Moscow artists' organization "October". The members of this group spoke for an official art that supported socialist ideals by following Russian folk tradition, rejecting both Socialist Realism and the abstract art of the Soviet avant-garde. In preparation for the design of a mural commissioned by Anatoly Lunacharsky, Commissar for Education and Art, Rivera filled a sketchbook with 45 watercolour drawings depicting the May Day Celebrations of 1928. These are the only artistic product of his visit to Russia, since the mural project for the Red Army Club came to nothing as a result of disagreement and intrigue; the drawings were used for certain parts of later murals. Rivera's deviant political and cultural views caused the Stalinist government to suggest that he should return to Mexico.

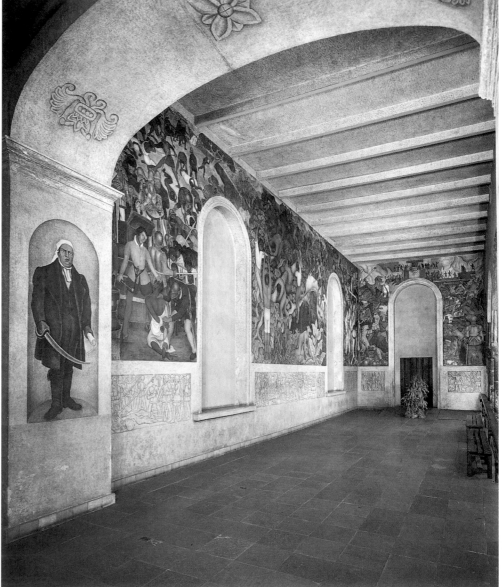

History of Cuernavaca and Morelos, Conquest and Revolution, 1930–1931
Historia de Cuernavaca y del Estado de Morelos, conquista y revolución
Fresco
Eight murals and eleven grisaille paintings, total painted surface 149 sq. m
Second floor of the gallery of the former Cortés Palace, now Museo Quaunahuac, Instituto Nacional de Antropología e Historia (INAH), Cuernavaca, Morelos
General view of the loggia
Photo: Rafael Doniz

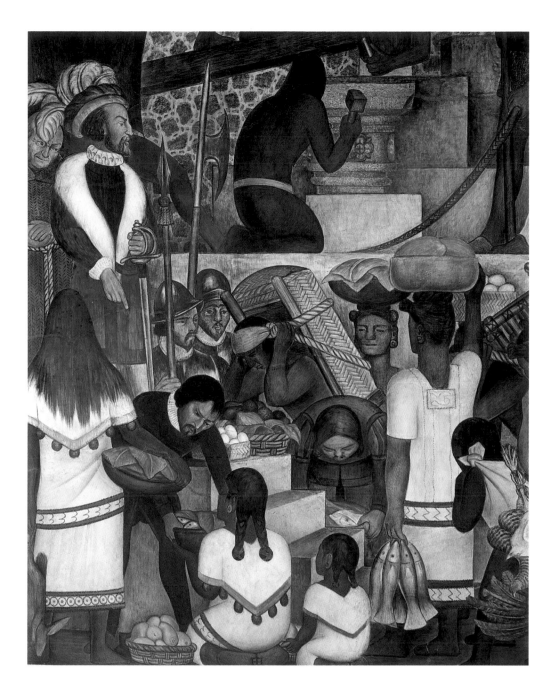

From the cycle: History of Cuernavaca and Morelos:
Building the Cortés Palace, 1930–1931
Construcción del Palacio de Cortés
4.35 x 2.70 m, west wall (detail)
Photo: Rafael Doniz

The construction of the Palace of the conquistador Hernán Cortés – the building that contains Rivera's murals – symbolizes the triumph of the Spanish over the indigenous Indian population.

After a number of fleeting affairs following the break-up with Lupe Marín, Rivera married Frida Kahlo on 21 August 1929; she was 21 years his junior (ill. p.34). A prospective artist, she had called on him the previous year, while he was still working on the murals in the SEP building, to seek his opinion of her first attempts at painting, and with his encouragement had decided to devote herself full-time to painting. For both, art and politics were the prime purposes in life, paving the way for a marriage of perfect companionship after the first passionate love relationship. The degree to which each needed the other is shown by their reunion after a year's separation in 1940, which lasted up to Kahlo's death in 1954.

At the time of their marriage, Rivera had just been elected director of the Academy of Fine Arts in San Carlos by the students. A new plan of studies designed by Rivera, with radical innovations, led to great controversy in the media. According to his new conception, students were granted the right to share in decisions on teaching methods and the appointment of teachers and staff. Rivera prescribed that teaching had to be organized in

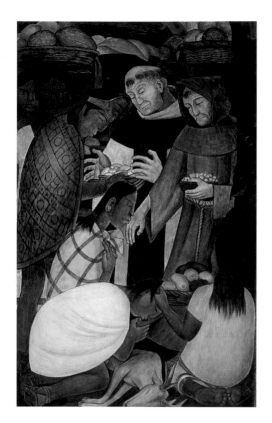

From the cycle: History of Cuernavaca and Morelos:
The New Religion and the Inquisition,
Part B, 1930–1931
La nueva religión y el Santo Oficio
4.25 x 1.34 m, south wall (detail)
Photo: Rafael Doniz

a system in which the school was seen more as a workshop than as an academy. On the model of Leonardo da Vinci, he wished to make the students into universal artists. He was shown the most bitter hostility by students and lecturers of the School of Architecture housed in the same building. Within a year they were joined by various enemies of Rivera from among conservative artists and also the Mexican Communist Party, from which he was expelled in September 1929 for being too close to the government. Eventually the university administration gave in to the protesters, and in the middle of 1930 he was obliged to resign from his post.

The Communist Party's criticism did on the one hand relate to Rivera's attitude to Stalinist policy, and on the other to the mural commissions which he had accepted from the governments of Calles and his successors after his work at the Ministry of Education and at Chapingo. In 1929 he had been commissioned to take over an enormous project in the National Palace (Palacio Nacional) in Mexico City, the president's seat of government, as well as the decoration of the conference hall of the Ministry of Health.

While Rivera was working on his large-scale history of the Mexican nation in the National Palace, which occupied him for several years, the US ambassador in Mexico, Dwight W. Morrow, pressed him to paint a mural in the former Cortés Palace in Cuernavaca. Morrow was a great admirer of Rivera's work and was offering him 12,000 dollars, the highest fee that the artist had ever received for a commission, and also offering to cover the costs of a subsequent trip to the United States.[16] When Rivera accepted the ambassador's commission and began work on the *History of Cuernavaca and Morelos* (ills. pp.40, 41, 42, 43), and on its completion in autumn 1930 accepted a further commission to paint murals in the United States, he gave

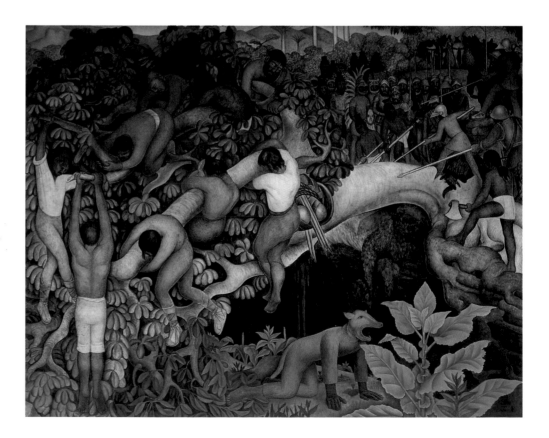

From the cycle: History of Cuernavaca and Morelos:
Crossing the Gorge, 1930–1931
Cruzando la barranca
4.35 x 5.24 m, west wall
Photo: Rafael Doniz

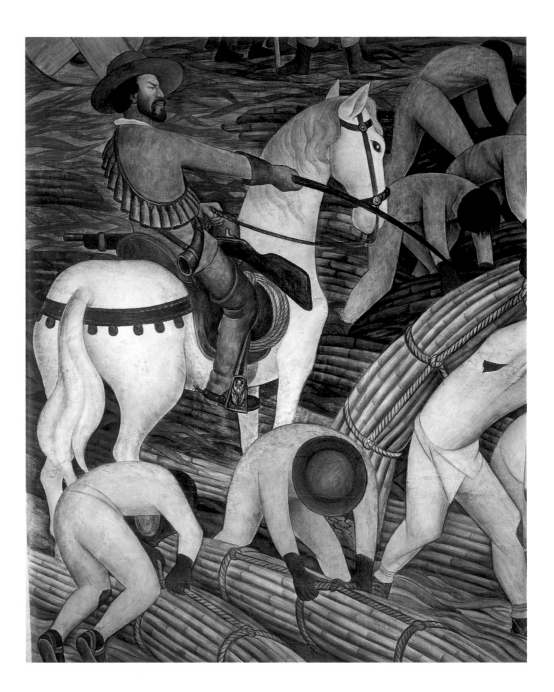

From the cycle: History of Cuernavaca and Morelos:
Sugar Plantation, Tealtenango, Morelos,
1930–1931
Ingenio azucarero de Tealtenango, Morelos
4.35 x 2.82 m, west wall (detail)
Photo: Rafael Doniz

the Communist press in Mexico renewed opportunity to attack him and was excoriated as an "agent of the millionaire Morrow and North American imperialism". He nevertheless decided to take up an invitation to San Francisco which had been renewed several times, and together with Frida Kahlo set off expectantly for the United States.

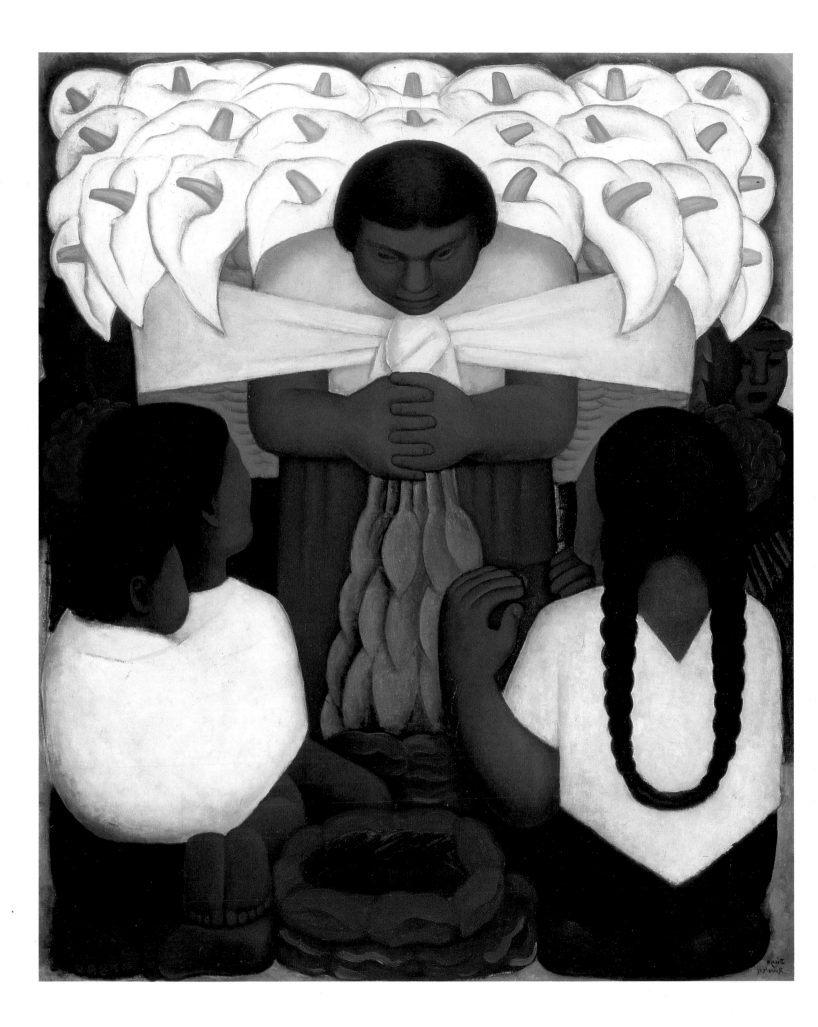

Communist Ideology for Capitalist Clients

The Mexican mural movement stimulated the integration of literary, artistic and intellectual forces in post-revolutionary Mexico and made a major contribution to the formation of a cultural Mecca which attracted many artists from the United States, Europe and other Latin American countries. In the United States the works of the "three great Mexican muralists", José Clemente Orozco, David Alfaro Siqueiros and Diego Rivera, were well-known from the 1920s, after the publication of numerous articles and a large influx of cultural tourists to Mexico to watch the artists at work. After many commissions for easel works had been received, especially by Rivera from American collectors, the latter was also commissioned to paint murals for American city authorities.

Rivera had received repeated invitations from his friend Ralph Stackpole to work in San Francisco. The Californian sculptor had become acquainted with Rivera in Paris, and the friendship deepened in 1926 when Stackpole visited Mexico. He greatly admired Rivera's work at the Ministry of Education and at Chapingo, and had bought some of his paintings and taken them home. One of these came as a gift into the possession of William Gerstle, the president of the San Francisco Art Commission. The art connoisseur was very keen for Rivera to paint a wall in the California School of Fine Arts, and Rivera was glad to accept the commission. When in 1929, together with other artists, he was commissioned to decorate the new San Francisco Pacific Stock Exchange building, Stackpole arranged for a wall to be reserved for the famous Mexican muralist.

Rivera's decision to make an extended stay in the United States was not only a response to American demand. The situation had progressively worsened for muralists during President Calles' term of office (1924–1928), most of them receiving no further commissions. The following years too were marked by repression of dissenting political voices. In 1929 the Communist Party was banned and many Communists, including Siqueiros, were imprisoned. The result was a cultural wave of emigration of many progressive artists and intellectuals to the United States, where many were offered alternative opportunities for work.

At first Rivera was refused entry into the United States because of his Communist opinions. This is scarcely surprising: although he had ceased to be a member of the Communist Party in 1929, as general secretary of the Anti-Imperialistic League of American Countries he had severely

Diego Rivera with the muralists David Alfaro Siqueiros and José Clemente Orozco, 1947
Courtesy Cenidiap Archive, Mexico City

ILLUSTRATION PAGE 44:
Flower Festival, 1925
Festival de las flores
Oil on canvas, 147.3 x 120.7 cm
Los Angeles County Museum of Art,
Los Angeles, Los Angeles County Fund
25.7.1

Diego Rivera painting the mural
Allegory of California in the Pacific Stock
Exchange Tower, San Francisco, 1931
Photo: Peter and Paul Juley, Courtesy
Cenidiap Archive, Mexico City

As models for the figures he painted in this
work Rivera took prominent Californians
like the tennis champion Helen Wills
Moody, the biologist Luther Burbank and
the gold prospector James Wilson Marshall.

condemned President Herbert Hoover, visiting Mexico in late 1928, for his
Nicaraguan policy. He finally obtained a visa through the support of his
friend the insurance agent and art collector Albert M. Bender, who had
bought Rivera's work on previous visits to Mexico, and who had contacts
with influential figures. From this time Rivera was criticized in the United
States for accepting contracts from American institutions, not only by the
media, from which he attracted anti-Communist comment, but also by en-
vious fellow-artists in San Francisco. The fact that the Mexican was offered
projects from which they were barred became more conspicuously evident
than ever when at the end of 1930 he was allowed to exhibit the considerable
number of 120 works at the California Palace of the Legion of Honor. Only
after he had finished the commissioned murals, which were enthusiastically
received not only by the public at large but also by the press, and after Rivera
had made public appearances with his artist wife, was there a general critical
change of opinion.

From December 1930 to February 1931 Rivera painted the mural *Alle-
gory of California* (ill. p.47) for the Luncheon Club of the San Francisco
Pacific Stock Exchange.[17] Together with his work in the Stock Exchange
building it was unveiled in March. After a holiday on the property of the
Stern family in Atherton, California, where he painted a small-size fresco in
his hosts' dining room, in April–June 1931 he completed *The Making of a
Fresco* (ill. p.48) for the California School of Fine Arts, now the San
Francisco Art Institute.

As soon as he had finished these works, Rivera was obliged to return to
Mexico to meet the president's request for him to finish his abandoned work
in the National Palace. Soon after his return he received an offer of a large-
scale exhibition at the Museum of Modern Art in New York. Following the
Henri Matisse retrospective, it was only the second one-man exhibition
organized by the Museum, which had been founded in 1929, and there was
no further exhibition of comparable scope and importance in the United
States until the exhibition in commemoration of Rivera's birth in 1986.
After the main wall of the stairway of the National Palace had been com-
pleted, the rest of the work in the Palace was now interrupted once again;
with Frida Kahlo and the well-known art dealer Frances Flynn Paine,
Rivera sailed for New York on board the steamer *Morro Castle*. As a mem-
ber of the powerful Mexican Arts Association, which was financed by the
Rockefeller family, Paine had made the offer of the retrospective to Rivera
in Mexico. The latter used the voyage to complete various easel paintings
after studies in his sketchbook, predominantly variations on details of his
frescoes at the Ministry of Education. In the month remaining between his
arrival in New York and the private view, Rivera worked as if possessed
on eight portable frescoes, of which five were also versions of scenes from
his Mexican murals, the other three expressing his first impressions of
New York in the Depression years. When the retrospective opened on
23 December, 150 works had been assembled. The overwhelmingly favour-
able press reviews brought 57,000 visitors to the exhibition – a considerable
figure for the time.

Through the popular American world tennis champion Helen Wills
Moody, who was also an art connoisseur, portrayed in the central female

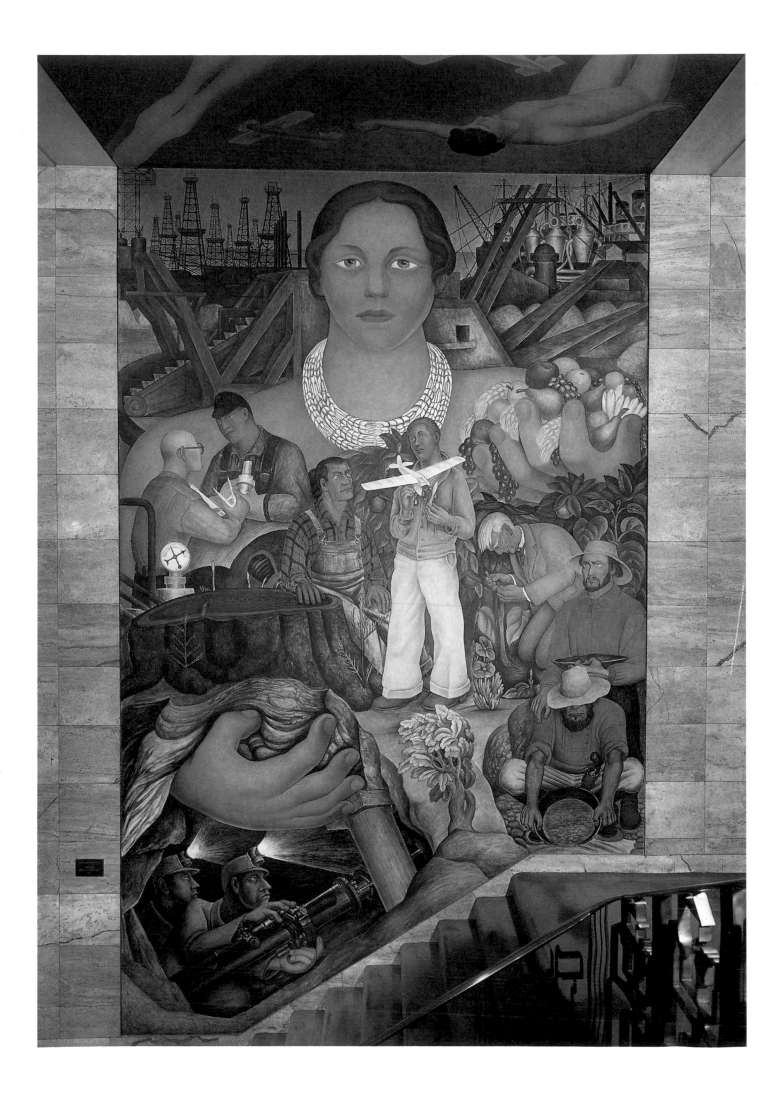

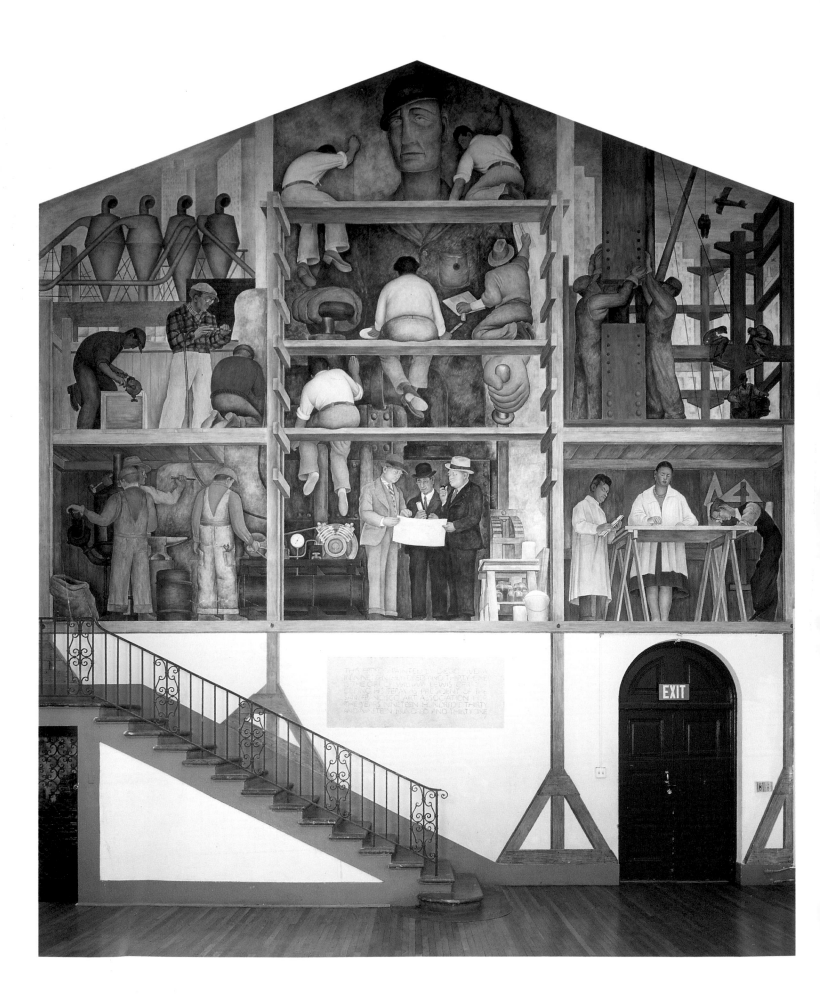

figure of the mural *Allegory of California* in San Francisco, Rivera met the leading representatives of the Detroit Institute of Arts, Dr Edgar P. Richardson and Dr William R. Valentiner. The two directors of the museum offered him an exhibition of paintings and drawings in February/March 1931 and proposed to the Institute's governing body, the Arts Commission of the City of Detroit, that Rivera should be commissioned to paint a mural in the museum's Garden Court. The muralist, as Richardson enthusiastically put it, had "perfected a powerful narrative style", which made him "the only living artist who can adequately represent the world we live in". Richardson found it interesting that "while most painting of the present day is abstract and introspective, an artist like Diego Rivera emerges, whose powerful and dramatic art can give incomparable narrative form to any subject he likes. He is a great painter and his subject-matter demands greatness."[18]

Thanks to the support of Edsel B. Ford, chairman of the City Arts Commission, Rivera was able to start work on preparations for the murals at the Detroit Institute of Arts in January 1932, immediately after the New York exhibition had ended. With Frida Kahlo he booked into a hotel situated opposite the museum. Edsel B. Ford, son of Henry Ford and first president of the Ford Motor Company in Detroit, had a budget of 10,000 dollars for the frescoes. The Institute's plan for only two wall surfaces of the inner courtyard to be painted, so as to ensure what was felt to be the appropriate artist's fee of 100 dollars per square metre painted, was rejected by Rivera when he inspected the site. He was so inspired by the spacious wall surfaces that he agreed without further ado to paint all four of them for the same total fee. For he saw that the subject-matter prescribed by the Commission would allow him to realize his dream – the creation of an epic of industry and the machine.

In the United States the fresco series *Detroit Industry* (ills. pp.50, 51, 52) is today considered one of the century's outstanding achievements in monumental art. The frescoes are a synthesis of the artist's impressions during his studies of the Ford family's industrial plant, and especially of what he saw at the River Rouge complex. A few months previously, the first new Ford Model V-8 had come off the production lines, and Rivera depicted its production in these murals. At the Ford works he became acquainted with the routines of factory work and the grave problems that had been caused by the anti-union policies of the period, and observed the miserable condition of the poorer classes that had been brought about by the world economic crisis. Before the scaffolding had even been erected in the courtyard of the museum the artist was designing the composition of the murals in preparatory sketches, from which he then progressed to drawings which were accepted by the Commission. "I've had to do a lot of preparatory work," Rivera wrote at the time to his friend Bertram D. Wolfe, "which has consisted mostly of observation. There will be 27 frescoes, which together will form a plastic and thematic unity. I am hoping that this series will be the most complete of my works; I feel the same excitement towards the industrial material of this place as I did towards rural material when I went back to Mexico ten years ago."[19]

The mural series on the four walls around the courtyard incorporates an iconography of the points of the compass, and where the walls mark off the

Detroit Industry or Man and Machine,
1932–1933
Fresco
Four wall surfaces divided into five, eight,
seven and again seven panels, total painted
surface 433.68 sq. m
Central Hall, Rivera Hall, east wall
The Detroit Institute of Arts, Detroit,
Michigan, Gift of Edsel B. Ford

The five panels of the east wall, which is
opposite the entrance, represent the origins
of human life and technology. On one side a
baby is depicted embedded in a tumer, and
on the other, two ploughs as the earliest
form of technology in agriculture.

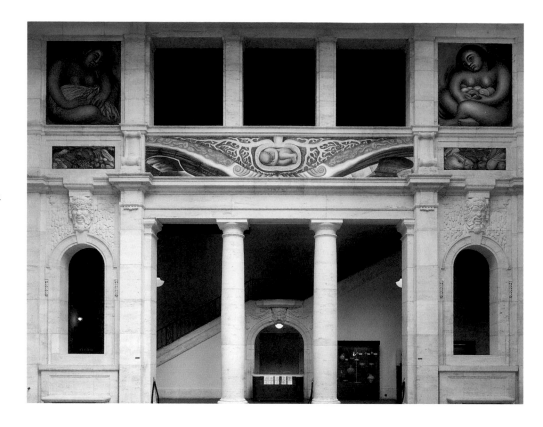

limits of the cosmos, space is extended by the mural paintings.[20] Together
with the decoration of the Chapingo Chapel, this is the only opportunity that
Rivera had to design a set of frescoes of comparable completeness to that of
the Renaissance spatial designs of the Arena or Sistine Chapels; all his other
murals are on separate walls or aligned groups of walls. He began work in
July 1932 on the east wall (ill. p.50) opposite the main entrance. These mu-
rals represent the origins of human life and of technology. The infant depic-
ted is often seen as the son of Diego and Frida lost in a miscarriage while
they were in Detroit, and here immortalized as a symbol of the cycle of
nature. On the west wall (ill. p.51), through which the inner courtyard is
reached, the new technologies of air and water are depicted. In the most
advanced technical achievement of the time, the aeroplane, man's triumph
over nature is represented. On the one hand peaceful use of technology is
shown in the manufacture of a passenger aircraft in process in the aeronaut-
ical department of the Ford company, on the other its misuse in a warplane.
Rivera not only pursues the theme of duality in the grisaille central area of
the wall, where the coexistence of nature and technology, life and death is
symbolized, illuminated by the star of human hope and striving, but makes it
the main theme of this entire series.

On each of the north and south (ill. p.52) walls two androgynous guard-
ian figures sit enthroned above the achievements and also the misuse of
industry, pharmacy, medicine and science in Detroit. They represent the four
races that make up the workforce of North America, and hold the mineral
resources of coal, iron, chalk and sand in their hands – the four basic ingredi-
ents in production of the steel needed for automobile manufacture. In the main
areas of each of the north and south walls the different stages in produc-
tion of the Ford Model V-8 car are shown: motor manufacture on the one wall
and the bodywork assembly line on the other. For the figures of the workers

in the foreground on the north wall Rivera used portraits of his assistants and of Ford workers.

In the murals of these two walls Rivera once again draws on various artistic models. The compression of space, the representation of simultaneous events, the breaking up of forms into basic geometric elements, are clearly derived from the compositional method of Cubism. The massive creations of pre-Columbian sculpture (ill. p.53 below) served as models for the gigantic machinery. The whole composition of these murals, the subdivision of each wall into main and subsidiary fields, the inclusion of portraits of donor figures, the depiction of the vaccination of a child in the manner of a Christian motif – all this refers back to Italian fifteenth- and sixteenth-century painting; the relief-like, monochrome, grisaille frieze running along the bottom of each main wall area is reminiscent of tympanum sculpture in medieval churches. Overall, Rivera creates a new aesthetic for the steel age.

While Rivera was still working on *Detroit Industry*, he was commissioned to paint a mural in the main corridor of the lobby of the as yet unfinished RCA building, known as the Rockefeller Center, in New York, and in 1933, continuing the leading theme of the Detroit frescoes, he painted *Man at the Crossroads* (ill. p.53 above), "Looking with Hope and High Vision to the Choosing of a New and Better Future", as the commissioning committee worded the theme. The Mexican artist's murals had already provoked controversy in the United States; now in New York the political position he expressed in the new fresco was to cause a major confrontation.

In Detroit critics had claimed to find blasphemous, pornographic and Communist elements in his work, and held it against him that he had admitted the raw world of industry into the sublime world of culture. The safety of his work had been in question, and physical attacks on it had been

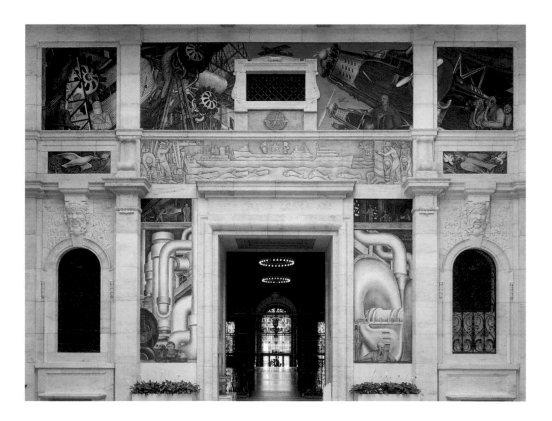

Detroit Industry* *or* *Man and Machine,
1932–1933
West wall

The depiction of peaceful and aggressive use of modern aviation technology in the upper wall panels has its counterpart in nature, with the dove and the hawk as symbols of peace and aggression.

threatened, until eventually Edsel B. Ford had made a public statement in support of Rivera. This was not to happen in New York when a showdown occurred over the mural at the Rockefeller Center, in which Rivera expressed his views on the evils of capitalism and the positive aspects of socialism. Only the previous month, April 1933, Abby Aldrich Rockefeller, wife of John D. Rockefeller, viewing the work while it was being painted, had praised Rivera's depiction of the Moscow May Day celebrations and bought the sketchbook containing preparatory drawings for it. However, a portrait of Lenin with other Communist ideologues now suddenly appeared in the mural as representatives of the new society; it had not been shown in the preparatory drawing approved by the commissioning committee. This drew bitter reactions from the conservative press and contrasting expressions of support for the artist from the progressive organizations of New York. The brothers Nelson and John D. Rockefeller, as the client's representatives, got in touch with the artist. Rivera refused their request to paint out the portrait.

Detroit Industry or *Man and Machine*,
1932–1933
South wall

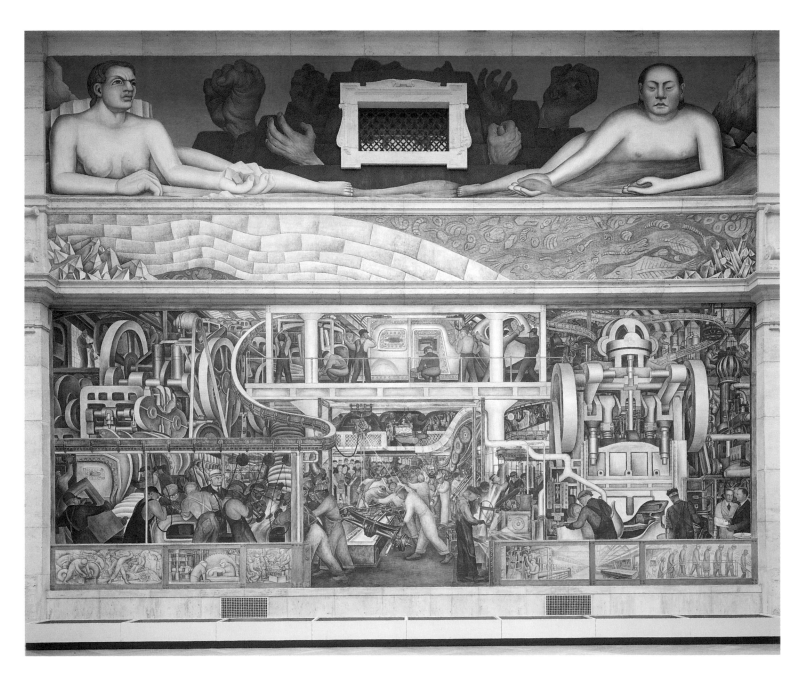

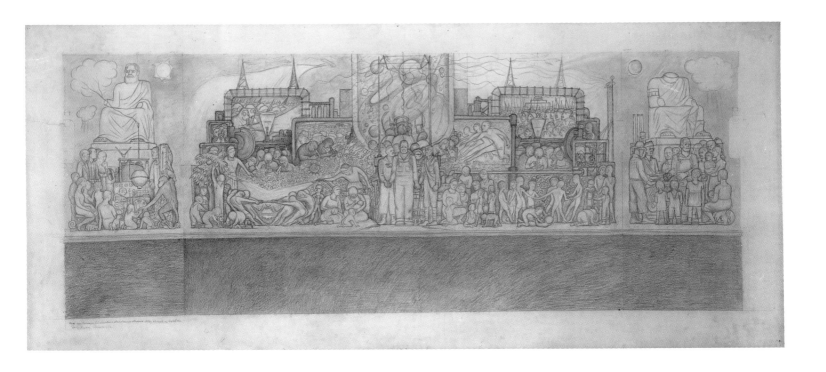

The unfinished mural was covered early in May; the artist was paid off and released from his obligation. So ended the capitalist world's patronage of the Mexican, and he returned in disappointment to his home country.

In February 1934 the mural was wholly destroyed, but in the same year Rivera received the opportunity to paint an almost identical version of the planned New York mural, entitled *Man, Controller of the Universe* (ill. pp.54–55), in the Palace of Fine Arts (Palacio de Bellas Artes) in Mexico City,[21] the first in a series of works by the leading figures of the "Renaissance of Mexican mural painting" commissioned by the Mexican government.

In the course of his four-year sojourn in the north, Rivera had become one of the most famous artists in the United States, as celebrated by the intellectual left and the artistic community as he was despised by the conservatives and industrialists. The destruction of his mural was the destruction of the illusion that he had found in the United States a country of clients who would allow him to make free artistic use of his political views.

Overall design for the mural begun in the RCA Building, New York and destroyed before completion ***Man at the Crossroads, Looking with Hope and High Vision to the Choosing of a New and Better Future***, 1932
Pencil on paper, 78.7 x 180.8 cm
The Museum of Modern Art, New York.
Anonymous gift

Aztec ***Coatlicue figure***, Tenochtitlán, c. 1487–1521
Stone, height 3.5 m
Museo Nacional de Antropología, Mexico City
Photo: Rafael Doniz

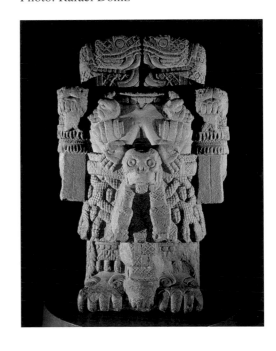

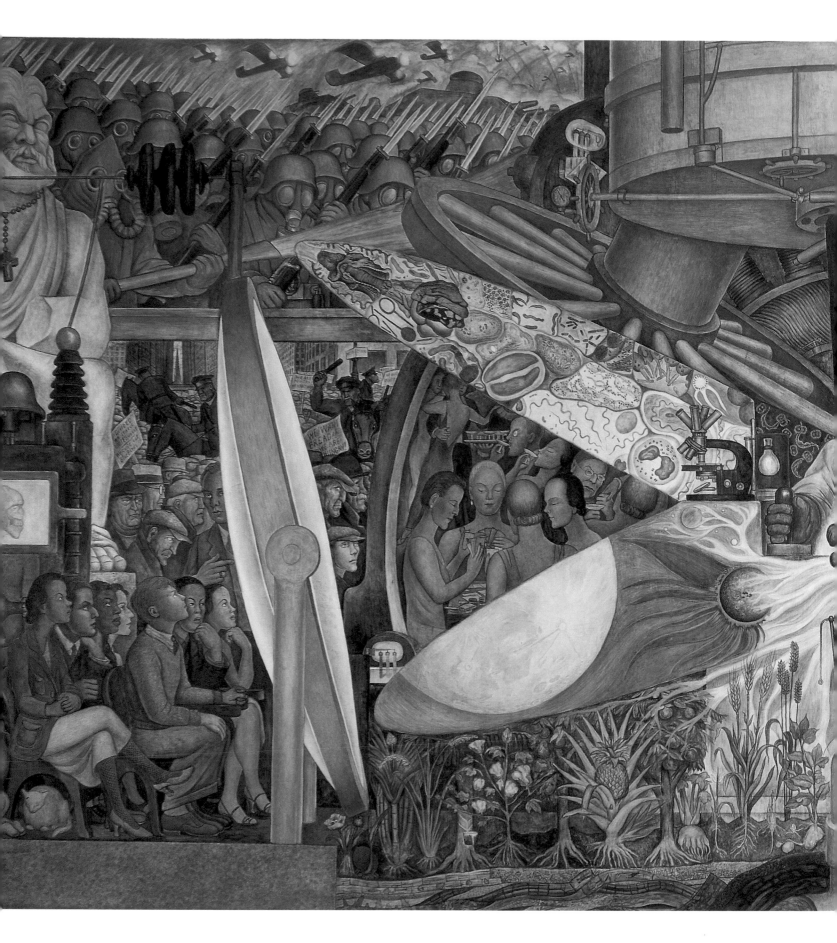

Man, Controller of the Universe *or* ***Man in the Time Machine*** (detail of central part), 1934
El hombre controlador del universo o *El hombre en la máquina del tiempo*
Fresco, 4.85 x 11.45 m. Stairwell, second floor
Palacio de Bellas Artes, Mexico City
Photo: Rafael Doniz

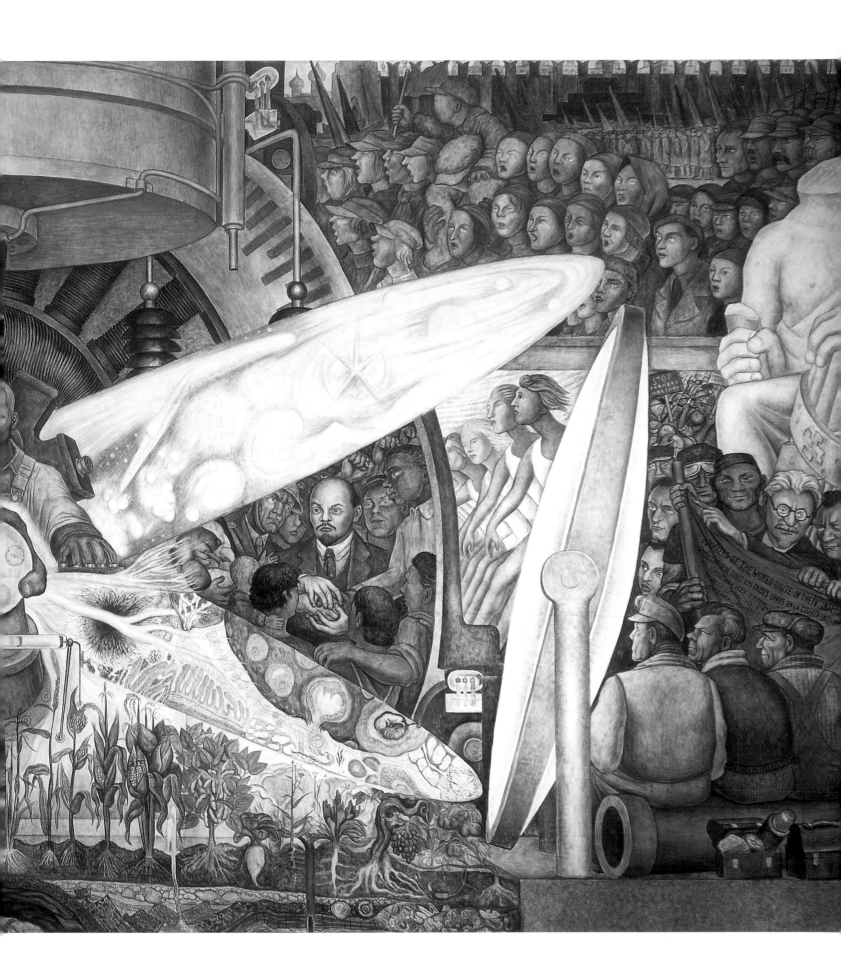

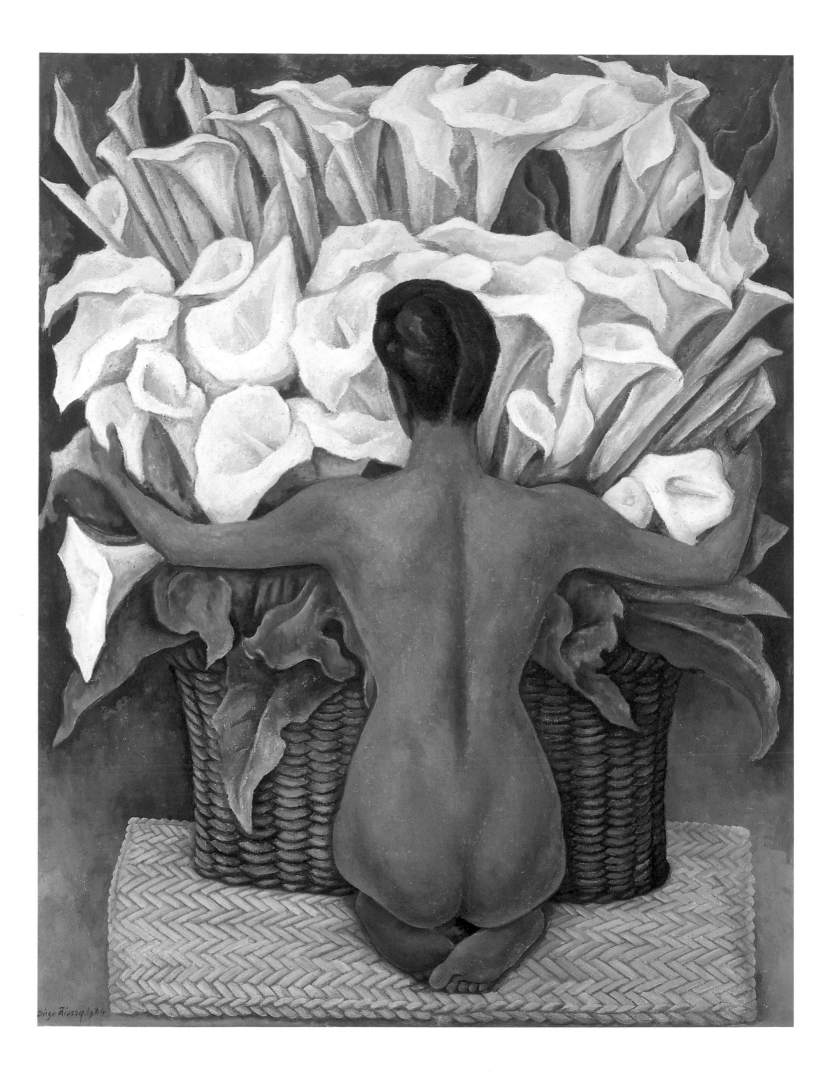

From Recognition to Renown

After their return from the United States, Rivera and Kahlo moved into the new studio-house that had been built in 1931 by Rivera's friend, the young architect and painter Juan O'Gorman. This building, comprising two square blocks in Bauhaus style, in the San Angel Inn quarter then lying outside Mexico City to the south, today houses the Diego Rivera Museum-Studio (ill. p.82). Frida Kahlo lived in the smaller blue block, linked by a metal overhead walkway to the larger block which was decorated in Mexican pink. Here on the top floor Rivera set up a spacious studio with plenty of light which provided him with ideal conditions for painting easel works over the next few years.

Both politically and artistically, Rivera was now in a difficult situation. He had been rejected by the Soviet Union, the political ideals of which had played a central part in the themes of his murals for a number of years, because he would not espouse the Stalinist ideal of Socialist Realism. He had been expelled from the Moscow-oriented Mexican Communist Party as a counter-revolutionary artist who would not toe the line. And finally, he had been disillusioned by his experiences in the United States, the land of modern industry; the destruction of his mural in the Rockefeller Center wounded him profoundly.

In November 1934 Rivera returned to his work on the main stairwell of the National Palace in Mexico City, and successfully completed it a year later.[22] He had been commissioned in 1929, by the then interim president, Emilio Portes Gil, to paint the three arched wall areas of the stairwell. Here he painted *Epic of the Mexican People* (ills. pp.58, 59, 60–61), three thematically linked murals having the effect of a triptych, allegorically depicting the history of Mexico in a chronological sequence of paradigmatic episodes. Beginning work in 1929 on the north wall, he depicted *Pre-Hispanic Mexico – The Early Indian World* (ill. p.58) as a paradisal time; on the main wall he painted (1929–1931) *History of Mexico from the Conquest to 1930* (ill. pp.60–61), showing the cruelty of the Spanish Conquest and Christianization, the dictatorship of the oligarchic régime, and the conclusive Revolution; in *Mexico Today and Tomorrow* (1934–1935) on the south wall (ill. p.59) he pointed to a future in accordance with Marxist ideals. No spot could have been more fitting for such a theme than the seat of executive power of the Mexican State, which the Conquistadores set up where the palace of the last Aztec ruler, Montezuma, had stood before they destroyed

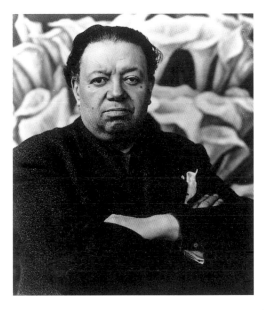

Rivera in front of one of his calla lily paintings (dedicated to his daughter Ruth), c. 1950
Photo: Guillermo Zamora, Rafael Coronel Collection, Courtesy Cenidiap Archive, Mexico City

ILLUSTRATION PAGE 56:
Nude with Calla Lilies, 1944
Desnudo con alcatraces
Oil on hardboard, 157 x 124 cm
Emilia Gussy de Gálvez Collection, Mexico City
Photo: Rafael Doniz

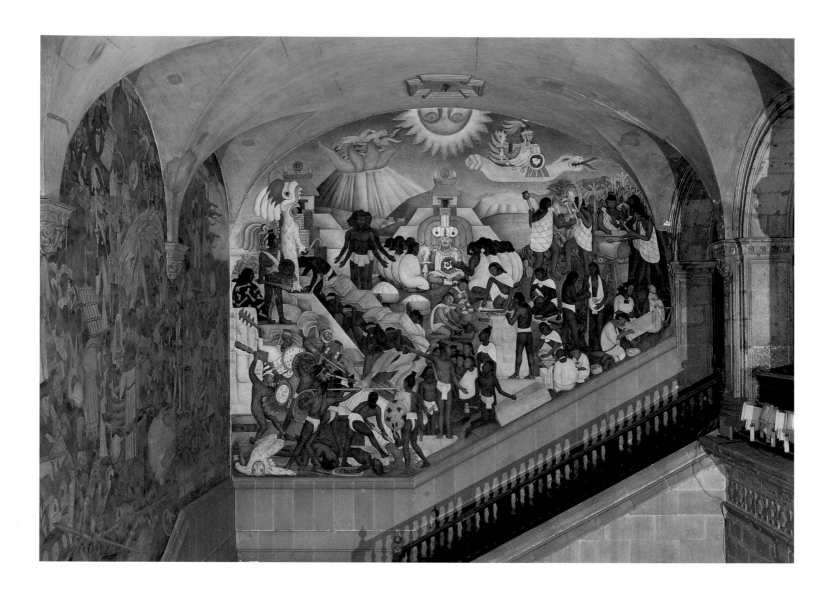

Epic of the Mexican People, 1929–1935
Epopeya del pueblo mexicano
Fresco cycle
Three monumental murals on staircase, total
painted surface 410.47 sq. m
Palacio Nacional, Mexico City
Pre-Hispanic Mexico – The Early Indian
World, 1929
México prehispánico – El antiguo mundo
indígena
7.49 x 8.85 m, north wall: general view
Photo: Rafael Doniz

it. Used by Cortés as his HQ, the building later became the residence of the
Spanish viceroys and then the seat of government for successive Mexican
heads of state. The National Palace occupies the entire east side of the main
square of Mexico City, Zócalo Square, on the north side of which the col-
onial Cathedral is built on the foundations of the principal temple of the
Aztecs. Rivera founds his view of the past in a historical-dialectical mat-
erialism, which stands closer to Hegelian idealism than to Marxism. In this
monumental series the artist's conception of history is more forcefully
articulated than in any other work.

Some years later Rivera painted another fresco series in the National
Palace, on the arcaded upper floor of the middle inner courtyard. The subject-
matter of *Pre-Hispanic and Colonial Mexico* (1942–1951; ills. pp.62, 63
below, 64–65) is predominantly pre-Columbian culture, based on his
preparatory studies of Mexican pre-colonial codices.

Rivera's artistic development as a mural-painter is strikingly demons-
trated in the three distinct narrative styles of this series in the National
Palace. In the murals on the stairwell main and north walls the conception
of reality and the historical scheme are conveyed in a unified pictorial
language; in those on the south wall, however, a polemical style appears,
indicating the artist's radicalization after his experiences in America. The
style of the third phase seen in the murals on the upper floor is markedly

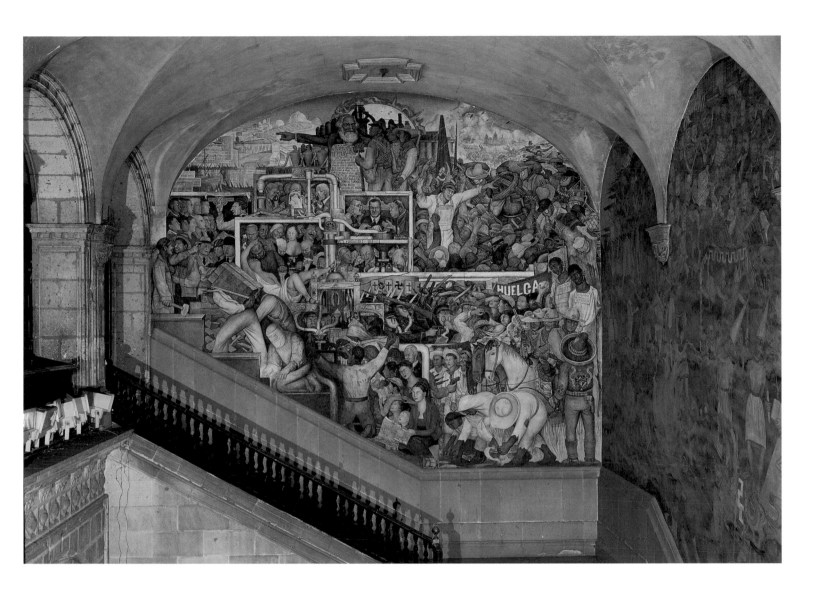

more focussed on narrative, and presents pre-colonial societies as in a show-case, as idealized forms of ancestral life.

Having completed the murals in the main stairwell of the National Palace in November 1935 and, with the exception of one small-scale project, having no further mural commissions outstanding, Rivera now devoted himself to easel painting. Between 1935 and 1940, using the most diverse techniques, he depicted customs and scenes from the everyday life of the Mexican people, as in *The Pinole Seller* (ill. p.68 above), in which he created what seemed Mexican archetypes. These are paintings reminiscent of Rivera's work during the 1920s.

By 1926 he had begun a new genre, painting and drawing portraits of mostly Indian children or mothers; it was evident that he had a fondness for these models and liked to express it. He could convey an extraordinary degree of intimacy and tenderness between his models, as in *Portrait of Modesta and Inesita* (ill. p.69). Indian children, especially attractive subjects for most American buyers, recur almost throughout Rivera's œuvre, particularly in drawings, watercolours and small oils of the latter half of the 1930s. Technically these predominantly small-sized works, easily transported, from time to time left something to be desired; Rivera almost mass-produced them, selling many to tourists for income with which to fulfil his collector's passion for pre-Columbian objects.

From the cycle: Epic of the Mexican People:
Mexico Today and Tomorrow, 1934–1935
México de hoy y de mañana
7.49 x 8.85 m, south wall: general view
Photo: Rafael Doniz

ILLUSTRATION PAGES 60–61:
From the cycle: Epic of the Mexican People:
History of Mexico from the Conquest to 1930, 1929–1931
Historia de México: de la Conquista a 1930
8.59 x 12.87 m, central area of west wall
Right and left halves
Photo: Rafael Doniz

59

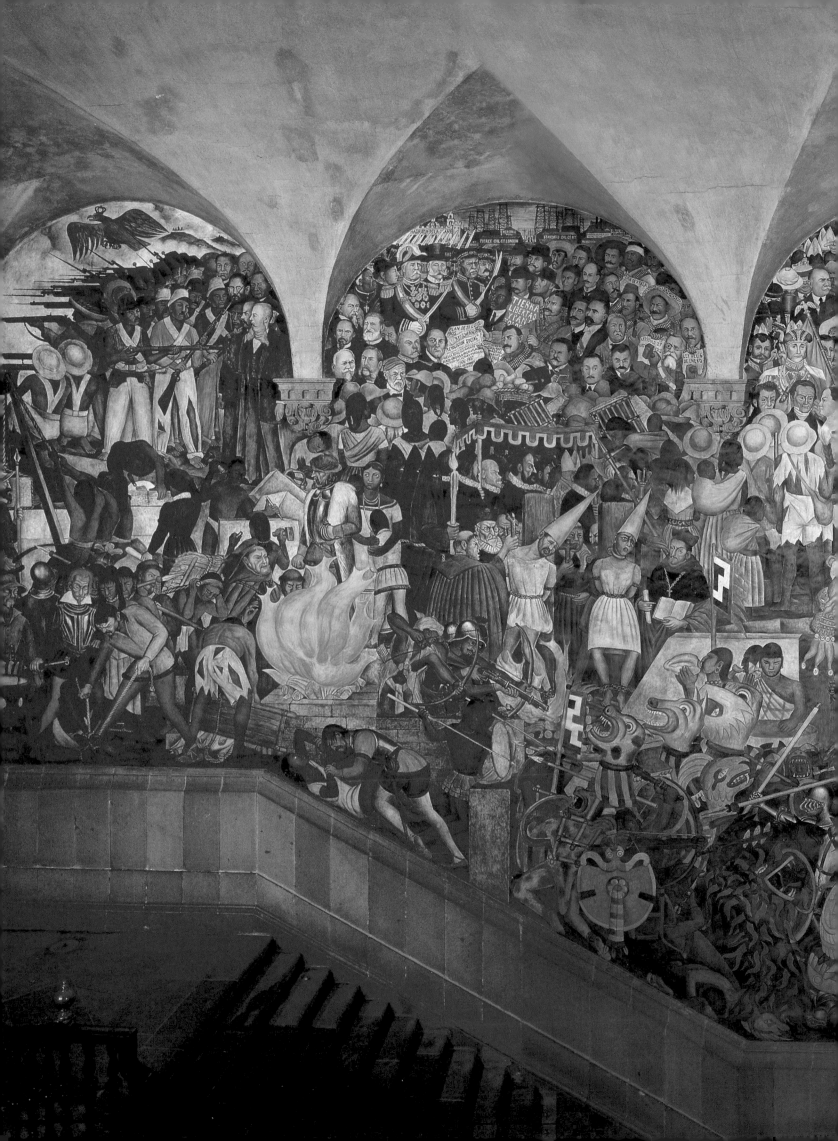

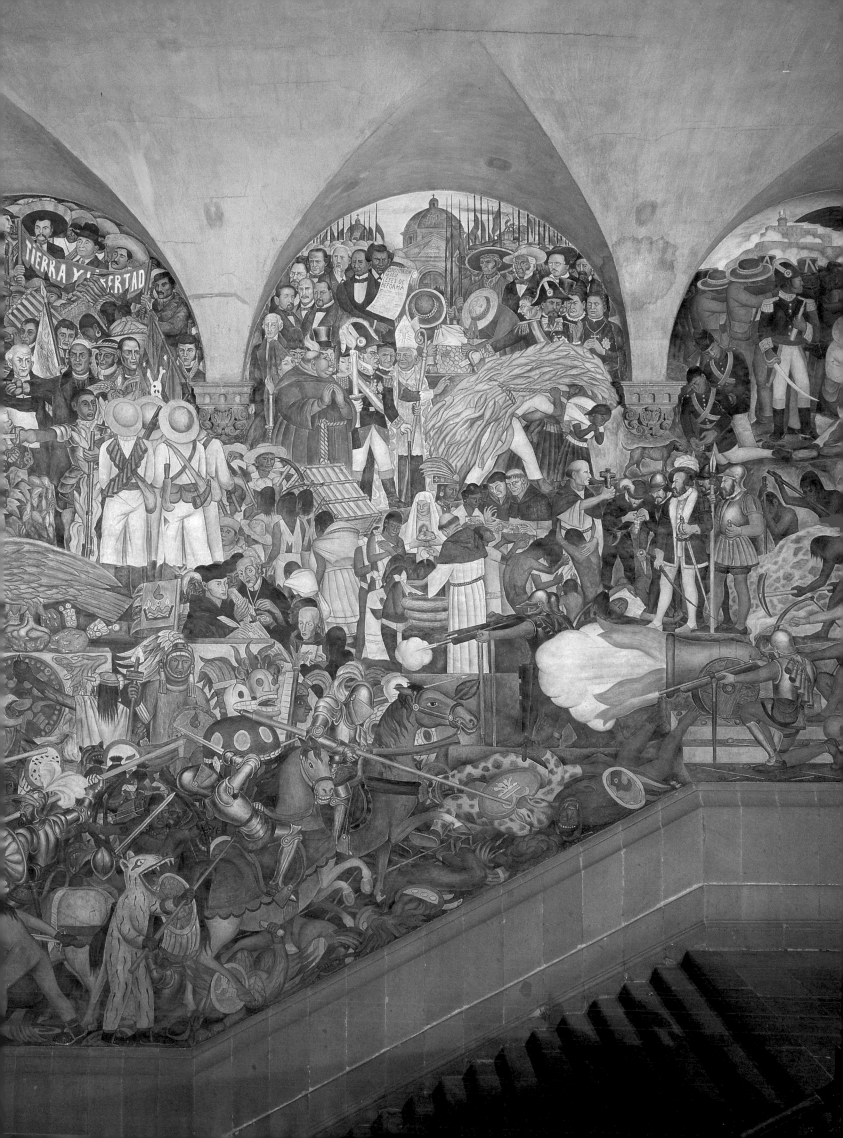

Pre-Hispanic and Colonial Mexico,
1942–1951
México prehispánico y colonial
Fresco cycle on movable metal framework
Eleven wall surfaces on arcaded upper floor
of the inner courtyard, total painted surface
198.92 sq. m
Palacio Nacional, Mexico City
*The Conquest or Arrival of Hernán Cortés
in Veracruz*, 1951
*La colonización o llegada de Hernán Cortés
a Veracruz*
4.92 x 5.27 m, eleventh mural on east wall
Photo: Rafael Doniz

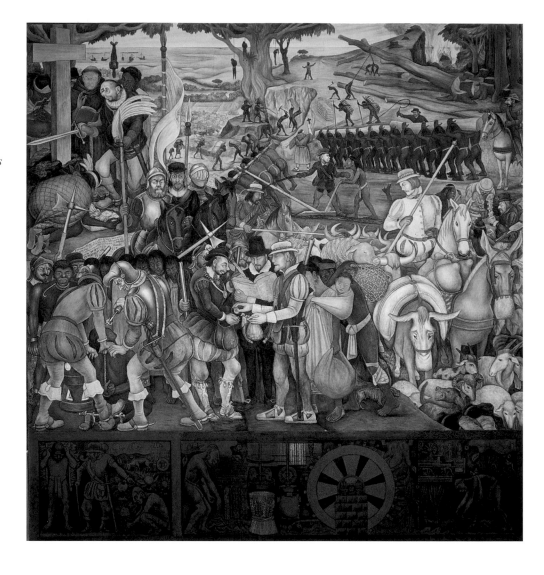

Diego Rivera painting *The Great City of
Tenochtitlán,* one of the murals (see ill. p.64)
on the first floor of the inner courtyard of
the Palacio Nacional, Mexico City, 1945
Photo: Hector García, Courtesy Cenidiap
Archive, Mexico City

The year 1939 brought an unusual commission. Sigmund Firestone, an American engineer and art-collector who had got to know the artist couple on a trip to Mexico, commissioned from Frida Kahlo and Diego Rivera not, as might be supposed, portraits of his family, but a self-portrait from each artist. The pair of pictures are identical in size, of similar palette and of almost exactly the same composition, with a plain yellow-coloured background. In both works a painted piece of paper, a traditional feature of nineteenth-century Mexican portrait-painting, which Frida Kahlo was particularly fond of using in her work, bore a dedication to their friend. At the same time the American actress Irene Rich asked Rivera for a self-portrait; it shows the artist from a slightly different view-point but in the same clothing and pose (ill. p.6). If these works were photographs, they would be assumed to be pictures taken from different positions at the same moment or one shortly after the other.

At various stages of his career and in various techniques, Rivera painted many self-portraits: rarely full-length, most often head and shoulders. It is the face that holds virtually the whole interest, without the distraction of background. In none of these self-portraits is there any attempt to idealize, a tendency that may be seen in his commissioned portraits of others; all are distinguished by an extreme realism. The artist knew, particularly in his older years, that he did not strike a handsome figure. In

Untitled, 1954
Sín título
Ball-point on paper, 28 x 21 cm
Elena Carrillo Collection, Mexico City
Photo: Rafael Doniz

The Tooth of Time (1949) the different stages of his life are recalled in the background behind the grey-haired head and furrowed face. Not only does Frida Kahlo affectionately compare her partner to a frog in *Portrait of Diego* (1949)[23], but Rivera himself frequently features his large protruding eyes in small caricatures of himself as a frog or toad. In the self-portrait as a boy in the mural in the Hotel del Prado (1947) he carries a toad in his jacket pocket (ill. p.75); short notes and messages are not infrequently signed "el sapo-rana", "the toad-frog" (ill. p.63 above).

In 1935 Rivera began a relationship with Frida Kahlo's younger sister Cristina, and the former temporarily moved to a separate residence and considered a separation; but then the couple came together again through common political interests (ill. p.71 above). Rivera's differences with the Mexican Communist Party continued after his return from the United States, and he was once again reproached for representing the conservative position of the government. He repeatedly clashed in public with David Alfaro Siqueiros, now as ever an energetic advocate of the Stalinist line. Relations between the two artists reached a showdown when they engaged in heated argument at a political meeting, each armed with a pistol. In response to Siqueiros's charge that he was an opportunist, Rivera for the first time revealed his reasons for breaking with the Mexican Communist Party and his new orientation towards the Trotskyist opposition. In 1933, during his stay in New York, he had got in touch with the Communist League of America, the central Trotskyist organization in the United States, and painted some frescoes for both it and the New Workers' School run for the

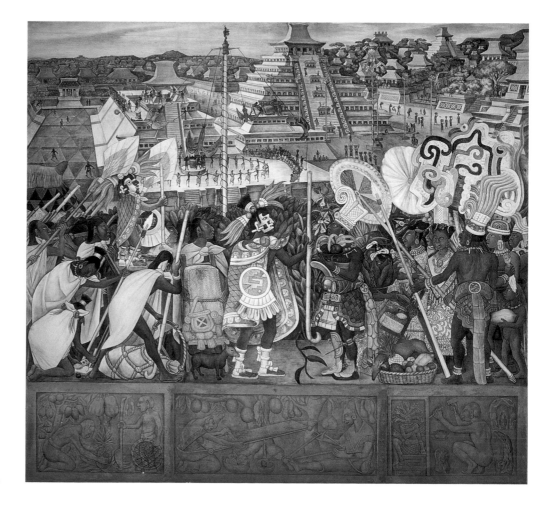

From the cycle: Pre-Hispanic and Colonial Mexico:
The Culture of Totonaken, 1950
Cultura Totonaca
4.92 x 5.27 m, sixth mural on north wall
Photo: Rafael Doniz

This panel shows Totonac nobility trading with Aztec merchants, who are accompanied by their protective deity. The scene is depicted in front of the magnificent panorama of the reconstructed Totonac city of El Tajín, in the modern State of Veracruz.

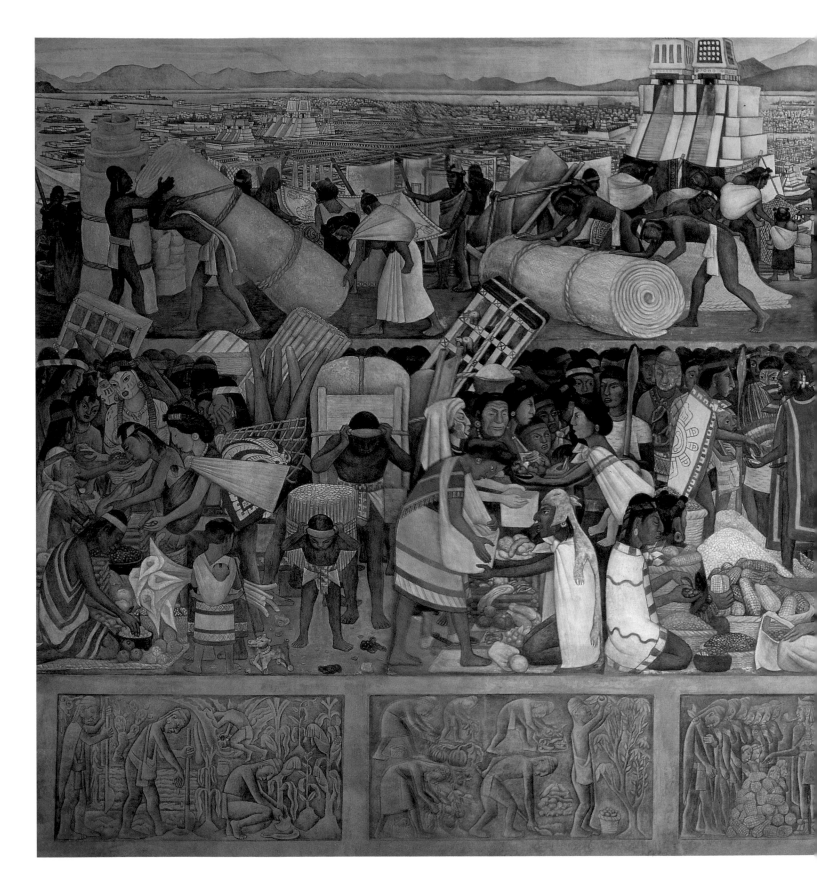

From the cycle: Pre-Hispanic and Colonial
Mexico:
The Great City of Tenochtitlán, 1945
La gran ciudad de Tenochtitlán
4.92 x 9.71 m, third mural on north wall
Right and left halves
Photo: Rafael Doniz

Rivera shows the Aztecs' extraordinary
talent for trade in this fresco depicting a
market at which wares from the most far-
flung parts of the Aztec empire are offered
for sale. The background of the Aztec
capital is very delicately painted, having
almost a watercolour effect.

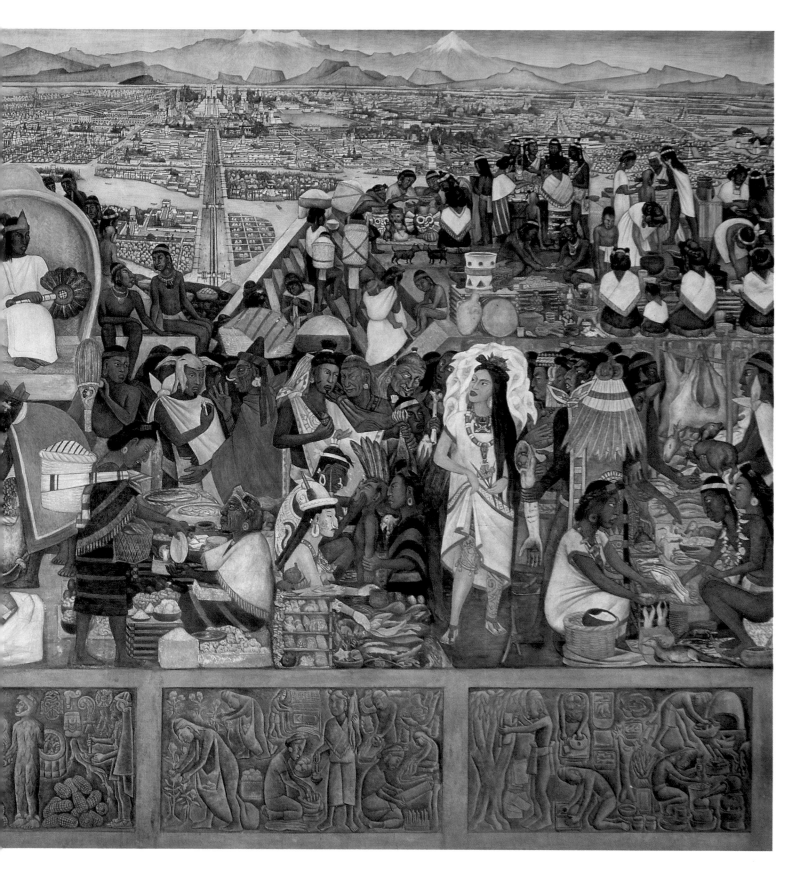

ILLUSTRATION PAGES 66–67:
Carnival of Mexican Life (detail of the first three murals), 1936
Carnaval de la vida mexicana
Fresco comprising four transportable murals, each 3.89 x 2.11 m, total painted surface 24.80 sq. m
Stairwell, second floor of the Palacio de Bellas Artes, Mexico City
Photo: Rafael Doniz

1. Dictatorship *(La dictadura)*
2. Dance of the Huichilobos *(Danza de los Huichilobos)*
3. Folkloric and touristic Mexico *(México folklórico y turístico)*

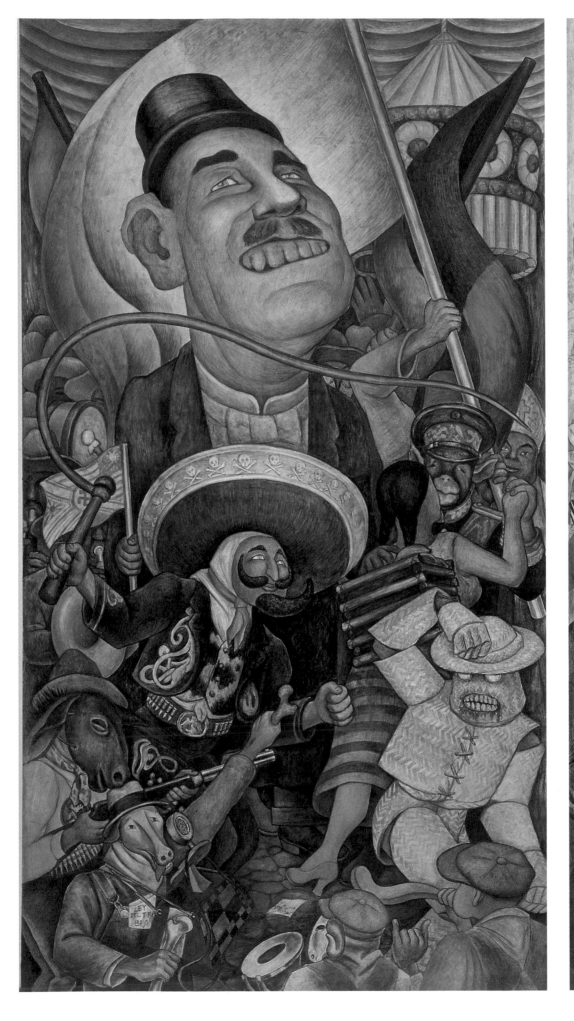
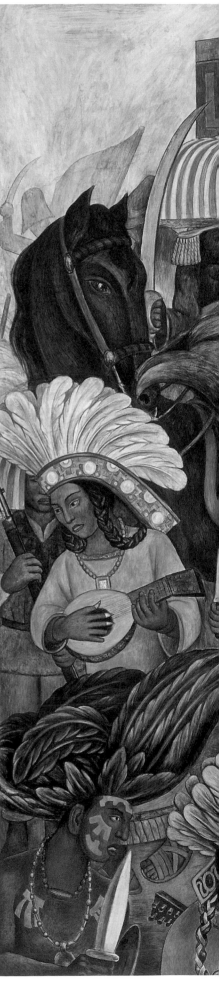

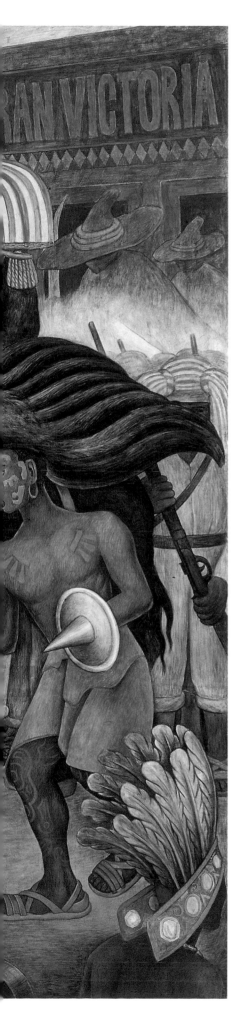
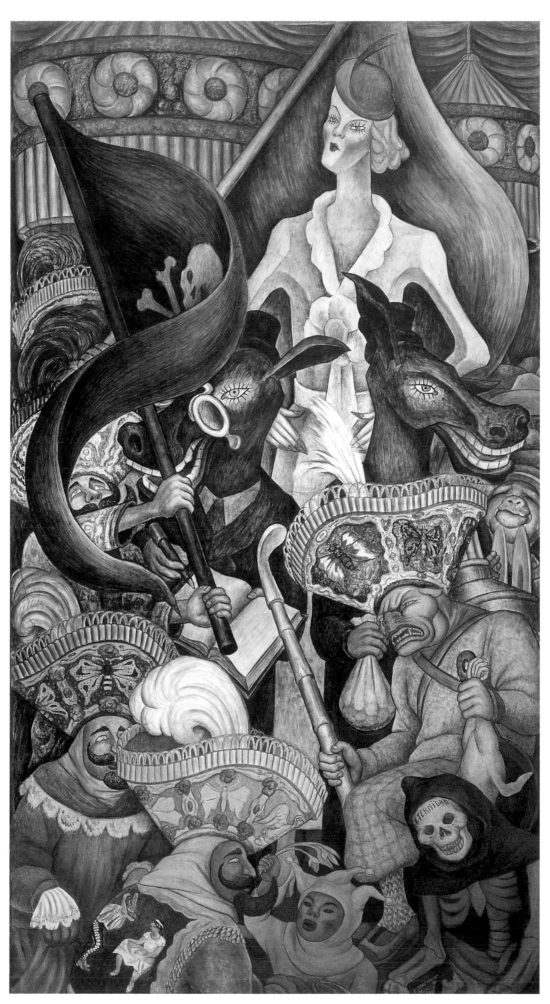

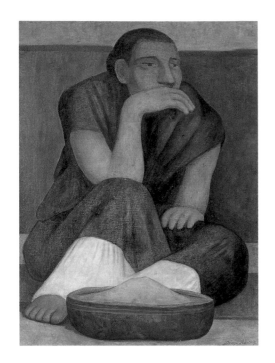

"Communist Party Opposition" by his friend Bertram D. Wolfe. Since then he had become committed to the Trotskyists and their political aims, and in 1936 he became a member of the International Trotskyist-Communist League.

Rivera and Kahlo now asked the Mexican president, Lázaro Cárdenas, to grant Leon Trotsky political exile. Cárdenas had been elected in 1934 and had introduced a programme of political liberalization. The reforms carried through by his government involved the first land redistribution in Zapata's sense since the Revolution. Foreign firms that had acquired control of oil in Mexico were expropriated and the entire oil industry was nationalized. Refugees from the Spanish Civil War were welcomed. The president was prepared to grant Trotsky asylum on condition that he did not become politically active in Mexico.

In January 1937 Leon Trotsky and his wife Natalya Sedova were received at the Kahlo family's "Blue House" in Coyoacán, and stayed on there for the next two years. The couple sought other accommodation in April 1939 when Rivera broke with Trotsky after a number of personal and

The Pinole Seller, 1936
Vendedora de pinole
Oil on canvas, 81.4 x 60.7 cm
Museo Nacional de Arte, MUNAL – INBA,
Mexico City
Photo: Rafael Doniz

***My Godfather's Sons (Portrait of Modesto
and Jesús Sánchez)***, 1930
*Los hijos de mi compadre (Retratos de
Modesto y Jesús Sánchez)*
Oil on metal, 42.5 x 34 cm
Fomento Cultural Banamex, Mexico City
Photo: Rafael Doniz

By the mid-1920s Rivera had evolved a new genre in portraits, both painted and drawn, of predominantly Indian Children. These became favourite travel mementos and collectors' pieces, especially for American tourists.

Portrait of Modesta and Inesita, 1939
Retratos de Modesta e Inesita
Oil on canvas, 99 x 69 cm
Collection of the Estate of Licio Lagos,
Mexico City
Photo: Rafael Doniz

Modesta was one of the models whom
Rivera frequently painted around 1940 in
what was for him the "classical" style of
traditional Mexican portrait-painting.

political arguments, the latter declaring that he no longer felt any "moral
solidarity" with the artist and his anarchistic ideas. Before this break, how-
ever, Rivera and Trotsky had held joint political meetings, and *Manifesto:
For a Free Revolutionary Art*, written by Trotsky, had been signed by
Rivera and André Breton (ill. p.71 below left). Breton, one of the leading
lights of the Surrealist movement and a sympathizer with the Trotskyist
League, had met Trotsky through Rivera when staying with the latter on a
visit to Mexico with his wife, Jacqueline Lamba, in the spring and summer
of 1938. The three couples, Breton and Lamba, Trotsky and Sedova, and
Rivera and Kahlo, became friends and took trips together in the Mexican
provinces. Rivera's contact with Breton without doubt lies behind the com-

The Temptations of Saint Antony, 1947
Las tentaciones de San Antonio
Oil on canvas, 90 x 110 cm
Museo Nacional de Arte, MUNAL – INBA,
Mexico City
Photo: Rafael Doniz

Rivera's depiction of anthropomorphic
radishes as grotesque characters with
exaggerated sexual parts was certainly
prompted by the traditional radish
competition held through the Christmas
season on the main square of Oaxaca. At
this event in a festive setting folk artists
competed for prizes with figure ensembles
in presentations of the Christmas story and
other themes.

position of two paintings of clearly Surrealist character, *Tree with Glove and Knife* and *The Hands of Dr Moore* (ill. p.71 below right), which were shown in 1940 at the International Surrealist Exhibition organized by Breton and other Surrealist artists and writers at Inés Amor's Gallery of Mexican Art.

In the same year Rivera received a commission for a mural project, his first for several years – once again from the United States. With the signing of the Russo-German Non-Aggression Pact in August 1939, Rivera's negative attitude towards the United States changed, and he accepted the invitation to California. His anti-fascist views led to his coming to stand for the solidarity of all American countries against fascism, and this is reflected in the subject-matter of the San Francisco project. The ten wall-panels entitled *Pan-American Unity* (ills. pp.72–73) show scenes from Mexican and North American history, with special emphasis on cultural development.[24] In the central part of the polyptych, against the background of San Francisco Bay, the fusion of both cultures takes place in the shape of the Aztec goddess Coatlicue, symbolizing dualism; she is represented on one side in the

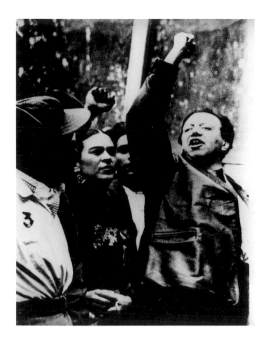

Diego Rivera and Frida Kahlo at a demonstration, 1936
Collection of Excelsior Archive, Mexico City
Print: Rafael Doniz

manner of an anthropomorphic figure following the tradition of monumental Mexican stone sculpture, and on the other side turns into a metal, robot-like machine.

In San Francisco, during his work on this mural, Rivera married Frida Kahlo, whom he has portrayed as an artist in the central area of the fresco, for the second time. He himself, with his American assistant Paulette Goddard, with whom he is said to have had a relationship, is depicted planting behind Kahlo the tree of life and love, symbol of the union of the two cultures of the American continent. Kahlo, after a prolonged stay abroad in 1938/39 and her first international success as an artist, had left Rivera and moved to her parents' home in Coyoacán. Both partners, however, found the separation difficult to endure, and when Kahlo returned to San Francisco to have treatment for her spinal column from a doctor friend, she immediately accepted Rivera's proposal and their second marriage took place on 8 December 1940. Shortly afterwards Kahlo returned to Mexico, and in February 1941, when he had finished the San Francisco mural, Rivera moved into the "Blue House" with her in Coyoacán. From then on he used the San Angel Inn house exclusively as a studio and retreat.

In 1942, after his return from San Francisco, Rivera began a project that was to occupy him for the rest of his life. He had discovered a passion for collecting works of folk art and pre-Columbian archaeological finds in the early 1920s, and on these he had since spent a large part of his income (ill. p.73 below). Inspired by the antique cultures of his native country, Rivera conceived the idea of constructing a monumental building modelled on the Aztec pyramid of Tenochtitlán. Originally intended as a house and studio on Pedregal Field, which at that time lay outside Mexico City,

The Hands of Dr Moore, 1940
Las manos del Dr. Moore
Oil on canvas, 45.8 x 55.9 cm
San Diego Museum of Art, San Diego, Bequest of Mrs E. Clarence Moore, 70.20

Diego Rivera, Leon Trotsky and André Breton, 1938
Photo: Manuel Alvarez Bravo, Courtesy Cenidiap Archive, Mexico City

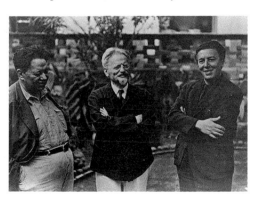

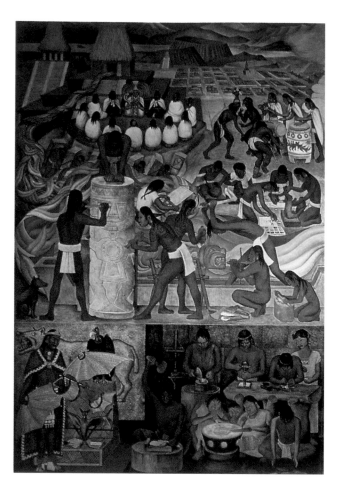
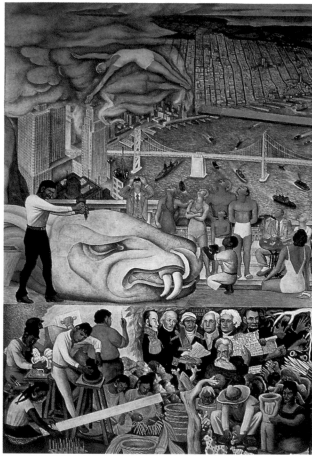
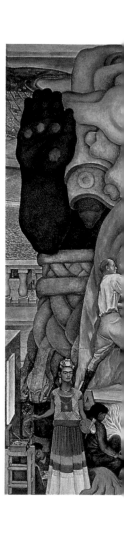

Pan-American Unity, 1940
Unidad panamericana
Transportable fresco
Ten murals, total dimensions 6.74 x 22.5 m,
painted surface 151.88 sq. m
City College of San Francisco, San
Francisco, lobby of the Auditorium
(originally executed for the Palace of Fine
and Decorative Arts at the Golden Gate
International Exposition, San Francisco)

"Anahuacalli", meaning "the house of Anahuac" in the Nahuatl language, was later used primarily as an exhibition space for a collection that had grown to 60,000 items.[25]

At this time Rivera was receiving increasing public recognition, his standing as one of Mexico's foremost artists was undisputed, and in 1943 the Mexican president, Avila Camacho, made him one of the first fifteen members of the newly founded National College (Colegio Nacional), an association of prominent Mexican scholars, writers, artists, musicians and intellectuals; he and Orozco represented the plastic arts. At the same time he was appointed to a professorship at the Academy of Art in La Esmeralda, which had opened the year before. Twenty-two artists were appointed to the staff in a thoroughgoing reform of art teaching, including Frida Kahlo besides Rivera. This was the latter's first teaching appointment since his short spell as director of the San Carlos Academy of Art in 1929/30. Shaped by the Mexican-national orientation of its staff, the teaching at La Esmeralda differed from that of other academies. Here at last Rivera was able to some extent to realize his conception of the artist's education. Instead of putting students to work before plaster models in a studio or having them copy European models, teachers sent them onto the street or into the countryside, to get their stimulus direct from Mexican reality. Besides their education in art, students were also taught academic subjects and left the Academy with normal school-leaving qualifications.

Like other teachers, Rivera went with his students on expeditions into the city and the provinces, to which, in the years 1943 and 1944 especially,

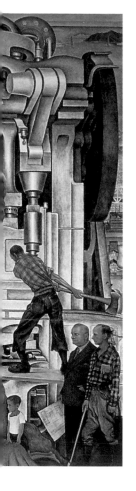

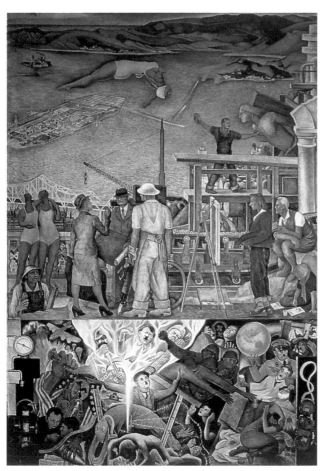

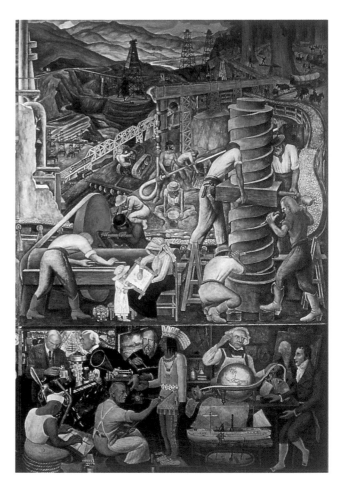

drawings and watercolours of everyday scenes and a number of landscapes
bear witness. A group of watercolours and ink drawings depicting the
eruption of the volcano El Paricutín in the State of Michoacán (ill. p.74
above) and the oil painting *Day of the Dead* (ill. p.74 below) date from
this period.

In 1947, shortly after his recovery from an inflammation of the lungs,
Rivera began work on a large-scale new mural. In the foyer of the sump-
tuous Hotel del Prado, situated in the centre of Mexico City opposite
the south side of Alameda Park, he painted *Dream of a Sunday Afternoon
in Alameda Park*[26] (ill. p.75). This condensed representation of the history
of Mexico, with its background of the central point of Alameda Park, a
favourite goal for the Sunday walks of city-dwellers seeking rest and re-
creation, is the last and most autobiographical of Rivera's great historical
murals. The 15-metre fresco takes the viewer on a Sunday walk through the
Park, meeting numerous prominent figures from Mexican history in a con-
tinuous row, chronological from left to right. In the central part (ill. p.75)
the boy Diego is led by the hand by Dame Catrina ("Calavera Catrina"),
a skeleton figure parodying vanity created by the popular graphic artist
José Guadalupe Posada. Posada, who is portrayed on the right of Dame
Catrina, gallantly offering her his arm, was highly revered by Rivera, who
claimed him as one of his artistic forebears and teachers. It is not known,
however, whether, like Orozco and Siqueiros, as a young painter Rivera
actually did spend time in the street-front city studio of the graphic artist
and publisher of *corridos*, cartoons and broadsheets, as has often been

Diego Rivera with his collection of pre-
Columbian clay figures, c. 1950
Courtesy Cenidiap Archive, Mexico City

asserted, or whether he first became interested in Posada's work after his return to Mexico from Europe. In any case, there is no doubt that the ironic narrative method of this gifted popular artist was an extremely influential model for Rivera's mural painting in particular. Calavera Catrina, a symbol of the urban bourgeoisie at the turn of the century, must also be taken here as an allusion to the Aztec Earth Mother Coatlicue, who is frequently represented with a skull. She wears the plumed serpent, symbolic of her son Quetzalcoatl, round her neck as a boa, and her belt-buckle displays the Aztec astrological sign of Ollin, symbolizing perpetual motion. In this mother of the gods, here also a mother-figure to Rivera himself, the origin of both life and of the quintessential Mexican spirit is represented, as well as the dual principle of pre-Columbian mythology, which has its counterpart in the Yin-Yang symbol of Chinese philosophy, which the adjacent figure of Frida Kahlo holds in her hand.[27] Kahlo's other hand rests maternally on the shoulder of the young Diego, who sets out on his walk through life and the world under her protection.

This mother-child aspect of the couple's relationship is also brought out by Kahlo in her article "Portrait of Diego" published in honour of the artist in 1949.[28] After major exhibitions of works by the muralists Orozco and Siqueiros, who with Rivera formed the mural-painting committee of the National Institute of Fine Arts (Instituto Nacional de Bellas Artes or INBA), in the year 1947, a comprehensive retrospective in 1949 to mark the fiftieth anniversary of the beginning of Rivera's artistic career, comprising over a thousand works, was opened by the Mexican president, Miguel Aleman, in the Palace of Fine Arts.

Erupting Volcano (folio from the album "Paricutín"), 1943
Volcán en erupción (del álbum "Paricutín")
Watercolour on paper, 44 x 31 cm
Museo-Casa Diego Rivera, Guanajuato
Photo: Rafael Doniz

Day of the Dead, 1944
Día de muertos
Oil on hardboard, 73.5 x 91 cm
Museo de Arte Moderno, MAM – INBA,
Mexico City
Photo: Rafael Doniz

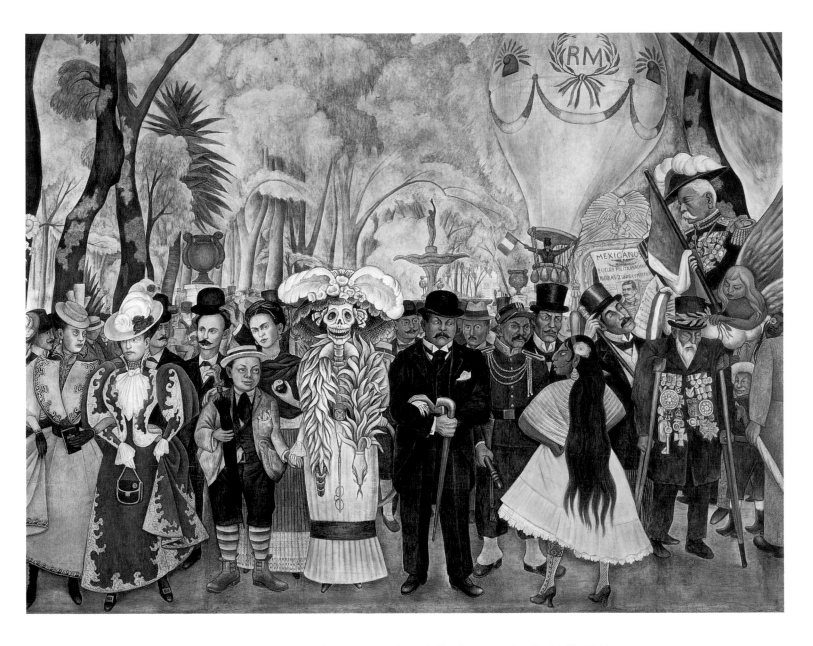

Dream of a Sunday Afternoon in Alameda Park (centre detail), 1947–1948
Sueño de una tarde dominical en la Alameda Central
Transportable fresco, 4.8 x 15 m
Museo Mural Diego Rivera, Mexico City
(originally in the Hotel del Prado on Alameda Park;
the building was pulled down after being
damaged in the earthquake of 1985)
Photo: Rafael Doniz

Dream of Peace and Unity: the Last Journey

When in 1950 Frida Kahlo had to spend nine months in hospital after several spinal column operations, Rivera, who was having a very productive phase, took a room in the hospital and stayed there almost every night. While continuing with the frescoes in the National Palace he illustrated, together with Siqueiros, the limited edition of Pablo Neruda's great epic poem *Canto General* and designed its cover (ill. p.76).

Early in 1951 Rivera received a new mural commission – the decoration of a waterworks scheme in Chapultepec Park, which would collect water from the Lerma as drinking water for Mexico City.[29] The new type of construction of this distribution system was intended to conform not only to practical and technical but also to aesthetic standards, and set the artist a great challenge in the decoration of the cistern basin, its floor and walls, and a tunnel. The mural *Water, Origin of Life* (ills. pp.78, 79) would for the most part be underwater, and so Rivera used an experimental technique with a combination of polystyrene and a rubber solution. The theme was homage to the life-creating power of water. In the well in front of the pumping station he executed the relief *Tláloc the Rain God* (ill. p.81 below), using a pre-Columbian mosaic technique with variegated stones.

Rivera's work in stone mosaic, a technique that he had first adopted at "Anahuacalli" in 1944 then in Chapultepec Park, was continued in a project planned on a larger scale in 1951/52 but only executed in small part. The commission was for the decoration of the outer wall surface of the new Mexico University stadium, for which Rivera depicted the evolution of sport in Mexico from the pre-Columbian period to modern times and designed various motifs relating to sport in numerous preparatory drawings. Only the central part of the frontal piece of the whole design was actually executed in mosaic relief, the funding of the project being cancelled at this point.

During President Miguel Aleman's term of office (1946–1950) Mexico openly turned towards Western capitalism, departing from the traditional Mexican line and moving towards cultural, economic and political modernization. Despite this, Rivera continued to paint murals from an unequivocal Mexicanist viewpoint, as in *History of the Theatre in Mexico* (ill. p.81 above) on the façade of the Insurgent Theatre, where he symbolized the ideals of the Mexican Revolution. Even when in 1950 he was chosen with Siqueiros, Rufino Tamayo and Orozco to represent Mexico at the Venice Biennale, and was awarded the National Prize of Plastic Arts, the most

Pablo Neruda, Diego Rivera und David Alfaro Siqueiros sign the 500 numbered copics of Neruda's *Canto General*, illustrated by Rivera and Siqueiros, 1950
Courtesy Cenidiap Archive, Mexico City

ILLUSTRATION PAGE 76:
Pre-Hispanic America (book cover for Pablo Neruda's *Canto General*), 1950
América prehispánica
Oil on canvas, 70 x 92 cm
Collection of the Estate of Licio Lagos, Mexico City
Photo: Rafael Doniz

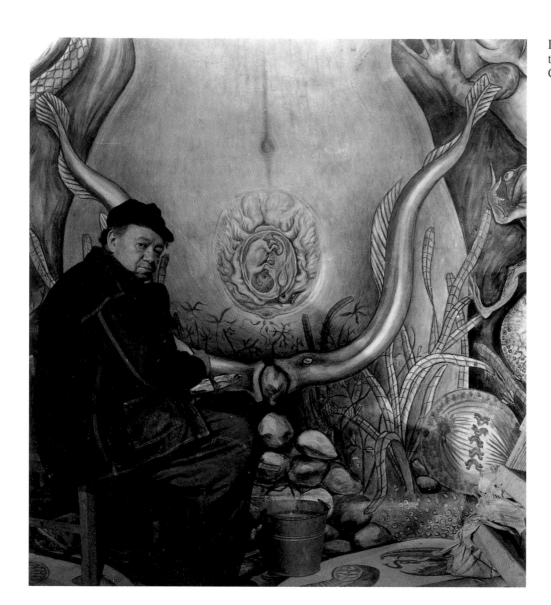

Diego Rivera painting the female figure in the mural *Water, Origin of Life*, 1951
Courtesy Cenidiap Archive, Mexico City

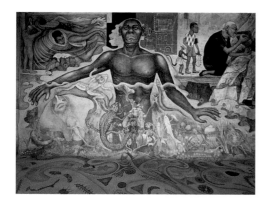

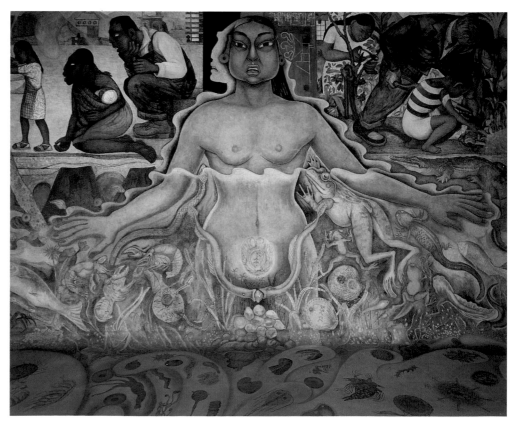

Water, Origin of Life, 1951
El agua, origen de la vida
Fresco in polystyrene and rubber solution
Ground and four wall surfaces, total painted
surface 224 sq. m
Cárcamo del río Lerma, Chapultepec Park,
Mexico City
Above: **Figure Symbolizing the African Race**
Figura simbolizando la raza negra
Right: **Figure Symbolizing the Asiatic Race**
Figura simbolizando la raza asiática
Photos: Rafael Doniz

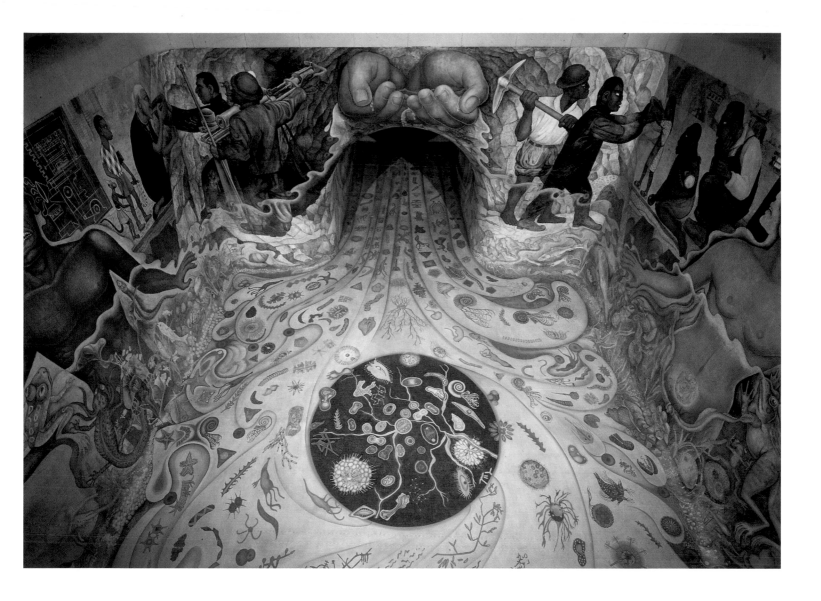

From the cycle: Water, Origin of Life:
The Hands of Nature Offering Water, 1951
Manos de la naturaleza brindando el agua
General view with parts of two adjoining
walls and ground
Photo: Rafael Doniz

important state prize, given annually to Mexico's foremost artists, Rivera
did not renounce his opposition to state policy.

In 1946 he had applied for readmission to the Mexican Communist
Party. His application was rejected, as was his later reapplication with Frida
Kahlo. But while Kahlo was accepted in 1949, yet another application by
Rivera was rejected in 1952. Early in July 1954 Rivera took part with Kahlo
in a declaration of solidarity with the government of Jacobo Arbenz in
Guatemala. Participation in a protest against the CIA's intervention in
Mexican affairs was the last public appearance of Rivera's partner. Frida
Kahlo died on 13 July at the age of 47. During the vigil over her body in the
Palace of Fine Arts her political friends, with Rivera's agreement, spread the
Communist flag over the coffin. In the sensation caused by this incident,
Rivera's renewed petition for readmission to the Mexican Communist Party
was successful. His first work after renewal of party membership was the
large painting *Glorious Victory*, depicting the fall of Arbenz in poster style.
Rivera sent this propaganda painting on tour to several countries of the
Soviet bloc; it disappeared after the last showing in Poland.

To this same year belongs the easel work *The Painter's Studio* (ill. p.85),
showing Rivera's work-room, with a model lying stretched out on an easy-
chair surrounded by threatening-looking figures of Judas. This work's title

Design for the mural *History of the Theatre in Mexico*, 1953
Historia del teatro en México
Pencil and ink on paper, 0.43 x 1.18 m, left half
Museo-Casa Diego Rivera, Guanajuato
Photo: Rafael Doniz

ILLUSTRATION PAGE 81 ABOVE:
History of the Theatre in Mexico, 1953
Historia del teatro en México
Glass mosaic, 12.85 x 42.79 m
Teatro de los Insurgentes, Mexico City
Photo: Rafael Doniz

ILLUSTRATION PAGE 81 BELOW:
Tláloc the Rain God, 1951
Dios de la lluvia Tláloc
Mosaic in stones
Well in front of the waterworks building
Cárcamo del río Lerma, Chapultepec Park, Mexico City
Photo: Rafael Doniz

Diego Rivera making a speech to the Mexican Communist Party (on the podium, from left to right: José Chávez Morado, Xavier Guerrero, David Alfaro Siqueiros and Enrique González Rojo), 1956
Photo: Mayo Brothers, Courtesy Cenidiap Archive, Mexico City

indicates the increasing importance of the artist's studio as a workplace in these years (see also ills. p.82 above and p.84). Not only his age but also the state of his health made work on monumental walls in the open more difficult for him, and so in his last years easel painting became his favoured medium.

Since the end of the 1940s he had worked on commissioned portraits, and during this period their number increased. The fact that the artist so committed to Marxism attracted admirers even in distinguished society is surely one of the most surprising of all the contradictory facets of Rivera's life. He was a favourite artist not only with American collectors who had been buying his portraits of Mexican children in Mexico ever since the late 1920s, but also, in the 1950s, above all with prosperous Mexicans, who commissioned portraits of their wives and children from him. These works are those of an artist who now painted "bourgeois pictures for the bourgeoisie", showing us "a kind of X-ray image of a new class at the very moment it was coming into existence, a class that acquired wealth through the onset of industrialization, and employed 'the Mexican' as a cosmetic element, a facial paint which was the exclusive fashion of filmstars, politicians' wives and a few intellectuals".[30] Two typical such portraits are *Sra. Doña Elena Flores de Carrillo* (1953; ill. p.89 below), wife of the then rector of Mexico University, and her daughter *Elenita Carrillo Flores* (1952; ill. p.89 above).

Almost all periods of Rivera's career include portraits. Besides numerous portrayals of historical figures in the murals, which served primarily political purposes, he began to paint portraits of persons close to him, friends and acquaintances, at a very early stage, during his years in Europe. In these works he sought to bring out the subjects' fundamental characteristics. Sometimes he emphasized certain parts of the body in an almost expressionist way, as in the extraordinary *Portrait of Lupe Marín* (1938; ill. p.83), depicting his former wife sitting in front of a mirror, a recurring motif in his portraits. In this one the artist seems intentionally to refer to various artists of the past: in the exaggerated proportions and the very pose, to El Greco; in the mirrored reflection, to works by Velázquez, Ingres and Manet;

Outside of the house in San Angel Inn, now the Museo Estudio Diego Rivera, Mexico City
Photo from: Bertram D. Wolfe, *Diego Rivera*, New York/London, 1939

On his return from the United States in 1934 Rivera moved into a new house. The two-square-block building in Bauhaus style, in which Frida Kahlo also lived for a few years, served him as home and studio for the rest of his life.

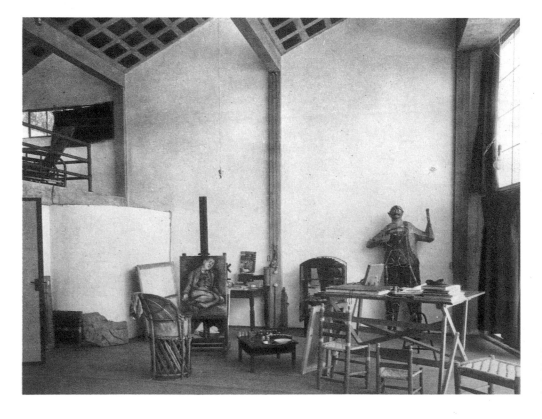

A corner of Diego Rivera and Frieda Kahlo's studio in San Angel Inn
Photo from: Bertram D. Wolfe, *Diego Rivera*, New York/London, 1939

Portrait of Lupe Marín, 1938
Retrato de Lupe Marín
Oil on canvas, 171.3 x 122.3 cm
Museo de Arte Moderno, MAM – INBA,
Mexico City
Photo: Rafael Doniz

Rivera painted this full-length portrait of
Guadalupe Marín, mother of their two
daughters Guadalupe and Ruth, in 1938,
many years after he had separated from her.

while the complex structure of the composition, with its intersecting and
linked planes and axes, points to Cézanne.

Having immortalized Lupe Marín and his daughters Guadalupe and
Ruth in the gigantic historical mural in the Hotel del Prado, in 1949 Rivera
painted the large-sized full-figure *Portrait of Ruth Rivera* (ill. p.87). The
subject stands in the manner of a figure from Classical Antiquity, wearing a
white tunic and thonged sandals, in front of a round mirror which reflects
her profile in brilliant yellow, strikingly resembling the Maya profiles seen
in pre-Columbian sculpture and reliefs.

The mythological impact that this painting makes is in sharp contrast
to most of Rivera's other female portraits where, as in *Portrait of Cuca*

Diego Rivera in his studio with
papier-mâché Judas figures, 1956
Photo: Héctor García, Courtesy Cenidiap
Archive, Mexico City

The Painter's Studio, 1954
Estudio del pintor
Oil on canvas, 178 x 150 cm
Collection of Secretaría de Hacienda y Crédito
Público, Mexico City. Photo: Rafael Doniz

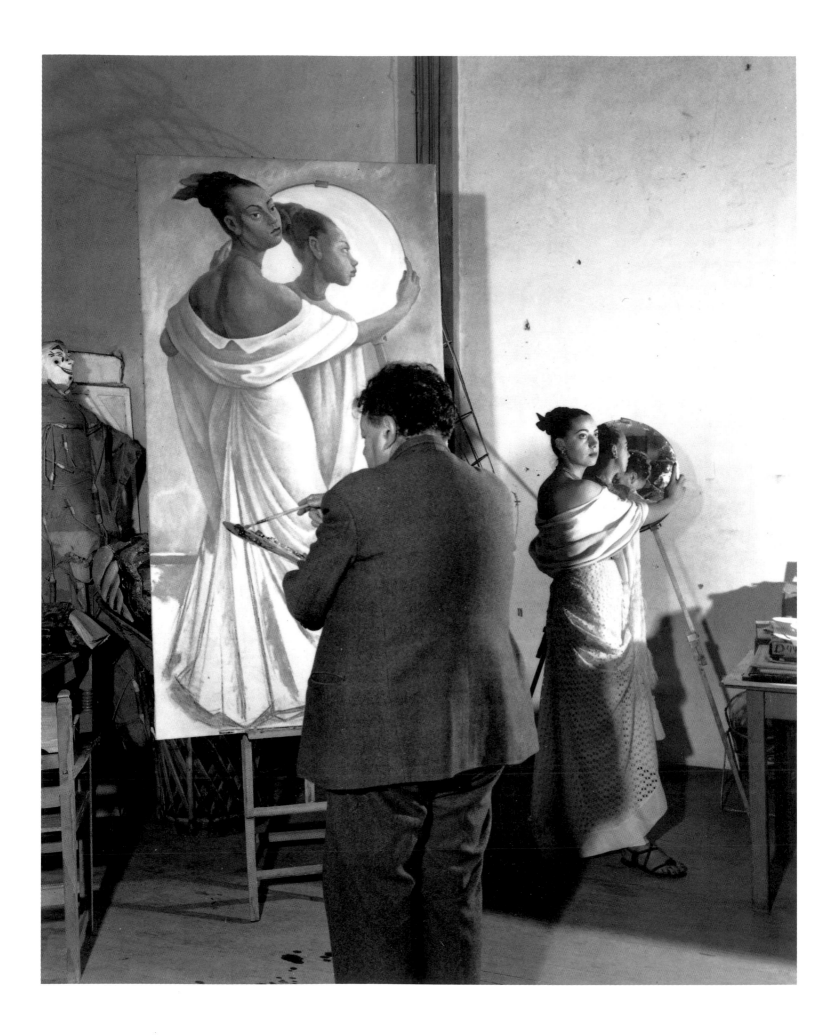

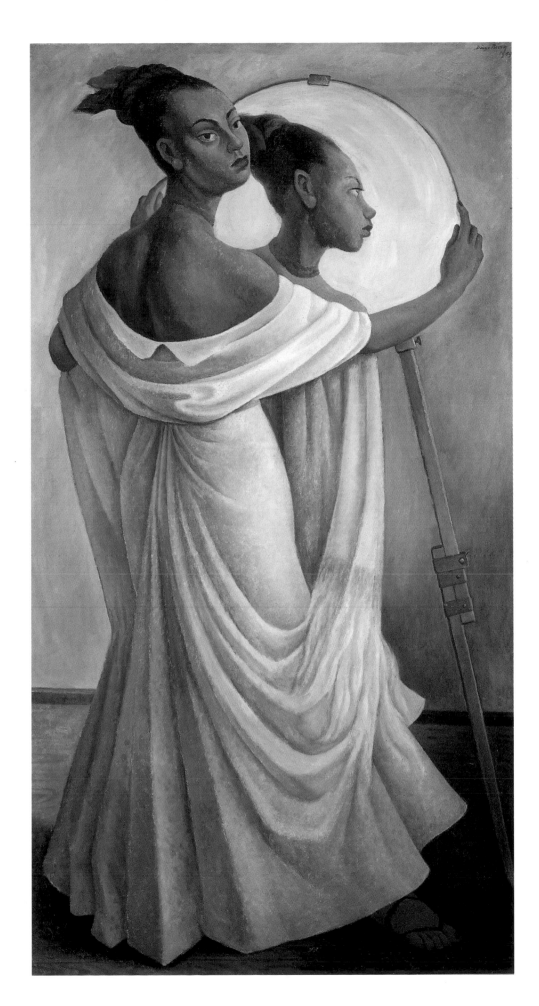

ILLUSTRATION PAGE 86:
Diego Rivera with his daughter Ruth,
posing for her portrait in the studio at
San Angel Inn, 1948
Photo: Juan Guzmán, Cenidiap Archive
Collection, Mexico City

Portrait of Ruth Rivera, 1949
Retrato de Ruth Rivera
Oil on canvas, 199 x 100.5 cm
Rafael Coronel Collection, Cuernavaca
Photo: Rafael Doniz

Rivera seldom painted easel portraits of
members of his family. He executed this
extraordinary large-size, full-figure painting
of his daughter after portraying Lupe Marín,
Ruth and Guadalupe in the gigantic
historical mural in the Hotel del Prado.

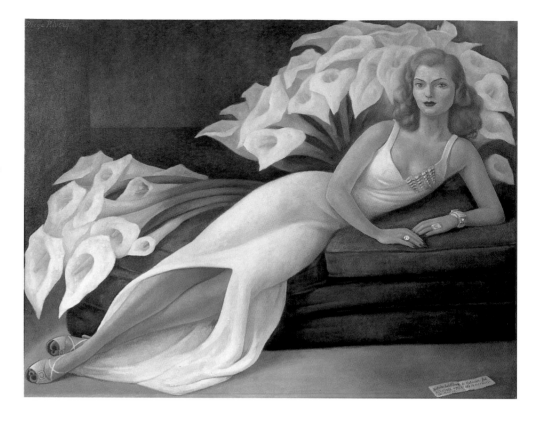

Portrait of Natasha Zakólkowa Gelman, 1943
Retrato de Natasha Zakólkowa Gelman
Oil on canvas, 115 x 153 cm
Jacques and Natasha Gelman Collection, Mexico City
Photo: Jorge Contreras Chacel, Courtesy Centro Cultural/Arte Contemporáneo, A.C., Mexico City

Natasha Gelman was the wife of a very well known and wealthy film producer. In this portrait her pose and close-fitting white dress reflect the elegant form of the calla lilies in the background.

Portrait of Cuca Bustamante, 1946
Retrato de Cuca Bustamante
Oil on canvas, 158 x 122.5 cm
Museo de Arte Moderno, MAM – INBA, Mexico City
Photo: Rafael Doniz

Bustamante (1946; ill. p.88 below), the subject is frequently shown in brightly coloured Mexican costume or there is a heightened Mexican ambience with exotic flowers and fruit. In paintings of the latter category, parallels are often drawn between background attributes and the women portrayed: the pose and the white, close-fitting evening dress of Natasha Gelman, for example, wife of a famous and prosperous film-producer, take up the elegant form of the calla lilies providing the prominent background, which at the same time symbolize the nature of the fine woman (ill. p.88 above). The figure of Machila Armida, a good friend of Kahlo and Rivera, said to have conducted a number of light-hearted affairs, is portrayed in *Macuilxochitl* as a machila flower in a "testimonial of love", as the inscription in the picture has it, and surrounded with exotic fruits and flowers. She herself becomes a part of this splendour, for the colours of her green dress, red mantilla and pink skin, reminiscent of the paintings of Renoir, are identical with those of the flowers and fruit. In these works Rivera refrains from his penchant for historical narrative and reveals himself as an extremely sensual painter, letting his feelings and fantasies flow freely into his compositions.

Shortly after he was found to have cancer, on 29 July 1955 Rivera married the publisher Emma Hurtado (ill. p.90 above). To her in 1946 he had ascribed the rights in all his paintings and drawings that were not the property of a client, for display in the Diego Gallery which she had opened for the purpose of selling his work. With his new wife he made a trip to the Soviet Union later in 1955 to undergo an operation and cobalt treatment; he had a great belief in Soviet medical achievements and hoped for a cure of his cancer. On his return journey he visited Czechoslovakia, Poland and East Germany, becoming a corresponding member of the Academy of Arts in Berlin.[31]

Some of the drawings he made on this trip were later used in oil paintings, among them *Ice Lingering on the Danube at Bratislava* (1956). Whether *May Day Procession in Moscow* (ill. p.90) was the original title for another oil painting dating from this period, however, is questionable. Rivera returned to Mexico at the beginning of April and so did not again attend the Moscow May Day celebrations. The colourful procession depicted in this work is more likely to have been a peace rally in these years of the Cold War, and the giant blue balloon which is carried by the demonstrators, displaying the word "peace" in various languages, would seem an indication of this. In its entire composition and palette, it is a thoroughly optimistic picture, and seems to express Rivera's own mood after receiving cancer treatment in the Soviet Union, an awareness of life that also enters a number of drawings of doves of peace belonging to this year. The artist appears to sense that his life is approaching its end, and feels a need to make peace with the world.

On Rivera's return to Mexico, Dolores Olmedo, a good friend, placed her house in Acapulco on the Pacific coast at his disposal, and here he spent the next few months in recuperation. Besides some mosaic decorations in stone with pre-Columbian themes for his hostess's house, he painted a large number of sunsets – small-size oils in extraordinary colours, views from the terrace onto Acapulco Bay (ill. p.91). In these almost miniature-like works too, the emphasis is on peace, on the artist's love for life, nature and his country, his need for harmony and tranquillity.

After his return to the capital Emma Hurtado exhibited these new works in her gallery in what, together with a show in honour of his seventieth birthday, was his last exhibition. Rivera spent the birthday itself quietly with family and close friends. The writer Efraín Huerta, who accompanied him on that day on a visit to his birthplace, Guanajuato, wrote later: "Diego wept, and there was a scarcely discernible trembling of the lips. We were in Guanajuato, opposite the house where he was born seventy years ago. And since then I have felt admiration for men who can weep. Twenty years ago I

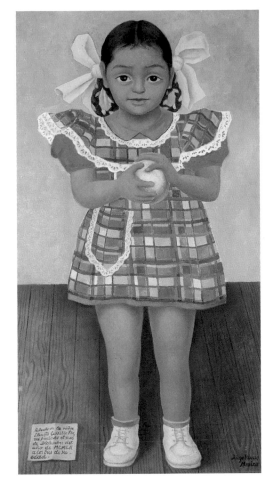

Portrait of the Young Girl Elenita Carrillo Flores, 1952
Retrato de la niña Elenita Carrillo Flores
Oil on canvas, 55 x 105 cm
Elena Carrillo Collection, Mexico City
Photo: Rafael Doniz

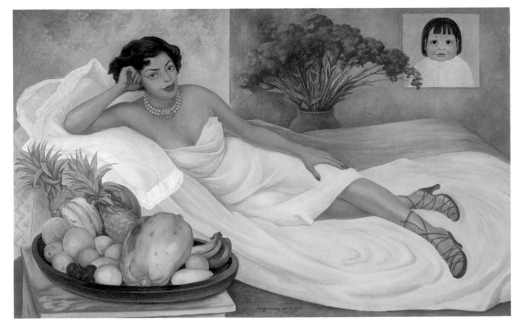

Portrait of Sra. Doña Elena Flores de Carrillo, 1953
Retrato de la Sra. Doña Elena Flores de Carrillo
Oil on canvas, 140 x 221.5 cm
Elena Carrillo Collection, Mexico City
Photo: Rafael Doniz

Diego Rivera and Emma Hurtado on their wedding day, 29 July 1955, in the artist's studio in front of *Portrait of Irene Phillips Olmedo*, 1955
Photo: Juan Guzmán, Cenidiap Archive Collection, Mexico City

saw him run the length of Cuba Street chasing a fascist after a very stormy meeting in Santo Domingo Square. And since then I've known that he is a brave and worthy man. Digno [Worthy] Rivera, he ought to be called. Or an M between his names would make a perfect name for him: Digno Mexicano Rivera [Worthy Mexican Rivera]."[32]

On 24 November 1957 Rivera died of a heart infarct, in his studio at San Angel Inn. Hundreds of Mexicans attended his funeral, as they had Frida Kahlo's. The terms of his will were not observed. He was buried in the Rotunda of Famous Men (Rotonda de los Hombres Ilustres) in the Civil Pantheon of Mourning (Panteón Civil de Dolores); his ashes were not mingled with those of Frida Kahlo in the "Blue House" which, like the building and collection at "Anahuacalli", he had bequeathed one year after his wife's death to the Mexican people as a museum. The writer Carlos Pellicer (ill. p.90 below left), a friend of his since 1922, had taken on the task of turning the two houses and their collections into museums.

May Day Procession in Moscow, 1956
Desfile del 1. de Mayo en Moscú
Oil on canvas, 135.2 x 108.3 cm
Collection of Fomento Cultural Banamex, Mexico City
Photo: Rafael Doniz

Portrait of Carlos Pellicer, 1942
Retrato de Carlos Pellicer
Oil on hardboard, 55 x 43 cm
Collection of the Carlos Pellicer family, Mexico City
Photo: Rafael Doniz

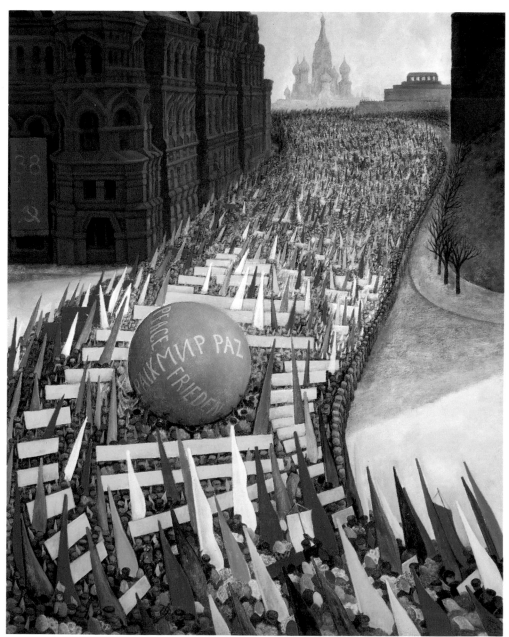

Evening Twilight at Acapulco, 1956
Atardecer en Acapulco
Oil and tempera on canvas, 30 x 40 cm
Collection of the Estate of Licio Lagos,
Mexico City
Photo: Rafael Doniz

After his cancer operation in Moscow,
Rivera returned to Mexico and spent several
months recuperating in the house of a
friend, Dolores Olmedo, at Acapulco on the
Pacific coast, where on the terrace with its
view of Acapulco Bay he painted a number
of small-size oils of sunsets. These works,
in which he experiments with colour, are
among his last paintings.

In the course of time Rivera's work came to be seen as inseparably
linked with Socialist Realism, and it must be conceded that his political
standpoint and the themes of his murals would seem to support this. The
style of his mural work, however, and indeed, his whole aesthetic, founded
on his studies of Italian Renaissance frescoes, classical proportion, pre-
Columbian sculptural forms, Cubist handling of space and Futurist represen-
tation of movement, ultimately have little in common with Socialist Realism.
His work contains not only observation of social circumstance but also com-
plex allegorical and historical narrative. Consideration of his œuvre as a
whole clearly indicates that, out of the many different techniques he mas-
tered, Rivera evolved his own completely individual style. His view of the
world, of the humanistic role that he saw for the artist and art in society,
were intuitive above all, and produced a universal art that still retains its
force today.

Diego Rivera 1886–1957: a Chronology

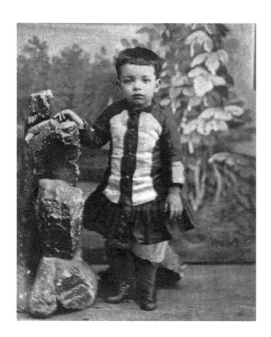

Diego Rivera at the age of three, c. 1889
Photo from: Bertram D. Wolfe,
Diego Rivera, New York/London, 1939

1886 José Diego María and his twin brother José Carlos María Rivera Barrientos are born in December in Guanajuato, capital of the State of Guanajuato, in Mexico, eldest sons of Diego Rivera and María del Pilar Barrientos.

1892 The Rivera-Barrientos family moves to Mexico City.

1896 Rivera begins evening classes at the San Carlos Academy after winning a prize.

1898 Enrols as a full-time student at San Carlos. His teachers are the painters Santiago Rebull, Félix Parra and José María Velasco.

1906 Exhibits for the first time, with 26 works at the annual exhibition of the San Carlos Academy.

1907 A travel grant enables embarkation for Spain in January.

1908 Travels in Spain.

1909 Visits France in spring, and then Belgium and England. In Brussels meets the Russian artist Angelina Beloff, who becomes Rivera's partner for the next twelve years and travels to Paris with him.

1910 Exhibits for the first time at the Society of Independent Artists in Paris. Returns to Mexico in August and exhibits at the San Carlos Academy in November. Witnesses the outbreak of the Mexican Revolution.

1911 Visits Paris again in mid-year and spends the winter in Catalonia.

1912 Moves with Angelina Beloff to 26 rue du Départ. Spends some time in Toledo in summer. First Cubist influence is seen in his work.

1913 Paints his first Cubist works and exhibits at the Autumn Salon.

1914 First one-man exhibition at the Berthe Weill Gallery in April. Trip to Mallorca, where he is overtaken by the outbreak of the First World War; further travels to Barcelona and Madrid.

1915 Returns in the summer to Paris, where he begins a relationship with the Russian artist Marevna Vorobyov-Stebelska.

1916 Exhibits at the Modern Gallery, New York in October. Son Diego born to Angelina Beloff.

1917 Working under contract to Léonce Rosenberg's Galerie L'Effort Moderne. In spring has a row with the art critic Pierre Reverdy, as a result of which he abandons Cubism and takes up figurative painting again. Meets the writer and art critic Elie Faure. In winter his son Diego dies.

1918 Moves with Angelina Beloff to the Champ-de-Mars. Cézanne's influence becomes noticeable in his work.

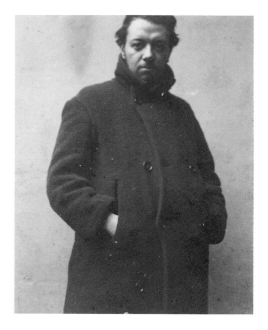

Diego Rivera as a student in Europe, c. 1908–1915
Museo-Casa Diego Rivera, Guanajuato
Photo: Rafael Doniz

1919 Meets David Alfaro Siqueiros and discusses with him the need for change in Mexican art. His daughter Marika born to Marevna Vorobyov-Stebelska.

1920/21 Travels in Italy, making numerous studies and sketches. Shortly after his return to Paris, makes his final return to Mexico.

1922 In January paints his first mural, in the Simón Bolívar Amphitheatre of the National Preparatory School. Marries Guadalupe Marín. In September begins the frescoes in the Ministry of Education (Secretaría de Educación Pública or SEP). He is co-founder of the Union of Revolutionary Painters, Sculptors and Graphic Artists and joins the Mexican Communist Party.

1924 Daughter Guadalupe born.

1925 While still working on the frescoes in the SEP building, he begins to paint

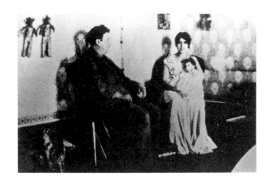

Diego Rivera with Guadalupe Marín and his eldest daughter Guadalupe Rivera Marín in 1924
Fotothek Collection, INAH, Pachuca, Courtesy of Cenidiap Archive, Mexico City

frescoes at the National School of Agriculture at Chapingo.

1927 Invited to the Soviet Union in the autumn to take part in the celebration of the tenth anniversary of the October Revolution. Daughter Ruth born.

1928 On his return from the Soviet Union, separates from Lupe Marín. Finishes work in the SEP building and at Chapingo.

1929 Marries Frida Kahlo. Paints the walls of the stairwell in the National Palace in Mexico City and also murals at the Ministry of Health. Commissioned by the US ambassador in Mexico to paint a mural at the Palace of Cortés in Cuernavaca. Appointed director of the upper school of the San Carlos Academy of Art, but soon dismissed.

1930/31 In San Francisco paints a mural in the Luncheon Club of the San Francisco Pacific Stock Exchange and another in the California School of Fine Arts. The newly opened Museum of Modern Art in New York offers him an exhibition.

1932 Designs sets and costume for Carlos Chávez's ballet *Horse Power*. Begins murals in the Detroit Institute of Arts.

1933 Begins to paint a mural at the Rockefeller Center in New York, incorporating in it a portrait of Lenin which results in the suspension of the project and later the complete destruction of the unfinished wall-painting.

1934 The mural which had been planned for the Rockefeller Center is executed in a new form in the Palace of Fine Arts in Mexico City.

1935 Completes the murals in the stairwell of the National Palace, left unfinished since 1930.

1936 Paints four frescoes in Ciro's Bar in the Hotel Reforma, in which he attacks Mexican political figures. The frescoes are removed from the Bar.

1937 Receives Trotsky and his wife Natalia Sedova in Frida Kahlo's "Blue House".

1938 André Breton and his wife Jacqueline Lamba stay with Rivera during their visit to Mexico.

1939 Breaks with Trotsky after rows between them. He and Frida Kahlo separate.

1940 Paints ten murals in San Francisco for the Golden Gate International Exposition, and while in San Francisco marries Frida Kahlo for the second time.

1941/42 Works mostly on easel paintings until receiving authorization to paint frescoes on the upper storey of the inner courtyard of the National Palace. Begins to build "Anahuacalli" to house his collection of pre-colonial objects and works of art.

1943 Paints two murals for the National Institute of Cardiology. Becomes one of the first members of the National College and holds a number of conferences on art, science and politics. Appointed a professor at La Esmeralda College of Art.

1946 Large-size mural commissioned for the new Hotel del Prado.

Diego Rivera with his daughter Ruth in front of "Anahuacalli" in the course of its construction, c. 1945–1950
Courtesy Cenidiap Archive, Mexico City

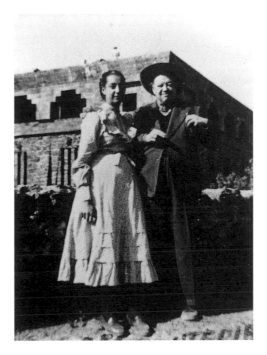

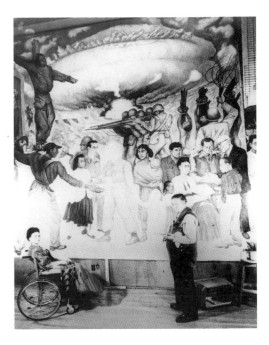

Frida Kahlo posing in a wheelchair for the painting *Nightmare of War, Dream of Peace*, 1952
Photo: by Juan Guzmán, Cenidiap Archive Collection, Mexico City
Photo: Rafael Doniz

1947 With José Clemente Orozco and David Alfaro Siqueiros, forms the National Institute of Fine Arts' (INBA) Commission for Mural-Painting.

1949 Fiftieth anniversary of Rivera's artistic career marked by a comprehensive exhibition organized by INBA at the Palace of Fine Arts.

1950 Illustrates the limited edition of Pablo Neruda's *Canto General* and designs the sets for José Revueltas' stage play *El cuadrante de la soledad*. With Siqueiros, Orozco and Tamayo represents Mexico at the Venice Biennale. Awarded the National Prize for Plastic Arts.

1951 Executes underwater murals in polystyrene in the "Cárcamo del Río Lerma" waterworks in Chapultepec Park in Mexico City and stone mosaic in the well at the entrance to the pumping station.

1952 Paints a portable mural for the exhibition Twenty Centuries of Mexican Art which is to travel round Europe, but the portrayal of Stalin and Mao Tse-tung causes the work to be taken out of the exhibition; it is donated to the People's Republic of China.

1953 Executes a mural in glass mosaic on the façade of the Teatro de los Insurgentes. At the same time finishes work on the front of the Olympic Stadium on the campus of Mexico University. Also paints a mural in La Raza Hospital, Mexican Institute of Social Security.

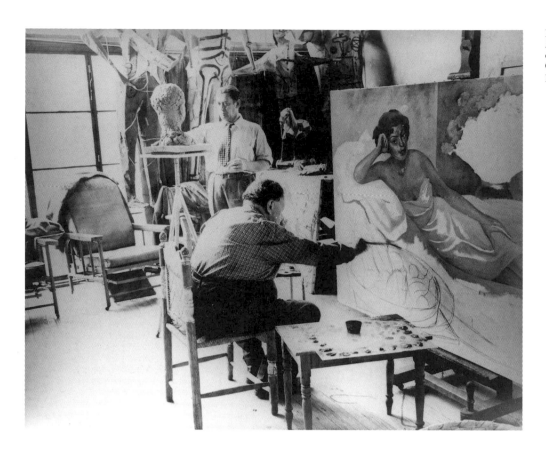

Diego Rivera painting *Portrait of Sra. Doña Elena Flores de Carrillo* in his studio at San Angel Inn, c. 1953
Cenidiap Archive Collection, Mexico City
Photo: Rafael Doniz

1954 Takes part with Frida Kahlo in a solidarity rally for the government of Jacobo Arbenz in Guatemala. Kahlo dies in July. In September, after several attempts, his application to rejoin the Mexican Communist Party is accepted.

1955 Marries the publisher Emma Hurtado in July. Bequeaths the "Blue House", Frida Kahlo's family house in Coyoacán, with "Anahuacalli" and his pre-Columbian collection to the Mexican people. Trip to the Soviet Union at the end of the year to undergo medical treatment.

1957 Dies in Mexico City on 24 November. The stipulation in his will for his ashes to be mingled with those of Frida Kahlo at the "Blue House" are not observed and he is buried in the Rotunda of Famous Men in the Civil Pantheon of Mourning.

Outside of the "Anahuacalli",
now Museo Anahuacalli, Mexico City
Photo: Rafael Doniz

Notes

1 Gladys March, *Diego Rivera: Mi arte, mi vida. Una Autobiografía* (translation of English ed., New York 1960), Mexico City 1963, p.12

2 See Rivera in exhibition catalogue *45 Autorretratos de pintores mexicanos*, Museo Nacional de Artes Plásticas, Mexico City 1947, p.56

3 The teaching method of the French Academician Jules-Jean Désiré Pillet involved drawing from direct observation of nature or from photographs.

4 Rivera in Loló de la Torriente, *Memoria y razón de Diego Rivera*, Mexico City 1959, I, p.264

5 On Rivera's years in Europe, see:
– Exhibition catalogue *Diego Rivera: The Cubist Years*, Phoenix Art Museum (Phoenix, New York, San Francisco, Mexico City), Phoenix (AZ) 1984
– Olivier Debroise, *Diego de Montparnasse*, Mexico City 1979
– Ramón Favela, "Rivera Cubista. A Critical Study of the Early Career of Diego Rivera, 1898–1921", unpublished thesis, University of Texas at Austin, Austin (TX) 1984
– María Cristina Flores Arauz, "La obra cubista de Diego Rivera", unpublished thesis, UNAM 1965
– Martín Luis Guzmán, *Diego Rivera y la filosofía del Cubismo*, Mexico City 1921
– Manuel Reyero (ed.), *Diego Rivera*, Mexico City 1983

6 Elie Faure, "Varia", 1937 in *Oeuvres complets*, Paris 1964, quoted from Rivera, *Iconografía Personal. Diego Rivera 1886–1986*, Mexico City 1986, p.32

7 Rivera in March, 1963 (see note 1), p.97

8 On the mural *The Creation* in the Bólivar Amphitheatre of the National Preparatory School, see: Alicia Azuela in Esther Acevedo et al., *Guía de murales del centro histórico de la Ciudad de México*, Mexico City 1984, pp.14–16.
It should be noted that no reproduction of a mural painting can be satisfactory and can only leave the impact of the work to the imagination, because its separation from the architectural setting and the social life around it contradicts the artist's original intended overall effect.

9 Diego Rivera, "From a Mexican Painter's Notebook", *The Arts*, 7, January 1925, pp.21–24

10 See text of the manifesto in *Kunst der mexikanischen Revolution. Legende und Wirklichkeit* (NGBK, Schloss Charlottenburg), Berlin 1974, p.135

11 On the fresco series in the Ministry of Public Education (SEP), see:
– Luis Cardoza y Aragón, *Diego Rivera: los frescos en la Secretaría de Educación Pública*, Mexico City 1980
– Olivier Debroise in Acevedo et al., 1984 (see note 8), p.131
– Olav Münzberg and Michael Nungesser, "Revolution und Utopie. Riveras Corrido-Zyklen im mexikanischen Erziehungs-ministerium", *Umbruch*, Frankfurt, No. 7/8, 25 July 1983, pp.26–30, 42–46
– Antonio Rodríguez, *Guía de los murales de Diego Rivera en la Secretaría de Educación Pública*, Mexico City 1984

12 *The Daybooks of Edward Weston*, ed. Nancy Newhall, I, Mexico City/New York 1973, p.35

13 Octavio Paz, "Pasos de una Iniciación" in exhibition catalogue *Octavio Paz. Los privilegios de la vista*, Centro Cultural/Arte Contemporáneo A.C., Mexico City 1990, p.34

14 On the murals in the National School of Agriculture, Chapingo, see: Olav Münzberg and Michael Nungesser, "Diego Riveras Weg zwischen Natur- und Gesellschaftsutopie, Weiblichkeitskult und kritischer Historienmalerei. Die Wandbilder in der 'sixtinischen Kapelle' von Chapingo", *Umbruch*, Frankfurt, 5, No. 5/6, Winter 1986/87, pp.37–45
On the symbolism of the points of the compass and the arrangement of subject-matter in these murals, see also: Francis V. O'Connor, "An Iconographic Interpretation of Diego Rivera's Detroit Industry-Murals in terms of their Orientation to the Cardinal Points of the Compass" in exhibition catalogue *Diego Rivera: A Retrospective*, The Detroit Institute of Arts, New York 1986, pp.215–34, especially pp.221ff

15 Willi Münzenberg's *Das Werk des Malers Diego Rivera*, Berlin 1928, in which the mural cycle in the SEP building is described, was a response to Rivera's visit to Berlin in 1927; Hans Friedrich Secker published a first detailed study of Rivera's mural work in the year of the artist's death (*Diego Rivera*, Dresden, 1957). This interest, and especially in the Mexican mural movement overall, was continued in Germany with Antonio Rodríguez, *Der Mensch in Flammen. Wandmalerei in Mexico von den Anfängen bis zur Gegenwart*, Dresden, 1967 and two exhibitions, *Kunst der mexikanischen Revolution. Legende und Wirklichkeit* (NGBK, Schloss Charlottenburg), Berlin 1974 and *Wand Bild Mexiko* (Nationalgalerie), Berlin 1982

16 On the murals in the Cortés Palace in Cuernavaca, see: Stanton L. Catlin, "Rivera's Cuernavaca Series", excerpt from an unpublished manuscript in the Museum of Modern Art Library, New York 1948
– Stanton L. Catlin, "Some sources and uses of Pre-Columbian Art in the Cuernavaca Frescoes", *Proceedings of the 35th International Congress of Americanists*, Mexico City 1962, pp.439–49
– Stanton L. Catlin, "Political Iconography in the Diego Rivera Frescoes at Cuernavaca, Mexico" in Henry A. Millon and Linda Nochlin (eds.), *Art and Architecture in the Service of Politics*, Cambridge 1978, pp.439–49
– Emily Edwards, The Frescoes by Diego Rivera in Cuernavaca, Mexico City 1932
– Jorge Gurria Lacroix, *Hernán Cortés y Diego Rivera*, Mexico City 1971

17 On the San Francisco murals, see: Elisabeth Fuentes Rojas de Cadena, "The San Francisco Murals of Diego Rivera: A Documentary and Artistic History", unpublished doctoral thesis, University of California at Davis (CA) 1980

18 Edgar P. Richardson in *Detroit News*, 15 February 1931, quoted from Bertram D. Wolfe, *La fabulosa vida de Diego Rivera* (translation of English ed., New York 1963), Mexico City 1986, p.246
On the Detroit fresco series, see:
– Exhibition catalogue *The Rouge: the image of industry in the art of Charles Sheeler and Diego Rivera*, Detroit Institute of Arts, Detroit (MI) 1978
– Alicia Azuela, *Diego Rivera en Detroit*, Mexico City 1985
– Max Kozloff, "The Rivera Frescoes of Modern Industry and the Detroit Institute of Arts: Proletarian Art under Capitalist Patronage" in Millon and Nochlin 1978 (see note 16), pp.216–29
– O'Connor 1986 (see note 14), pp.215 ff, especially pp.221–34
– Addison Franklin Page, *Detroit Frescoes by Diego Rivera*, Detroit (MI) 1956
– George F. Pierrot and Edgar P. Richardson, *An Illustrated Guide to the Diego Rivera Frescoes*, Detroit (MI) 1934

19 Rivera in Wolfe, 1986 (see note 18), p.249. In a leaflet published by the Detroit Institute of Arts in 1933 Rivera himself describes the themes of this series; see Detroit 1986 (see note 14), p.126

20 O'Connor, 1986 (see note 14), pp.22ff

21 On the mural in the Rockefeller Center and its second version in the Palace of Fine Arts, Mexico City, see:
– *Los Murales del Palacio de Bellas Artes*, Mexico City 1996
– Winfried Wolf, "Diego Rivera: Der Mensch am Scheideweg", *Umbruch*, Frankfurt, No. 7/8, 25 July 1983, pp.26–30, 32–34

22 On the *Epic of the Mexican People* in the National Palace, Mexico City, see:
– Diego Rivera: Sus frescos en el Palacio Nacional de México, Mexico City 1957
– *Diego Rivera en Palacio Nacional. Obra Mural*, Mexico City 1987
– Gurria Lacroix 1971 (see note 16)
– R. S. Silva E., Mexican History: *Diego Rivera's Frescoes in the National Palace and Elsewhere in Mexico City*, Mexico City 1963
– Berta Taracena, *Palacio Nacional*, Mexico City 1962

23 Frida Kahlo, "Retrato de Diego", *Hoy*, Mexico City, 22 January 1949, pp.18–21; excerpts cited in Andrea Kettenmann, *Frida Kahlo*, Cologne 1992, pp.73ff

24 On the frescoes at the Golden Gate International Exposition, San Francisco, see: Dorothy Puccinelli, *Diego Rivera: The Story of His Mural at the 1940 Golden Gate Exposition*, San Francisco 1940

25 On the building of "Anahuacalli", Mexico City, see: *Diego Rivera Arquitecto*, Museo Anahuacalli, Mexico City 1964

26 On the mural in the Hotel Prado, Mexico City, see:
– Gurria Lacroix 1971 (see note 16)
– Michael Nungesser, "Satire und Sonntags-träumerei. Riveras Wandbild im 'Hotel del Prado' ", *Umbruch*, Frankfurt, 5, No. 5/6, Winter 1986/87, pp.46–48

27 See Betty Ann Brown, "The Past Idealized: Diego Rivera's Use of Pre-Columbian Imagery" in Detroit 1986 (see note 14), p.154

28 See note 23

29 On the frescoes in the Cárcamo del Río Lerma, Mexico City, see: Ma. Teresa Hernández Yáñez, "El Agua Origen de la vida. El Cárcamo de Chapultepec", *México en el Tiempo*, Mexico City, 1, No. 4, December 1994/January 1995, pp.52–57

30 On the portraits, see: Rita Elder, "Los retratos de Diego Rivera" in exhibition catalogue *Diego Rivera: Retrospectiva*, Centro de Arte Reina Sofia (Madrid etc 1986–88), Madrid 1992, pp.207ff, especially p.209

31 As in the case of Rivera's stay in Berlin in 1927, this visit to East Germany led to the publication of a study of his mural work; see note 15

32 Efraín Huerta, "Digno Mexicano Rivera" in André Henestrosa et al., *Testimonios sobre Diego Rivera*, Mexico City 1960, p.49

In this series: